Practice as Research in the Arts

Also by Robin Nelson

BOYS FROM THE BLACKSTUFF: The Making of TV Drama
(*editor with Bob Millington*)

MAPPING INTERMEDIALITY IN PERFORMANCE
(*co-editor with S. Bay-Cheng et al.*)

STATE OF PLAY: Contemporary 'High-End' TV Drama

STEPHEN POLIAKOFF ON STAGE AND SCREEN

TV DRAMA IN TRANSITION: Forms, Values and Cultural Change

Practice as Research in the Arts

Principles, Protocols, Pedagogies, Resistances

Written and edited by Robin Nelson
Director of Research, Royal Central School of Speech and Drama,
University of London, UK

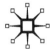
First published 2013 by
PALGRAVE MACMILLAN

Palgrave Macmillan in the UK is an imprint of Macmillan Publishers Limited,
registered in England, company number 785998, of Houndmills, Basingstoke,
Hampshire RG21 6XS.

Palgrave Macmillan in the US is a division of St Martin's Press LLC,
175 Fifth Avenue, New York, NY 10010.

Palgrave Macmillan is the global academic imprint of the above companies
and has companies and representatives throughout the world.

Palgrave® and Macmillan® are registered trademarks in the United States,
the United Kingdom, Europe and other countries.

ISBN 978–1–137–28289–7 hardback
ISBN 978–1–137–28290–3 paperback

This book is printed on paper suitable for recycling and made from fully
managed and sustained forest sources. Logging, pulping and manufacturing
processes are expected to conform to the environmental regulations of the
country of origin.

A catalogue record for this book is available from the British Library.

A catalog record for this book is available from the Library of Congress.

10 9 8 7 6 5 4 3 2 1
22 21 20 19 18 17 16 15 14 13

Printed and bound in Great Britain by
CPI Antony Rowe, Chippenham and Eastbourne

To Avril

Contents

List of Figures

Acknowledgements

First, I acknowledge all those students and colleagues with whom I have worked on 'practice as research' projects over many years to arrive at the insights set out in this book. Many are named through citation but others, although they may remain anonymous, are nonetheless important to the 'PaR initiative' as I have come to understand it. Second, I am grateful to Paula Kennedy at Palgrave Macmillan for recognizing the distinctiveness of the approach of this book, and to her editorial assistant, Nick Sheerin, for guiding the book to completion. I also wish to thank Keith Povey, who, helped by Mark Hendy, copyedited the book in a truly sympathetic manner. I acknowledge that some of the material is reworked from 'Modes of Practice as Research Knowledge and Their Place in the Academy' in L. Allegue *et al.* (eds) *Practice-as-Research in Performance and Screen* (Palgrave Macmillan, 2009). I thank colleagues Zachary Dunbar, Tony Fisher, Avril Haworth, Alison Richards and Joanne Scott for reading – and offering helpful feedback on – the book in process. I am grateful also to my contributors for engaging in a dialogic process in the writing and editing of the chapters. The library staff at MMU Cheshire and Central School, University of London have gone out of their way to locate resources for the book and I thank them. This book builds upon a range of sources and, in trying to make sometimes complex arguments accessible, I trust I have done them justice. As ever, some of the best ideas are other people's; the faults are all mine.

ROBIN NELSON

Notes on the Contributors

Annette Arlander is Professor of Performance Art and Theory at Theatre Academy, Helsinki. Her art work is focused on performing landscape by means of video or recorded voice. Her research interests are related to performance as research, performance studies, site specificity, landscape and the environment. Recent publications in English include: 'Performing Landscape as Autotopographical Exercise', *Contemporary Theatre Review*, **22** (2) (2012), and 'Performing Time Through Place', in *SPACE–EVENT–AGENCY–EXPERIENCE*, Centre for Practise as Research in Theatre, University of Tampere 2012.

Veronica Baxter has taught theatre at South African and British Higher Education institutions, focusing on applied theatre, directing and South African theatre. Her doctoral research was conducted through Winchester University's theatre and media for development programme, and involved PaR projects. Dr Baxter's research projects have concerned such issues as land legislation, health, the school curriculum and wellbeing. She has managed a youth theatre and theatre-in-education companies and has written and directed for the stage.

Dieter Lesage obtained his Doctorate in Philosophy in 1993 at the Institute of Philosophy in Louvain, Belgium. He was a scientific attaché at the Royal Academy of Sciences, Letters and the Arts of Belgium (1994), a cultural policy adviser to the Secretary of the Flemish Parliament (1996), and a visiting professor at the Piet Zwart Institute in Rotterdam (2003–5) and at the Leuphana Universität Lüneburg (2007). Dieter Lesage is a Professor of Philosophy and Art Criticism at the Department of Audiovisual and Performing Arts Rits, Erasmus University College Brussels, and at the Vrije Universiteit Brussel.

Suzanne Little lectures in Theatre Studies and Performing Arts Studies at the University of Otago, where she also coordinates the interdisciplinary Performing Arts Studies programme. In addition to working and teaching on theatrical direction, voice, Shakespearean performance, research methodology, stage design, and interdisciplinary performance, Suzanne has studied visual arts and film. She has published on political dance, traumatic representation, practice as research, reflective learning

and documentary theatre, and has contributed a chapter to the upcoming Cambridge publication *Culture and Trauma*.

Robin Nelson is Professor of Theatre and Intermedial Performance and Director of Research at the University of London Royal Central School of Speech and Drama, as well as being an Emeritus Professor of Manchester Metropolitan University. He has published widely on the performing arts and media and on 'Practice as Research'. He served on the RAE 2008 sub-panel for Drama, Dance and Performing Arts, and is a member of the REF sub-panel 35 for 2014. Recent books include *Mapping Intermediality in Performance* (2010) (co-edited with S. Bay-Cheng *et al.*) and *Stephen Poliakoff on Stage and Screen* (2011).

Shannon Rose Riley is Associate Professor of Humanities and Coordinator of the Creative Arts Program at San José State University, California. She has a PhD in Performance Studies and Critical Theory from the University of California, Davis and an MFA in Studio Art (Performance, Video, Installation) from Tufts University and the School of the Museum of Fine Arts, Boston. She has exhibited and performed internationally and published widely. She is co-editor, with Lynette Hunter, of *Mapping Landscapes for Performance as Research: Scholarly Acts and Creative Cartographies* (Palgrave Macmillan, 2009) and is currently completing a manuscript entitled 'Performing Race and Erasure: Cuba, Haiti, and US Culture, 1898–1940'.

Julie Robson is an artist, educator and researcher with an award-winning practice-led PhD in performance. She has been Senior Lecturer and Postdoctoral fellow at Edith Cowan University, Perth and an Associate Investigator with the ARC Centre of Excellence for Creative Industries and Innovation. Her performance company, Ladyfinger, is currently in residence at the Judith Wright Centre of Contemporary Arts, Brisbane. Julie has a background in performance making across music and theatre domains, and her research interests include innovation in contemporary arts education, feminist performance and female vocality.

List of Abbreviations

ACUADS	Australian Council of University Art and Design Schools
ADSA	Australasian Drama, theatre and performance Studies Association
AHRC	Arts and Humanities Research Council (UK)
ARC	Australian Reserch Council
ASTR	American Society for Theatre Research
AVPhD	audio-visual PhDs (UK)
B/M/DFA	Bachelor/Master/Doctor of Fine Arts
CARPA	Colloquium on Artistic Research in Performing Arts (Helsinki)
CNAA	Council for National Academic Awards (UK)
DHET	Department of Higher Education (South Africa)
DramAidE	Drama Approach to AIDS Education
ELIA	European League of Institutes in the Arts
ERA	Excellence in Research Australia
HEIs	higher-education Institutions
IAPL	International Association of Philosophy and Literature
IDSVA	Institute for Doctoral Studies in the Visual Arts (USA)
IFTR	International Federation of Theatre Research
MFA	Master of Fine Arts
NOfOD	Nordic forum for Dance Research
NRO	Nominated Research Outputs (Aotearoa/New Zealand)
NTRO	Non-Traditional Research Outputs (Australia)
OECD	Organisation for Economic and Cultural Development
PaR	Practice as Research
PAR	Performance As Research
PARIP	practice as research in performance
PhD	Doctor of Philosophy

PBRF	Performance Based Research Fund (Aotearoa/New Zealand)
PSi	Performance Studies International
RAE	Research Assessment Exercise (UK)
REF	Research Excellence Framework (UK)
RQF	Research Quality Framework (Australia)
STEM	science–technology–engineering–maths
TEAK	Teatterikorkeakoulu (Finland)
TEO	Tertiary Education Organisation (Aotearoa/New Zealand)
TRO	Traditional Research Outputs (Australia)
UKCGE	United Kingdom Council for Graduate Education
UNESCO	United Nations Educational, Scientific and Cultural Organization

Part I
Robin Nelson on Practice as Research

1

Introduction: The What, Where, When and Why of 'Practice as Research'

Why research?

People engage in research from a variety of motives but, ultimately, the rigours of sustained academic research are driven by a desire to address a problem, find things out, establish new insights.[1] This drive is apparent in the arts throughout history, but it is relatively recently that it has been necessary to posit the notion of arts 'Practice as Research'. Time was when there were arts practices, on the one hand, and 'academic' research on the other.[2] Artists engaging in inquiry through their practices may not have thought of what they did as 'research', even though they were aware of an exploratory dynamic to address issues and achieve insights.[3] The term arts 'Practice as Research' would probably not have been coined had artists not got involved with modern higher education institutions in respect of programmes of learning, particularly at PhD level.[4] The emphasis on studio practice in art schools or academies has found itself in tension with university protocols in respect of degree-awarding powers and the question of what constitutes knowledge in research.

Among the arts, literature, music and the visual arts have historically been nominated as figuring more in respect of academies, whereas conservatory schools for dance or theatre have been more typically associated with vocational training (and perhaps with entertainment, as Carlson suggests below) than knowledge-production.[5] While the scope of this book embraces all the arts, the emphasis is on the performing arts, in part because less has been published on them in respect of 'Practice as Research' (hereafter PaR) than the Visual Arts. Also the ephemerality of the performing arts poses particular challenges to their inclusion in an already contested site of knowledge-production.

3

Numerous instabilities in the diversity and ephemerality of performing arts practices pose particular challenges to ideas of fixed, measurable and recordable 'knowledge'. At the same time, however, the concept of 'performance' has contributed a new conceptual map – and mode of knowing – to the academy and to research. In McKenzie's formulation, 'performance' 'will be to the twentieth and twenty-first century what discipline was to the eighteenth and nineteenth, that is an onto-historical formation of power and knowledge'.[6] Indeed, 'performance' and 'the performative' have become influential concepts in a number of academic disciplines.[7]

Once artists of all kinds entered today's HEIs, and it was possible – at least in principle – for arts, media, and other practices to be recognised as knowledge-producing and submitted as research for PhDs and professional research audits (RAE, REF, RQF), a complex web of questions about processes and protocols began to be woven.[8] Even now, however – after much debate over two decades, several conferences and two AHRC-funded investigations of the phenomenon in the UK and equivalent initiatives in some other places – PaR remains for some either elusive (in that they are unclear how to go about it) or incomprehensible (in that arts approaches are thought not to be readily reconciled with established conceptions of 'academic research').[9] For a range of very different reasons, different constituencies prefer to dismiss the idea. For some arts practitioners, the requirement to do a little more to articulate their research inquiry is an unwarranted imposition from beyond their culture. For some established arts scholars, PaR is not accepted as a respectable methodology and is seen perhaps to tarnish newly-established arts and media subdisciplines.[10] For academics in non-arts disciplines with established methodologies and (quantitative and qualitative) methods, PaR is at once both a challenge to some of the fundamental assumptions about 'research' and 'knowledge', and another competitor for a limited pot of research funding. Confronted with this complexity, some find it convenient permanently to defer understanding in a world where everything is deemed to be fragmented, relative and undecidable.

There is, however, a burgeoning literature (see the Bibliography) on PaR to reflect 'an international and spreading phenomenon, with strong established or emergent movements of postdoctoral and post-graduate practitioner-researchers'.[11] The literature is dominated by the presentation of case studies which do not always bring out clearly what constitutes research (as subtly distinct from professional practice). Furthermore, case studies do not typically aim to illuminate a generic

methodology distinguishing the approach of practitioner-researchers nor offer an exemplary pedagogy to support the development of new practitioner-researchers. An agglomeration of case studies does emphasize that very richness and diversity of PaR enquiries which has made it difficult to establish the commensurability between projects required, for good or ill, in institutionalized research culture. Indeed, Kershaw's summary remark, that PaR 'thrives on a proliferation of types of creative and investigative difference that always-already will tend to resist the incorporation into meta-schemes or systems of knowledge', retains an attractive radical sonority in this context.[12] But it might not best serve students and tutors struggling to get PaR accepted within their project, institution or territory. Limited attention has been paid to the institutional constraints that in some instances have hindered the development of PaR.[13] These range from strong academic traditions which privilege theory, to divisions between theory and practice in the very structures of education (university vs. art school/conservatoire), and regulatory frameworks which in some instances effectively exclude PaR by inscribing 'the scientific method' into research regulations.

The literature also includes some complex conceptual work on the problematics of PaR. This book resonates with much of what has been written, in particular the common aim to challenge the schism in the Western intellectual tradition between theory and practice and to valorize what I shall call 'praxis' (theory imbricated within practice – see Chapter 3), or what some call intelligent practice or material thinking.[14] Though this book explores new modes of knowing, it notes and puts aside ('parks' in the philosophical sense of marking an aporia) some of the limit paradoxes which propose that practitioner-researchers may well 'have no coherent epistemology upon which to ground their multifarious activities'.[15] In an elegant and sophisticated essay, Simon Jones has teased out the many conceptual paradoxes of PaR and suggested that it

> moves outwards in two opposing directions simultaneously, towards two limit cases – the interior void of the soul and the exterior void of absolute possibility, rather than inwards toward a common ground or sense of knowing.[16]

Piccini and Rye have in parallel concluded that, unless praxis can be directly experienced, assessment is typically made by way of documentation that always inevitably (re)constructs the practice such that the thing itself remains elusive.[17]

These are compelling reservations about the PaR initiative and would seem at first sight to militate against it on principled grounds. But, informed by these insights, it is possible to make a significant distinction between documentation (by way of translation) of a practice and documentation of a research inquiry based in practice. Where, typically, the visual arts, including screen media, produce (relatively) stable objects, literature produces book-based publications and music frequently has scores, the practices of the other performing arts leave only traces. Where some form of durable record is institutionally required of research findings, the documentation of practice may at worst displace the thing itself (see Chapter 4). Indeed, Kershaw notes, 'in practice-as-research communities of the twenty-first century "documentation" has been conflated with 'evidence" and "document" with audiovisual material'.[18]

In the context of arts peer review in the UK, however, an understanding has developed such that few now mistake the audio-visual document for the performance itself. Indeed Piccini and Rye recount fresh approaches to documentation which afford a 'telling otherwise' and keep alive 'a sense of "what might be", rather than a fixity of what was' (see Chapter 4).[19] Documentation of a product serves as just one kind of evidence (with an indexical aspect, albeit reconstructed) in the multi-mode approach advocated in this book in which different kinds of evidence serve to confirm the findings of a consciously articulated research inquiry. Moreover, in rigorously critiquing PaR methodology, we should recognize – as argued in Chapter 3 – that in the twenty-first century no methodology or epistemology can be taken to yield an unmediated, self-evident truth.

While it revisits some key debates, this book takes a more pragmatic approach, aiming to extend the acceptance of PaR within 'the academy'. It offers examples of particular challenges and opportunities in specific aspects of projects rather than general case studies. Though it does not aspire to a meta-scheme, it develops a model in which a diverse range of enquiries conducted by means of arts and performance practices might be framed. It has four additional purposes:

- first, to afford (quite directly in Chapter 2) a 'how to' approach to PaR;
- second, to propose a distinctive pedagogy for PaR, operable at all levels of heuristic learning and leading into a methodology of research – fleshing out the paradigm of 'performative research' posited by Haseman;[20]

- third, to consider a range of institutional constraints through reflection on undergraduate as well as postgraduate arts education contexts; and
- fourth, through a dialogic engagement with different 'territories' to try to understand why and how PaR has variously burgeoned or been met with resistance in different parts of the world.

While the book will take on the complexity of things – and indeed show some advantages to PaR of the contemporary intellectual context at the 'performance turn' – the aim is to be as clear and direct as possible. A direct approach is taken to articulating what 'Practice as Research' is, how the concept came about and how working practices have now established a number of protocols.

The directness is achieved in Part I by a single-authored account drawing from, rather than explicating, actual examples in my own experience, substantially in the performing arts and screen media (though also embracing visual arts and writing projects), and mainly in the UK. Though the effect of this approach is to have a UK-centric – if not a Nelson-centric – bias, I call upon a range of voices to assist in making the case. By the single-authored means in Part I, however, it is possible to be less broadly illustrative and more reductive about what has been proven to work and what has proved difficult, if not disastrous, for some students in the domain. It is in this sense that the book in part constitutes a practical 'how to' guide. The writing of the book is prompted by participants in the many seminars on 'Practice as Research in the Arts and Media' to which I have contributed in the UK and abroad, who have proposed that I should write up what I have articulated. Repeatedly, colleagues have been encouraging in saying that my presentations and my model for PaR are exceptionally clear and persuasive. The approach taken here, though in writing rather than performed, aims to sustain that clarity.

It must be said, however, that I do not claim my model to be the only one with all the answers. Stressing the plural, Jones has proposed that, '[o]ur greatest challenge is to find ways . . . of *housing the mix* of performative and textual practices alongside each other'.[21] Emphasizing the *dialogical* relation between elements yielding *resonances* by way of affirmation (the italics are used to emphasize key terms), my model affords one way of 'housing the mix'. Those colleagues who take the view that a practice alone is sufficient without a written complement may well resist it (see Chapter 8), and there certainly has been a UK tradition in

Music for composition alone to be submitted as a research outcome.[22] However, I share Schippers's view that

> [a]lthough much music making involves research, the latter does not necessarily qualify all music making as research. Not every rehearsal is a research project and not all performances are research outcomes . . . Much of what musicians do may certainly be high-level professional practice, but all does not necessarily constitute research.[23]

Those who are deeply sceptical about the viability of PaR as a scholarly practice may not be persuaded by the arguments rehearsed here, though I hope they will approach the proposed methodology with as open a mind as possible. The model does require a shift in established thinking about what constitutes research and knowledge, but it has proven to work for a considerable number of colleagues and students. My approach owes a debt to those students with whom it has been developed and also to numerous other symposia contributors – some of whom I am unable to acknowledge personally in what follows – for what I have learned in the process of engagement and debate. To offset an inevitable partiality in Part I, the second part of this book comprises contributions from colleagues in different parts of the world where PaR is well established, emergent or resisted.

Part II, in dialogic engagement with Part I, thickens the description of the overall account. Contributors are drawn from Aotearoa/New Zealand, Australia, (continental) Europe, the Nordic countries, South Africa, and the US. The choices are not intended to give world coverage but to reflect different aspects of the debate about PaR and how different inflections of meaning and practice operate in different 'territories'. In some substantial territories, continental Europe and the US for example, postgraduate programmes in universities have not emerged as quickly as might have been expected given the now substantial provision in the UK and elsewhere. Indeed, there are significant pockets of entrenched resistance. Each contributor to Part II of the book responds to aspects of Part I, affording an overview of their 'territory' and marking any differences of approach and cultural specificities from their perspective. Thus, besides a direct 'how to' approach, the book will additionally afford an overview of developments in research based in a range of arts and cultural practices.

What is 'Practice as Research'?

Let me be clear at the outset what I mean by PaR. PaR involves a research project in which practice is a key method of inquiry and

where, in respect of the arts, a practice (creative writing, dance, musical score/performance, theatre/performance, visual exhibition, film or other cultural practice) is submitted as substantial evidence of a research inquiry. In contrast to those sceptical scholars who dismiss, or look down upon, PaR as insubstantial and lacking in rigour, I recognize that PaR projects require more labour and a broader range of skills to engage in a multi-mode research inquiry than more traditional research processes and, when done well, demonstrate an equivalent rigour. I have been known to steer prospective PhD students towards more traditional approaches since a PaR process is tough. Indeed, to take on a PaR PhD student, I would need to be convinced that the proposed inquiry necessarily entailed practical knowledge which might primarily be demonstrated in practice – that is, knowledge which is a matter of doing rather than abstractly conceived and thus able to be articulated by way of a traditional thesis in words alone.

A simple example of practical knowledge is that of 'knowing' how to ride a bicycle. To know how to ride a bike is to ride it. Following Heidegger's sense of material thinking, philosopher David Pears remarks:

> I know how to ride a bicycle, but I cannot say how I balance because I have no method. I may know that certain muscles are involved, but that factual knowledge comes later, if at all, and it could hardly be used in instruction.[24]

I shall return to this example because its simplicity masks the complexity of the issue of what counts as knowledge, particularly in 'the academy'.[25] I shall take up also the crucial question of how arts practices which constitute research differ from those which do not. This is one of the issues that the literature to date has teased out but does not fully address. But, for now, the example of bicycle riding evidences a kind of practical knowing-in-doing which is at the heart of PaR. In my taxonomy, PaR arises only where an insightful practice is submitted as a substantial part of the evidence of a research inquiry. Moreover, PaR is not just a matter for arts practitioner-researchers; educational, ethnographic and many other disciplinary practices might equally follow the PaR model to be proposed.

Other commentators use other terms besides PaR.[26] Following the seminal work of Carole Gray (1996), 'practice-led research' is commonly used in Australia to indicate something very similar to my conception of PaR.[27] As Brad Haseman summarizes, 'practice-led research'

describes what practitioner-researchers do, captures the nuances and subtleties of their research processes and accurately reflects the process to research funding bodies. Above all it asserts the primacy of practice and insists that because creative practice is both on-going and persistent; practitioner-researchers do not merely 'think' their way through or out of a problem, but rather they 'practice' to a resolution.[28]

I do not wish to unsettle a workable usage, but 'practice-led' may bear a residual sense that knowledge follows after, is secondary to, the practice which I know some of its users do not mean to imply.[29] I am not precious about terminology but I recognize that words matter. An acknowledgement that arts innovation cannot be ignored in the academy accompanied by a reluctance to recognize that arts practices might constitute 'research' has led in some quarters to a semantic wriggling which sustains the sense that the arts do not quite meet established criteria.[30] It must be understood that here we are talking about a category in which knowing-doing is inherent in the practice and practice is at the heart of the inquiry and evidences it, whatever term is used.

To offer an example from a relatively traditional PaR practice, in John Irving's research into Mozart's music by playing the historic Hass clavichord, insights into qualities of the music and its playing are derived from the 'feel' of the action of the instrument.[31] They are manifest in the performance which evidences the inquiry even though, as is typically the case, the framing of the inquiry in (written or spoken) words assists dissemination and the understanding of the non-specialist.[32] 'Practice-based' research is also used by some to indicate what I understand by PaR.[33] But I reserve this last term for research which draws from, or is about, practice but which is articulated in traditional word-based forms (books or articles).[34] 'Artistic research' is quite commonly used in the visual arts.

Artworks, and other material practices, are often very complex, resonant and multi-layered, while the articulation of a research inquiry needs to be as clear as possible. Particularly in the context of PaR examination or audit, it is helpful for the assessor to be given in writing a 'clue' ('clew') as to the research inquiry. In the modern form of the word, a 'clue' in writing is useful in PaR since the research inquiry is not identical to the practice, though it is evidenced by it. The old form of the word, 'clew', literally denotes a thread, and students have found it to be a productive metaphor for holding on to the line of the research inquiry as it weaves through the overall process.[35] If the processes of

PaR are as richly labyrinthine as many accounts suggest, 'clew' is subtly distinct from 'clue' in specifically drawing attention to the *thread of the researcher's doing-thinking* articulated in complementary documentation and writings, and I use it occasionally with this accent throughout the book.

As will be elaborated below, the suggestion that writing may be helpful is not to demand a verbal account of the practice, and certainly not to require a transposition of the practice into words. Bolt remarks that 'the exegesis provides a vehicle through which the work of art can find a discursive form',[36] but my approach looks rather for a *resonance* between complementary writing and the praxis itself.[37] A typical balance between practice and complementary writings in UK PhDs is 50:50 – the thesis constitutes a substantial practice together with 30,000 to 40,000 words (see Chapter 5). But, in presenting research in other contexts, a simple verbal articulation of the research inquiry – such as might be achieved in as few as 300 words – proves useful in almost all cases. In most instances, further elaboration and documentation afford additional ways of *articulating and evidencing the research inquiry*.

Where and when did PaR emerge?

The PaR initiative, as I have come to call it, has a history spanning at least two decades, though research in the arts and arts practices have, of course, a much longer history. PaR may have originated in Finland in the mid 1980s and was emergent in the UK about that time.[38] Australia has become a significant force in developing PaR and there are strong pockets of activity in Nordic countries, South Africa, France and (particularly francophone) Canada.[39] In some parts of (continental) Europe PaR has met with resistance (see Chapter 8)[40] and in the US development has been much stronger in the visual than the performing arts (see below and Chapter 11). My timescale marks the period in which arts practices have increasingly been submitted as evidence of findings in modern institutional research contexts. In the UK the initiative was mobilized in part when formerly autonomous arts schools and music, theatre and dance conservatoires became largely subsumed by universities. But the former schism in arts higher education, reflecting an entrenched binary between theory and practice, is not peculiar to the UK. In Van Gelder and Baetens's summary of the situation in continental Europe, '[a]rt history and theory as well as musicology [were] hosted by university faculties . . . training in the practice of concrete arts and music, however, is located in specialised schools, which are separated from the

theoretical environment'.[41] Where they had previously established their own procedures and protocols for evaluating practices, largely dependent upon peer review within the respective professional communities, the conservatoires were confronted by a broader set of 'academic' standards and regulatory frameworks which, being essentially word-based (through publication in journal articles or books) did not readily accommodate studio practice.

The timing of the emergence of PaR varies between the arts domains and in different geographical territories. The full detail of such histories is beyond the scope of this book but selective illustration serves to indicate what is at stake.[42] Music, having been a curriculum subject since the formation of the medieval university has a distinct history of practice in the academy, with PhD and DMus degrees awarded latterly. As we shall see, Music has been regarded slightly differently from the other arts as PaR has developed but, in the UK at least, a broadly common approach is now taken across the performing arts, focusing upon the research inquiry.[43] The Visual Arts engaged more explicitly in PaR debates a little ahead of the Performing Arts, though later in some countries than others. From the US, Elkins reports on a Los Angeles conference session in 2003 at which the audience response to the idea of PaR brought from elsewhere was 'by turns astonished, unconvinced, dismissive and paranoid'.[44] The LA conference was informed of 2000 art students in the UK enrolled on arts PhD programmes and of ten universities in Australia which would imminently offer practice-based PhDs. After 2003, studio art PhD programmes developed significantly in the US,[45] while, interestingly, equivalent programmes in the Performing Arts still remain almost non-existent (see Chapter 11). Though not himself without serious reservations, Elkins foresaw that 'the PhD in studio art will spread the way the MFA did half a century ago',[46] and he took the view that, 'it is best to try to understand something that is coming, rather than inveighing against it'.[47] This anecdote illustrates a not untypical trajectory from initial resistance to PaR through to measured scepticism and perhaps to ultimate acceptance.

It is worth exploring further the American response to the arrival of PaR from abroad, notably from the UK. The discursive position of Elkins's edited volume is antagonistic – indeed hostile at times – to the idea of the new doctoral degree in studio art. Elkins's choice of contributors includes a number of sceptical voices (some from the UK) which, though I have heard them on occasion, are not typical of my experience of the PaR debate over the past decade. Elkins openly asserts that he thinks 'a great deal of theorizing about research and the

production of new knowledge is nonsense'.[48] The volume is particularly negative about developments in the UK where he alleges 'threadbare concepts' are employed,[49] although the models ultimately expounded and favoured by Elkins seem to map on to current UK practices. It is perhaps not surprising that American colleagues were shocked and disturbed by the arrival in the States of the practice-based doctorate since it unsettles the art school environment where the MFA had been firmly established as the 'terminal degree' for arts practitioners.[50] As Emlyn Jones notes, the doctorate 'has been a long time coming to art and design and to other creative and performing arts. No wonder it might seem strange'.[51]

Elkins's hostility, like that of other contributors, is aimed partly at the audit context in the UK (RAE), which is seen as an instrumental imposition responsible for particular approaches to research and knowledge.[52] Moreover, the new doctorates are seen to make unwarrantable demands by drawing upon research paradigms (ranging from arts and humanities through to aspects of the sciences) thought to be incompatible with an arts culture. Elkins speaks in part from within an art school tradition but, situated within a university arts department he speaks also in terms of established disciplines. Even when he recognizes the advantages of links between the arts and other disciplines, he views things from a disciplinary perspective with a strong sense of the requirements of the specialist scholarly traditions of subdisciplines such as art history and art theory. From this perspective, the multi-modal approaches of PaR and the inclusion of a substantial practice seem to entail an erosion or dilution of established knowledge because it is not possible within the time frame of a PaR PhD to pay as much detailed attention to art history or art theory as it would be in a traditional PhD based in those subdisciplines. There is accordingly an imputation that practice-based doctorates must in some sense inevitably be superficial.

But I argue that the comparison is inappropriate and that, because he looks from a particular standpoint, Elkins is disposed to see only the losses and not the very substantial gains to be made through positive models of interdisciplinary, practice-based approaches. My standpoint lies elsewhere since I have always been disposed to be interdisciplinary. Following some time at theatre school, I chose an avowedly inter-disciplinary new university to study philosophy and literature in a Humanities context which also required the study of history and a foreign language. Much of my time – as throughout the first half of my career – was taken up with theatre practice (acting and directing) alongside teaching and research. My Masters research degree is

in Renaissance Theatre while my (traditional) PhD is concerned with Television Drama and Postmodern Aesthetics. For much of my university teaching career I ran a practice-based inter-disciplinary BA (Hons) Creative Arts programme in which students combined two disciplines (from Dance, Drama, Music ,Visual Arts and Writing) but followed a core of practical inter-disciplinary workshops and a lecture-seminar programme on 'arts and ideas', developing what I now call 'conceptual frameworks'. Subsequently, I developed an MA Contemporary Arts on a similar pedagogic basis of praxis as a taught preparation for the PaR PhD. My standpoint on PaR, significantly different from Elkins's more specialist ground, has no doubt evolved through my own educational history, which is less troubled by a sense of disciplinary specialism and its necessary conditions. My approach might be seen to be more consonant with a postmodern relational and rhizomatic model and Elkins's with a modernist surface-depth model.[53] Both approaches are in my view valuable but they are different and I do not share Elkins's (and others') construction of practice-based doctorates as the negative 'other' of traditional doctorates.

Emlyn Jones suggests that

[t]he case against PhDs in studio art in America has rested more on the anxiety of academics worrying that they might need to go back to art school to regain credentials as teachers than on any academic grounds.[54]

In MFA programmes, broader contextual study and substantial writing are not required. Part of the resistance to the introduction of PaR PhDs lay also in the unwillingness, or perceived inability, of arts students to undertake in addition a more traditional mode of study. However, in Emlyn Jones's view, 'it was apparent [by the mid-noughties] that the status of the MFA as a terminal degree was already in doubt in many US universities, where it was well understood that the different academic requirements of these two degrees [MFA and PhD] sets them distinctively apart'.[55] He proposes that arts HE institutions, 'should nest the MFA and doctorate together in a 1+2 combination, just like the conventional PhD in non-art disciplines worldwide'.[56]

Similar tensions were experienced in the UK in the early 1990s, when polytechnics – with a disposition towards vocational education and consequently towards practice-based first-degree programmes of all kinds – were redesignated universities. Several formerly independent art schools, having been quite comfortably subsumed into the polytechnic

sector, found themselves departments or faculties in universities.[57] The polytechnic arts sector offered masters programmes which, like the MFA in the States, had been conceived as a terminal award substantially based in studio practice. Under accreditation by the CNAA, however, the 'post-1992' universities were able to offer PhDs but found themselves exposed to more traditional 'academic' requirements.[58] Lecturers in the new universities were encouraged to engage in research, not least to inform teaching through the promotion of a sense of critical inquiry. Affirming the traditional binary between theory and practice, however, a perception lingered from the mid-1980s, as Judith Mottram relates, that undertaking a doctorate would take artists away from studio practice.[59]

The ways a research inquiry might be undertaken through a practice were not much understood even as practice-based PhDs were emerging. Indeed, a statement in 1989 of the CNAA Art and Design Committee denied that creative practice might be a legitimate scholarly activity.[60] This reflected a dominant international view derived from the 1979 exclusion of the arts from the United Nations categorization of fields of science and technology which might engage in research.[61] Indeed, as late as 2002, the *Frascati Manual* affirmed such a prejudice, particularly in continental Europe, by specifically 'excluding artistic 'research' of any kind' from institutional recognition and support.[62] However, the volume and success of the Art and Design, and Dance, Drama and Performing, arts submissions to the national research audit, the Research Assessment Exercise (RAE) in 1992 in the UK, invited a re-evaluation on the one hand but clouded some key issues on the other. As Mottram reports, the formerly clear CNAA distinction made between research activity and creative professional activity was effectively collapsed.[63] Subsequently, in the UK over the 1990s decade, a tangle was gradually fabricated of not always consistent approaches to, and criteria for, practice-based knowledge production, including PhDs.

Throughout Europe, the 'Bologna Process' aimed by 2010 to transform higher education and mark the European Union as the world's biggest knowledge economy.[64] The process in summary sought

[e]asily readable and comparable degrees organised in a three-cycle structure (e.g. bachelor–master–doctorate): Countries are currently setting up national qualifications frameworks that are compatible with the overarching framework of qualifications for the European Higher Education Area and define learning outcomes for each of the three cycles.[65]

Higher education institutions (HEIs) in the (now) 47 European signatory countries thus became committed to 'the academy' in implementing the Bologna Process. Higher arts education thus took on an obligation to become 'academic' in respect of achieving the accredited standards at a time when some arts HEIs were engaged in developing pedagogies – involving distinctive modes of learning and teaching on the studio practice side of the theory/practice divide – which were intended to be less 'academic' (see Chapter 7). The Bologna Process has thus contributed to (in some instances enforced) the need for an accommodation between practice-based learning and the more book-based, abstract modes of traditional academic arts and humanities programmes.[66]

In some parts of the world circumstances such as those above which might mobilize PaR have not arisen. In some very mature educational cultures, notably the US and parts of continental Europe, PaR PhD programmes in the performing arts are either inadmissible or have scarcely emerged. If, as I have suggested, PaR becomes an issue mainly when the arts world meets the institutional academic world, the sense of 'Practice as Research' will be different in these territories. That is not to say, of course, that artists are not engaging in inquiry through their practices but simply that the notion of PaR may not be so fully wrought in the educational culture. Nor is the instrumental approach to research audit – which in the UK, Australia and New Zealand has been a significant factor in formalizing arts research – universal, though it is spreading rapidly across the globe. Thus, following on from the brief historical sketches above, it is instructive to broaden the debate a little and consider pedagogy in respect of the US in theatre schools as distinct from departments of theatre studies in universities.

To sum up this section, I do share a viewpoint with Elkins on a number of matters, indeed on some of the questions that matter. Elkins asks:

> *Can* [the practice-based doctorate] *contribute to new ways of thinking about interdisciplinarity? Can it help reconfigure the conventional ways of conceptualizing the difference between making something and studying it? Can it help justify the presence of art departments in universities? Can it provide models for bridging history, theory, criticism, and practice – models that might have meaning beyond the humanities?* (Elkins's italics)[67]

A number of such key issues need to be addressed. The historical and institutionalized division between theory and practice needs to be unpacked. A means is needed to distinguish between those creative,

cultural and material practices which are knowledge-producing (and thus constitute research) and those which are not.[68] A pedagogy in preparation for PaR doctorates requires development, and supervisors need to be educated in the processes entailed. Models must be established which not only suit arts practitioner-researchers but which also are accepted by the broader academy and applicable in cognate domains. We need to be critically reflective on the range of possible models for PaR PhDs in order to establish a rigour equivalent to that in other HE domains. Elkins rightly notes that 'the question is not whether the new programs are coming, but how rigorously they will be conceptualized'.[69] This book aims to convince by articulating a conceptual model and fresh approaches to rigour in PaR. It may even be that the rhizomatic model affords a new research approach appropriate to new ways of thinking in the twenty-first century. Crucially at stake is the relation between theoretical knowledge and practical knowing and the distinction between professional practice and research (see Chapter 3).

Pedagogy: the 'how to' of PaR

Given the extraordinary diversity of PaR projects, as manifest in the numerous published case studies to date, questions have been raised about how such projects at PhD level might be supervised. It might equally be asked if PaR can be taught. This section posits that a praxis approach might be taken, from undergraduate taught programmes through to professional research, balancing arts practices with a deliberate engagement in a range of challenging ideas. The approach is ultimately the basis of my model for PaR expounded in Chapter 2. But institutional constraints might need to be addressed and overcome for it to be implemented as pedagogy.

In a recent article in *Theatre Survey*, Professor Marvin Carlson reflects on the summary closure of two 'distinguished and long-established' theatre studies programmes in New York State.[70] He bemoans 'the antitheatrical prejudice' in the US, and the fact that 'in American culture theatre has rarely been considered a "serious" art, as music or painting are' (2011: 118). Carlson reflects also on the place of theatre in the higher education system, recalling that

When [he] entered the profession in the 1950s, the general model of theatre in higher education, then most notably advocated by the large Midwestern universities and influenced on the one hand by German *Theaterwissenschaft* and on the other by the pedagogical theories of

John Dewey, sought to produce theatre scholar practitioners, equally at home in the archives or onstage, and equally adept at writing a scholarly article or directing or designing a production.[71]

A move to specialization both within the profession and in the academy in the 1960s and 1970s, however, challenged the above model and effected a split between the practical and the 'academic' study of theatre. As Carlson summarizes:

> Theatre historians, it was argued, would be taken more 'seriously' by 'real historians' if they devoted themselves to research and did not spend their energy 'putting on plays.' Similarly university theatre productions would be taken more 'seriously' by the 'real theatre' if their artists, like 'real artists,' were not burdened by research obligations.[72]

One result of the subsequent 'professionalization' of university theatre training was the rapid growth of MFA programmes across America at the expense perhaps of the PaR PhD – though Carlson's account reveals other resistances in a complex situation. At the same time access for 'academic' undergraduate students to expensive theatre buildings on US university campuses was diminished as they were given over to semi-professional productions.

In looking to the future, Carlson suggests that 'academic' theatre and performance education, uninformed by practice, is not desirable. He suggests that one possibility might be 'the development of an American version of the performance as research model now booming in England and elsewhere but so far having gained little traction in this country'.[73] Carlson concludes that 'whatever their future course, American university theatre programs must no longer allow themselves to be drawn into the ongoing antagonism between those who study the theatre and those who create it, an antagonism that is so widespread and so debilitating within the general American culture'.[74]

Implicit in the kind of approach favoured by Carlson is a pedagogy in which 'professional practice' and 'academic theory' are not separated. In his 1950s experience a 'both-and' approach operated at undergraduate level and, in the performance as research model, he glimpses how it might function at postgraduate level, right up to PhD. Reflections on part of my own experience of working in a post-1992 UK university map onto Carlson's account though the context is very different. Large numbers of students whose interest is primarily in the practice of

theatre were enrolled in UK Drama or Theatre Studies programmes in post-1992 UK universities on BA (Hons) programmes. The established training of professional actors remained separate, however, the province of accredited drama schools, or conservatoires (many of which subsequently became drawn, mainly for financial reasons into the university sector, as noted).[75] Most drama and theatre studies programmes were not, however, funded to provide intensive practical workshops and thus the challenge for such programmes was to develop a practice-based pedagogy, different from the intensive voice and bodywork of the conservatoires but attractive to students, while at the same time achieving 'academic' respectability.

It was in my years at Manchester Metropolitan University that, with colleagues, I established the interdisciplinary BA (Hons) and MA programmes noted above which, while they no doubt differ in detail from the US programmes in Carlson's experience, map onto his preference for an approach which renders porous the historical and institutionalized divide between theory and practice.[76] It may even be, as his article hints, that theatre departments in the US might gain strength by establishing their identity through the distinction of a pedagogy based in praxis. While it remains necessary to establish what precisely is involved in academic research at PhD level and beyond, in my work the pedagogic approach remains essentially similar from undergraduate to postdoctoral tuition. Rendering porous the firm institutionalized binary between theory and practice, it involves an iterative, dialogic engagement of doing-thinking, as this book will recount. It is also my conviction, incidentally, that some of the most innovative practice arises from such an approach while it also mobilizes the potential for the 'substantial new insights' or 'new knowledge' required of the PhD.

Scope of the book

Following this introductory chapter, Chapter 2 takes the perspective of an established practitioner entering 'the academy' and outlines what adjustments she needs to make to become a practitioner-researcher. This strategy does not imply that the route from professional artist to practitioner is the only way; indeed it addresses all those engaged in practices who might be drawn to present their work as research, whether they be undergraduates progressing to postgraduate study, faculty members who wish to extend their range of research approaches, or, indeed, professional artists entering the academy. The chapter explains how the *articulation of a research inquiry* might be through an arts practice but this

does not mean that all practices constitute research. In most instances, it is proposed, additional material – documentation and complementary writings – enhance the *articulation and evidencing of a research inquiry*, the work itself constituting substantial evidence but not the only evidence. The chapter proceeds to formulate a model in which different types of evidence arising from a multi-mode research inquiry can be effectively mobilized. It shows how 'know-how' combined with 'know-what' in relation to 'know-that' maximizes the potential of that contribution to knowledge which 'academic' research entails.

Chapter 3 takes on more abstractly the problem of practical knowledge and sketches an intellectual context in which significant shifts have taken place in conceptions of what and how we know – including the performative paradigm and the performance turn. Since PaR involves praxis (in my formulation the imbrications of theory within practice), a discussion about PaR – like the process itself – entails a conceptual framework such as Chapter 3 affords. A key issue is whether insightful thought might be engaged materially as well as abstractly 'in the mind'. A number of the key shifts in today's intellectual context open up opportunities for the kinds of knowledge – or knowing, as I ultimately prefer – produced by arts praxis. The noun 'knowledge' might suggest a clearly bounded object of knowledge separate, and at a distance from, an observing subject and available to be seen–known across time and space by other viewing subjects. The verb (present participle) 'knowing', in contrast acknowledges a subject engaged in the act indicated and perhaps engaged in a processual relationship spatially more proximal to the object to be understood.[77] As we will see in Chapter 2, the attempt to make tacit knowledge more explicit involves a process of dynamic movement from the closeness of subjectivity to a greater distance, if not quite achieving objectivity as traditionally conceived.

Though modes alternative to the 'scientific method' have a history spanning at least a century, they have not become fully accepted across the academy, despite the strides taken exploring subject–object relations through research undertaken in a range of domains by qualitative methods (such as the participant–observer or action researcher) as well as by the PaR initiative in the arts. Chapter 3, then, serves also to explain some of the conceptual resistances practitioner-researchers continue to encounter within institutional contexts and serves to promote understanding, hopefully on all sides. Aiming to collapse binaries, the book addresses both those who are committed to PaR (seeking to facilitate understanding and good practice) and those who are opposed to it (seeking to persuade). It affords the ammunition, necessary in some

instances, to defend the PaR position but, more positively, it opens up opportunities to make a creative contribution. Along with Smith and Dean, I 'do not see practice-led research and research-led practice as separate processes, but as interwoven in an iterative cyclic web'.[78] Chapter 4 offers some examples of praxis, not in the form of full case studies but by selecting aspects of projects which illuminate specific issues which have arisen in my experience of PaR, in practice and in the supervision, examining and auditing of projects. Attention is paid particularly to the role of documentation. Chapter 5 turns to advice specifically aimed at PaR PhDs but nevertheless relevant to most projects. It deals briefly with lessons learned from the history of the PaR initiative and with protocols and regulatory frameworks. It refines the guidelines published following research undertaken in the 1990s which, by many reports, have proved useful to students and tutors alike.

Part I draws, as noted, largely on experience in the UK where PaR is substantially developed, while Part II draws on other territorial perspectives to broaden the book's scope and redress any unhelpful partiality. It is hoped that, collectively, the chapters will provide an overview of the extent to which PaR in a variety of forms has been established (or resisted) alongside a direct account of PaR – how to go about it, how to avoid the snares which have entrapped others, and how to make the best of great opportunities. If it assists particularly the arts and media communities at one end of the spectrum to abandon the lament that 'nobody understands PaR', and, at the other end, to abandon entirely the very term 'PaR' because the methodology has become established in 'the academy', it will have achieved its aim.

Vision

I ended an earlier publication claiming that 'it is time to speak less of "practice as research" and to speak instead of arts research (a significant methodology of which just happens to be based in practices)'.[79] Though this wish has not fully come true, I fervently hope 'the academy' worldwide is close to full acceptance of PaR and that the general economic retrenchment in higher education does not lead universities to fall back entirely on the refereed journal article as the gold standard of research outcomes. I share Haseman's optimism that a PaR methodology not only enhances the academy but also has particular relevance to a widespread political concern on the part of governments for research to be seen to be of broader social benefit. While some aspects of the 'impact' agenda seem contrived, PaR, if fully understood and embraced, might

genuinely[80] 'have applications far beyond the creative arts, design and related creative disciplines. For performative research is aligned with the processes of testing and prototyping so common in user-led and end-user research'.[81] Research through doing-thinking is important on a number fronts.

As I explain in Chapter 3, I am by no means opposed to words but, having recognized their slipperiness, we should give up the pretence that they are transparent and convey knowledge immediately. Though I have striven in my use of words here to be direct, even didactic, I acknowledge that they are inevitably coloured by my passions and interests, among which is a desire to see practical knowledge properly credited where, in the deep history of the Western intellectual tradition it has all too often been constructed as the negative 'other' of privileged theory.[82] I look in this book to bear out another contention of Brad Haseman, who proposes that

> [t]here is evidence enough to recognise that we stand at a pivotal moment in the history and development of research. Practice-led researchers are formulating a third species of research, one that stands in alignment with, but separate to, the established quantitative and qualitative research traditions.[83]

2
From Practitioner to Practitioner-Researcher

When introducing PaR in presentations, I have come to speak about it as located at the confluence of different, but interlocking, spheres, notably 'the arts world', 'the mediasphere' and 'the academy' (Figure 2.1). Though this grouping is a section from a much larger constellation of interconnected praxical spheres, it has proved a productive means to emphasize what I call 'both–and' spaces in which aspects overlap. But there is a historical as well as a conceptual dimension. In the early days when PaR became a possibility, a number of established professional arts and media practitioners entered the academy perhaps to teach as part-time tutors, to undertake research or to work towards a PhD. Where misunderstandings arose about the differences between professional practice and research through practice, a number of issues needed direct address.

Though I mainly speak to established arts practitioners in what follows, it should be understood that the PaR methodology applies to all those who are turning to Practice *as Research*, though they may have a considerable record of practice and/or research through their prior education and experience. Some will approach PaR from the professions perhaps because they have found opportunities for study or employment in the academy. Others will come from the kinds of practice-based arts BA and MA programmes indicated in Chapter 1 in which their learning is already located more in doing than in the tradition of the Arts and Humanities dominated by book-based study with written outcomes. Some may even come from the latter educational tradition and have research publications yet see advantages in the different methodology of PaR. Since I am committed to creative cross-overs in an interconnected academy, I welcome also those who come from other disciplines.

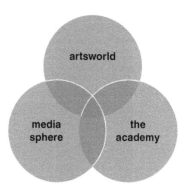

Figure 2.1 Interlocking spheres

As noted in Chapter 1, PaR was defined when arts practices came to be submitted as research in an academic institutional context. Initially there were misunderstandings on several fronts. On one hand, artists sometimes could not accept that their practices were not self-evidently research. Since each creative iteration is distinctive (even if it more or less follows a formula), it is in a weak sense 'original' and, since originality is a requirement for research, artists assumed their practices amounted to research. Indeed, on occasion resentments surfaced when candidates were asked critically to reflect on their practice and to document and perhaps write about it in essay form. But there is a significant difference between a fresh iteration of a creative practice and an original 'academic' research inquiry to yield new knowledge. On the other hand, established 'academics' could not comprehend that arts practices might be knowledge-producing and that the practices themselves might on occasion articulate a research inquiry.

To those already committed to PaR, it may seem that I am overly defensive in what follows. But one of the striking aspects of my involvement in the PaR initiative is that, when progress seems to have been achieved and arguments won, the same sceptical questions arise again in another quarter. From the accounts in Part II, it is evident that many colleagues in academia remain to be persuaded. Academics may simply be ruffled when their established culture is unsettled. Slow development, or even outright resistance, might be attributed in part to a fear in relatively new disciplines that an even more radical innovation may undermine the respectability recently achieved. Creative writing, dance studies, film, media and television studies, performance studies, and theatre studies, for example, are all (sub)disciplines newly established in

the academy, and still frequently marginalized. If it remains contentious that the arts and screen media are worthy of study at university level, then it may be even more questionable that their practices might constitute research. But as Raymond Williams observed, 'academic subjects are not eternal categories'.[1] Indeed, knowledge of the history of 'the academy' reveals many changes and accommodations since the medieval university curriculum entailed the study of grammar, dialectics, rhetoric, arithmetic, geometry, music and astronomy.[2]

Given the historical divide between theory and practice in the Western intellectual tradition, moreover, it is not surprising that misunderstandings within and without the academy arose when it appeared that arts practices were suddenly becoming acceptable in the research domain. It did not help that, misunderstanding PaR in believing their professional practice self-evidently constituted research, some would-be practitioner-researchers were reluctant to do anything other than they did as established professionals. This might be close to what is required in PaR, but, as we shall see, certain adjustments in approach need to be made. There are established protocols for research in the academy different from those in other spheres.

Some misunderstandings arose from different accents on the word 'research', as used in different spheres. In the arts world, it was possible to apply to the Arts Council in the UK for research and development (R&D) money to develop a creative practice; in the media world, people might be employed as 'researchers'. It is thus helpful to unpack several accents in common usage:

- *personal research* – involves finding out, and sifting, what is known;
- *professional research* – involves networking, finding sources and collating information;
- *academic research* – involves conducting a research inquiry to establish new knowledge

All of the above involve investigation, finding things out and drawing conclusions, even if it is personal market research to establish which digital camera is the best for your purposes. But only academic research requires that you must *establish new knowledge* or, to use the slightly softer phrase, afford *substantial new insights* (again the emphases are used to indicate the importance of these phrases). These criteria apply in all disciplines and, while it is possible to challenge established doxa – and indeed many challenges from practitioner-researchers have seen adjustments within the academy – these fundamental tenets

of academic research as they have emerged in the modern scientific tradition since the Enlightenment would be hard to shift, even were it desirable to do so.

In one sense, I recognize and acknowledge that my approach to PaR has involved a reconciliation of the new with the old. I have sought to establish a model for PaR which is consonant with academic research as established and meets its criteria. For example, I have resisted the proposal (taken up in some contexts) to have a separate set of doctorates for the arts (D. Dance, D. Fine Arts, D. Theatre etc.) awarded according to different criteria for high achievement in an arts practice. Because (as will be explained in Chapter 3) I believe PaR can be demonstrably knowledge-producing, I have worked with others to secure the PhD award involving arts practices, and a model for PaR which maps on to established methodologies and criteria. This has not been an easy task in a context in which positivism and 'the scientific method' have lingered in informing a dominant understanding of academic research and the criteria for knowledge, even though many innovative scientists have moved far away from this nineteenth-century paradigm. But, in the regulations for PhD awards in some UK universities, it emerged that 'the scientific method' was a prerequisite for research and, needless to say, in such contexts, significant battles were engaged before changes ensued (see Chapter 5). Institutional adjustments have needed to be matched, however, by adjustments of professional practitioners entering the academy. So what is needed to be done?

The PaR submission

In my approach, a PaR submission is comprised of multiple modes of evidence reflecting a multi-mode research inquiry. It is likely to include:

- a product (exhibition, film, blog, score, performance) with a *durable record* (DVD, CD, video);
- documentation of process (sketchbook, photographs, DVD, objects of material culture); and
- 'complementary writing' which includes locating practice in a lineage of influences and a conceptual framework for the research.

The practice, whatever it may be, is at the heart of the methodology of the project and is presented as substantial evidence of new insights. Where work is ephemeral (e.g. theatre, performance, dance, live art) it

is ideal if the practice can be experienced directly in any assessment process. In the context of UK PhDs it is now firmly established that the examiners experience the practice at first hand, typically making an additional visit prior to a viva voce examination for the purpose (see Chapter 5). Because, however, a durable record of all evidence submitted is required of PhD submissions, it is now customary for a recording (typically on DVD) of the ephemeral event to be bound into the hard-copy 'black book' on final submission. Where in other assessment circumstances it is logistically impossible for all practice to be experienced at first hand, the DVD recording is, in my view, better than nothing, though, of course, it has inherent limitations (see below and Chapter 4).[3]

Though I insist that a research inquiry can be evident in the practice, it is not typically self-evident. Both arts practices and research investigations take place in contexts. Indeed, many projects which produce substantial insights nevertheless follow tried and tested paths. Across all disciplines, the findings of relatively few research inquiries are paradigm-shifting; Einsteins are few and far between. In the case of the arts, it is possible to think of rare events which fit the bill. The emergent dance theatre of Pina Bausch might be one in my own experience. Historically one might think of Seurat's use of juxtaposed coloured dots informed by the visual science of his time, or of Beethoven's use of woodwind instruments.[4] The point, however, is that such self-evident instances of wholly innovative practice are rare – and, indeed, often not recognized in their own time. As Polanyi remarks, 'it took eleven years for quantum theory to gain final acceptance by leading physicists'.[5] But to set the bar for *new knowledge* at the level of the paradigm shift is to set it too high. Fortunately for most of us, *substantial insights* are more readily attainable and this is in no way to demean them.

Indeed, as noted, artworks are often complex, multi-layered and resonant. Accordingly, there are several possible lines of research inquiry, some perhaps compositional, some technological, some involving performance qualities (such as the 'touch' of John Irving's clavichord playing) and others conceptual. This is where, in the first instance, a clue to the intended research inquiry is additionally needed. It may constitute little more than an 'artist's statement' which indicates the line of inquiry upon which the candidate wishes to be assessed.[6] Once identified, the clew (thread) can be readily traced through the practice. But, because I take PaR to involve a multi-mode inquiry, evidence may emerge beyond the practice itself (if conceived as a final showing, the product of the research). Many insights emerge in the

processes of making and doing. Hence, documentation of process has emerged as another key dimension of PaR and such documentation should be appropriately sifted, edited and downloaded to a DVD for submission. Much more will be said about documentation in Chapter 4 but, for now, it is worth noting that it might include notebooks, sketch-books, photographs, fabricated objects, scores, video footage, audio recording – indeed any of many things which artists customarily do as part of their practice but inflected to capture and reveal moments of discovery. An additional emphasis is placed upon documentation in the light of the research inquiry but I suggest the adjustment is likely to be minimal. As Schön has noted, '[a]lthough reflection-in-action is an extraordinary process, it is not a rare event. Indeed for some practitioners, it is the core of practice'.[7]

The creative process involves a number of aspects. In respect of devised performance, my first PaRPhD student, Anna Fenemore, has recently enumerated these as: '1. anticipation, imagination, and projection, 2. playing, pretence and pleasure, 3. direction, repetition and/or insistence, 4. editing, *mise-en-scène* and composition.'[8] Though research usually builds upon an advanced training in a subject domain, typically to masters level, the process of creativity runs throughout arts education. Techniques and skills may be developed in training but the creative process involves gestation, allowing time for the spark of an idea to be fired, and a process in which it is wrought into realization. The workings of the unconscious mind can be mobilized in sleeping and daydreaming. Some practitioners like to take a walk or a bike ride, others find travelling on a bus or train helps. It is also a matter of the studio practice of trying things out.

While education and training afford the know-how of process, new sparks are often struck by taking the risk of (re)invention in a leap of de-familiarization. Scientists are at times involved in enforced rotation since it is recognized that to become too deeply immersed in one way of thinking or a single process can be stultifying, when a move into another mode of operation can yield results. Such defamiliarization maps onto my advocacy of engagement in other disciplines rather than more deeply mining a 'home' discipline. I do not rule out the latter, but often creativity arises in the frisson of encounter between different approaches to research or knowledge paradigms. Collaboration and rich environ-ments also foster creativity. A good reason for artists to engage with 'the academy' is the richness of intellectual environment and defamiliariztion it affords. I do not subscribe to the romantic model of the lone artist in a garret inspired by his or her muse; in my experience, inspiration comes

through working with, and sparking off, others. The research dimension also requires stepping outside the process to reflect on it.

Critical reflection on process is an integral part of the research inquiry, as it might well be in the making of artwork.[9] But, because arts research is subtly different from arts practice and makes small, but significant, additional demands, it is necessary in PaR actively to promote critical reflection. As I see it, the thinking in intelligent contemporary practice is likely to resonate with ideas circulating in other domains and perhaps other disciplines. A programme of reading of all relevant kinds should be undertaken simultaneously with the commencement of the practical inquiry to mobilize an interplay between practical doing-thinking (what Carter (2004) calls 'material thinking') and more abstract conceptual thinking, typically understood to be verbally articulated (in books and articles). Bolt sums this movement up neatly when she writes of a 'double articulation between theory and practice, whereby theory emerges from a reflexive practice at the same time as practice is informed by theory'.[10] I will have more to say below, however, about how we might avoid the historical binary between 'theory' and 'practice' and about how the one can be seen to be *imbricated within* the other, but I agree with Bolt that critical reflection mobilizes a double articulation of thought central to PaR.

While PaR is ineluctably centred in practice, I also hold that reading, as in any research programme, is another mode in the multi-modal research inquiry. I take writing – of notes, scores or more formal essays – also to be part of a multi-modal process aimed at the tricky business of *articulating the research inquiry*. In short, I prefer to speak of 'praxis' to summarize all these research activities.

Summary of adjustments from practitioner to practitioner-researcher

- Specify a research inquiry at the outset.
- Set a timeline for the overall project including the various activities involved in a multi-mode inquiry.
- Build moments of critical reflection into the timeline, frequently checking that the research inquiry remains engaged and evidence is being collected.
- In documenting a process, capture moments of insight.
- Locate your praxis in a lineage of similar practices.
- Relate the specific inquiry to broader contemporary debate (through reading and exposition of ideas with references).

Based on a science model, many application forms for registration or funding ask for a 'research question' to be set at the outset. It may seem a small point but I prefer to ask for the specification of a 'research inquiry', partly because questions typically imply answers and, in turn, evoke perhaps 'the scientific method' in which data lead to the resolution of a hypothesis (see Chapter 3). In my experience, PaR typically affords substantial insights rather than coming to such definite conclusions as to constitute 'answers'. However, it is important to be as clear as possible at the outset about the line of inquiry you propose to follow. It is recognized that, as the research progresses, the direction might shift and perhaps become more focused in the process – and this holds for research conducted by all methodologies in all disciplines. But, particularly because there is a small but significant difference between making artworks and conducting academic research, it is important to mark the proposed line of flight at the research liftoff. Also, though the methods of PaR may seem somewhat playful, erratic even, in comparison with those of the established methodologies of the sciences and quantitative social sciences, it is unhelpful to overemphazise serendipity and simply say we won't know what the inquiry is until the praxis is underway. Indeed, it is worthwhile at the outset taking up the challenge of articulating your research inquiry, aims, objectives methodology, methods and outcomes with key guiding references on two sides of A4 paper.[11]

Once the process is under way, practitioners typically get so engrossed in the practical work that it has proved very helpful at the outset literally to draw up a timeline for the project and mark on it the times when the various activities of the research inquiry will take place. Significant time should be marked to step back from the busy doing to reflect on whether the research investigation is still on track. If it is not, the inquiry might drift too far away from initial intentions or be lost altogether. If the inquiry has found a new and justifiable track, then this can be identified rather than waiting until the notional end of the project only to find unhelpfully that you have arrived elsewhere than your planned destination.

Equally, it is advisable to think through in advance the variety of documentary strategies in which it might be helpful to engage and to be ready to mobilize them as occasion demands. For example, it is neither possible nor desirable to video every rehearsal of a performance production process. First, the presence of the camera can interfere with the process. Second, to record everything would be to end up with an amount of footage too massive to sift and edit in this context. So what is to be documented and when?[12]

Though this question is not easy to answer, to pose it in the first place is likely to heighten awareness of documentary possibility. Additionally, it may help to look forward to a notional end of the project anticipating what kind of documentation might be useful to *evidence the research inquiry*. In making work previously, you might have been aware of moments you would like to have captured – those moments perhaps when things began to take shape, to 'work'. If a sixth sense might be activated to keep a look out for such moments as they might occur in the current project, you will most likely be alert in the moment. If you have pre-thought the need to have a notebook, sketchbook, recording device or camera (stills or video) to hand, then the moment might be captured. What is needed in respect of documentation, then, is a disposition matched by strategies and organizational planning. If it is possible to have an assistant, somebody dedicated to supporting this task, life will be easier. Practices and issues of documentation are further unpacked in Chapter 4.

Another important PaR research activity is summed up in my phrase 'location in a lineage'. If we wish to claim that our praxis manifests *new knowledge* or *substantial new insights*, the implication is that we know what the established knowledge or insights are. In respect of arts practice it means that we know what other artists in this domain have achieved historically and, in particular, what other practitioner-researchers in the field are currently achieving. In actuality, this means that we know the backstory of our work and experience other people's practice as professional artists typically do. The small adjustment might be to write up the experience of a performance, gallery visit, workshop and so on such that a chapter locating praxis in a lineage in the 'complementary writing' can be included in the final submission. Even more important, assessing the achievements of other people's practice assists us in identifying what specifically our praxis is contributing to knowledge.

Perhaps the biggest adjustment practitioners need to make in the process of becoming practitioner-researchers is overtly to engage in conceptual debate. This part of the research inquiry serves two functions: defamiliarization and affirmation. My sense of the process, as noted, is that intelligent contemporary work is likely to resonate with ideas circulating elsewhere in culture and perhaps more specifically within other academic disciplines. On some occasions, differences ignite the spark of defamiliarization, while, on others, consonances emerge. Indeed inquiry related to arts PaR reveals similarities in approach in other disciplines such as anthropology, archaeology, architecture, education,

ethnography, neuroscience and many more. To realize this has helped us get over an unhelpful initial stance in arts PaR that artists have an exclusive way of seeing and doing which nobody else understands. There may be productive differences, but, to identify parallel approaches helps us more accurately to mark those differences as well as to acknowledge a consonance which, in turn, promotes a sense of belonging to what Polanyi calls 'a society of explorers' rather than (self-) exclusion.[13]

It is important, however, to reflect upon the nature of the relation between ideas and processes in one field and another. It might be analogical rather than logical or causal. Recent discoveries in neuroscience, for example, affirm a consonance between brain functions and creativity but it would be a mistake to say one causes the other. The least successful projects in my experience are those where practitioners engage in a practice first (perhaps because that is the most comfortable zone in which their background has taught them to operate) and only subsequently begin overtly conceptualizing and reading. At worst, in research submissions, 'theory' has been plucked out of the air in an attempt to lend gravity to a 'practice'. It seems like a rationalization after the event because it most likely is. My use of 'praxis' is intended to denote the possibility of thought within both 'theory' and 'practice' in an iterative process of 'doing-reflecting-reading-articulating-doing'.

It is very understandable, given the logocentric dominance of the Western intellectual tradition (see Chapter 3), that practitioners not deeply versed in the history of ideas by way of their education feel obliged to reach out for a weighty theorist to ground their project. In doing so, however, they may betray a lack of trust in PaR, ironically privileging theory over practice. It may be that supervising tutors inexperienced in PaR may also wish to settle their own nervousness about the knowledge-producing worth of a PaR project by proposing the anchoring of a practice with weighty tomes. Let me be clear. I am not advocating an abandonment of complex ideas. I am proposing that ideas circulating in the practical investigation might be clarified in the discovery of *resonances* with other research inquiries expressed in words. Because it is a two-way process, something has gone wrong in the PaR inquiry if a practitioner-researcher feels that she needs to grab at a theory to justify the practice.

It is important to remember that arts practices can be thoughtful and that, correspondingly, writing (of all kinds) is a practice. Not all practice is insightful, but Susan Melrose notes that 'some expert practitioners *already theorise* in multi-dimensional, multi-schematic modes . . . just as it can be argued some writers theorise in writing but not others'.[14] She points out

that, just as arts practitioners dance or write or compose to find expression for complex, and not easily apprehended, thoughts and feelings, writers coin tropes to 'cover over a gap in reasoning and a gap in material evidence'. She posits that Bourdieu's concept of 'habitus' is 'a creative invention, the outcome of a skilled writer's *expert-intuitive* leap'.[15] In doing so, she helps to dispel the historical binary opposition between 'theory' and 'practice' and between 'writing' and 'fabrication'. In commenting on Bourdieu, she is not making a criticism so much as acknowledging that writing is itself a practice and that writers do not simply express their complex thoughts and feelings in words of crystalline clarity but rather also gesture at articulation and work hard to achieve it.

As in all creative–critical practices, further refinements come with time and effort. My own articulation of PaR in terms of the succinct 'theory imbricated within practice' arose from my dissatisfaction with my earlier formulation that 'practice is informed by theory and vice-versa' which seemed to imply an unhappy separation of theory and practice and possibly a temporal relation of precedence. Similarly, as I see it, a process of refinement takes place in the arts studio in which practitioners strive for expression. Furthermore, a rigorous process of editing, refinement and reworking is entailed in the processes of practitioner-researchers and I firmly believe that better-quality artwork results.

Some artists hold that their work is intuitive and to engage in critical reflection upon it would be to extinguish the creative spark. I do not share this view, which is not to discount the 'expert-intuitive leap' of which Melrose speaks. While creativity has traditionally been located in a mythologized right side of the brain, recent research in neuroscience has found interconnections between the brain's hemispheres. As McCrone summarizes the position following Fink's research findings:

> at least there seems no prospect of a return to the old left–right caricatures that inspired so many self-help books exhorting people to liberate their right brains and avoid too much sterile left-brain thinking. As Fink says, whatever the story about lateralisation, simple dichotomies are out'.[16]

On this basis, and in the light of pedagogic experience, I hold that engaging in reading and writing of all kinds alongside the doing of an arts practice mobilizes a process of dialogic engagement. It is not a matter of going into the studio waving your copy of any theorist from Aristotle to Žižek but a matter of allowing ideas relevant to your project to circulate freely in the investigative space (actual or virtual). In respect

of *articulating and evidencing the research inquiry*, complementary writings of all kinds afford additional opportunities for dialogic engagement.

Content of complementary writing

In a typical PaR PhD under my supervision, the following chapters of complementary writing are likely to appear:

- location in a lineage by way of a practice review
- conceptual framework
- account of process

Literature-practice review

Custom requires a traditional PhD to begin with a review of literature. The purpose of this review is to establish the published knowledge in the field to date and, further, to demonstrate that you have exhaustively explored the domain of your particular research (see Chapter 5). I do not accept that a review of literature is always necessary (even for a traditional arts and humanities PhD) because my approach to research is open and interdisciplinary and thus less dependent upon a specific body of knowledge requiring prior mastery. As noted in Chapter 1 in respect of Elkins's concerns, where an arts research inquiry is specialist – in art history, for example – traditional approaches might well be appropriate.[17] In my experience, PaR is likely to be interdisciplinary and to draw upon a range of sources in several fields; and, while it is not possible for a PaR student to equal the specialist in all disciplines drawn upon, the shortfall does not amount to a lack of thoroughness. Rigour in this aspect of PaR lies elsewhere in syncretism, not in depth-mining. In addition to challenging the student, a PaR approach does indeed challenge supervisors and assessors. As Elkins remarks, '[t]he specialist no longer acts as a specialist in her own field',[18] and it is the case that supervisors need to develop an approach different from the traditional. But, as Mottram notes:

> We are starting to have a population of researchers and research supervisors who do form a community of research practitioners, and who may start to generate common understandings and shared agendas as part of their research culture.[19]

I do hold that candidates' knowledge should be up to date since how can new knowledge be asserted, if existing knowledge has not been

established? But in a PaR project, the location of work in a lineage of practice might be more appropriate than a literature review (though it is typically a matter of 'both-and'). I would expect this chapter to give accounts of several practitioners/companies working in similar territory with a disposition to distinguish what each has achieved. Such writing should set up a platform for the account of process to bring out the specificity of the practitioner-researcher's own findings.

The conceptual-framework chapter is likely to be the most traditional in form and content. I suggest that it is written in traditional academic, quasi-objective form (in the passive mode or third person), partly to demonstrate a mastery (if that is not too gender-loaded a term) of this mode of writing. The mode has been aptly critiqued for manifesting a pretence of objectivity by the middle-class males who dominated the academy. There has been significant debate about the possibility of a transparent or neutral truth language which I will take up in Chapter 3. I still hold that the aim of impartiality – or, better, maximum intersubjectivity – of the traditional mode of academic discourse has a value (as long as the deception that it is a neutral truth language is avoided). Indeed, it is part of my sense outlined above that it is a challenge to express ourselves fully and to articulate our thinking clearly in any mode of discourse (including arts praxis) and that we should take advantage of a range of modes of expression, particularly in respect of articulating a research inquiry.

Accordingly, in the account of process, and contrasting with the conceptual framework chapter, I propose the use of the first person. It would seem absurd to deperzonalise and write 'the choreographer went into the studio and . . . ', when that person could more straightforwardly write 'I undertook such-and-such a process'. As Macleod and Holdridge remark, '[t]he first person singular is axiomatic as is a specific intimacy with research findings'.[20] There is a sense of improvization, indeed playfulness, in much studio practice even where the research is most rigorous. It thus seems even more ridiculous to be formal about an informal process and, in my experience, first-person accounts of process read well. It may even be that more gestural poetic modes of expression are useful in this aspect of the complementary writing in the attempt to articulate in words what is ultimately better danced.

The account of process aims to bring out practical methods in the frame of the PaR methodology and to document and share the approaches which produced both the artwork and the research findings. I have on occasion found artists reluctant to relate the specifics of their process, first because they do not think that they will be of interest.

Because individuals and groups of practitioners have established ways of working, they overlook that these may not be self-evident both across the arts community and beyond. There are subtle differences, for example, in the ways dancers, film-makers, writers, musicians and theatre-makers approach composition, and in the accents on the vocabulary they use ('rhythm', for example, signifies different things in different domains). There are differences, too, within disciplines. Indeed, there is a considerable, under-mined territory of practices which might be better articulated and disseminated. But this brings me to the second reservation of artists. Some are reluctant to reveal their process either because they feel, as noted, that to do so would 'extinguish the spark' or because they are precious about what they do. Both these grounds might be legitimate in arts practice but sit less happily in the research domain which, despite notorious examples of competition, has a broad disposition to share knowledge for the general good.

I have used my preferred term 'complementary writing' without explaining why I opt for it. In the early years of PaR, much of the debate focused upon why any writing was required in a PaR thesis. People might say things such as, 'if I could put it into words, I wouldn't have to dance it'. While I have considerable sympathy with this point of view, it can be unhelpful. On rare occasions I do believe the practice alone may evidence a research inquiry. But an artwork cannot take account of the context(s) in which it might be experienced.[21] If we hold, from a poststructuralist perspective, that signifiers are multi-accented, dependent on dialogical negotiation in context to achieve any intersubjectively agreed sense of significance, and, if the impact of artworks might exceed their phenomenal properties, can we assume the research inquiry is self-evident in the practice? This open question will be addressed in Chapter 3.

The aim of complementary writing is absolutely not to transpose the artwork from its own medium into that of words. It is not a requirement to translate the work, as some have alleged. By way of complementing the practice, writings assist in the *articulation and evidencing of the research inquiry*. In the context of the academy, PaR is called upon to meet the criterion of disseminability. It should be possible for persons operating within an academic institution to share their research findings with non-specialists. Though I am not an astro-physicist, there is a sense in which I am able to access research in that domain through articles in refereed journals. Though I may not fully appreciate the intricacies, I would like to think I can at least follow the gist in a way which affords insights. Similarly, I believe the complementary writings

of artists might afford access to the complex process of making to non-specialists. It may be that expert peers best appreciate the nuances of research findings as articulated in both the work itself and the complementary writings – and peer review remains a cornerstone of formal academic assessment. But access to insights is afforded to a broader community in the first instance by a clue to the research inquiry, and then additionally by a clew through it, in documentation and complementary writing(s). I take this to be part of the noted disposition within the academy to share knowledge for the general good.

To express in diagrammatic form the multi-mode, dialogical, dynamic approach I have outlined, I offer the revised model shown in Figure 2.2.

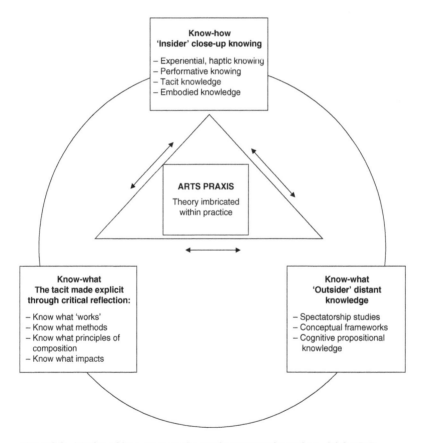

Figure 2.2 Modes of knowing: multi-mode epistemological model for PaR

Unpacking and using Nelson's PaR models

The model shown in the figure is a refinement for this book of previous models I have published. It is similar to the others in that it involves a multi-mode approach to PaR and evidence produced through different modes of knowledge: 'know-how; know-what and know-that'. It is specific to PaR in that practice is at its heart and it embraces modes of knowing (tacit, embodied-cognition, performative) only recently, but increasingly, acknowledged in 'the academy'. But it is far from exclusive in that it reaches out to knowledge established by other methodologies, although it calls into question their assumption of supremacy. Leonard and Sensiper propose the following:

> Knowledge exists on a spectrum. At one extreme, it is almost completely tacit, that is semi-conscious and unconscious knowledge held in people's heads and bodies. At the other end of the spectrum, knowledge is almost completely explicit or codified, structured and accessible to people other than individuals originating it. Most knowledge of course exists between the extremes.[22]

The explicit is typically associated with 'objective' (value-free) knowledge of objects seen clearly from a distance. It is 'know-that' in character since it can be represented mathematically in numbers or diagrammatically, or articulated as rules or laws in writing in the passive voice. The tacit might, by way of negative definition, include modes of knowing (such as embodied cognition) which cannot be readily formulated by these means. In various ways to be explored in Chapter 3, the 'objectivity' of explicit knowledge has been called into question over the past century while, at the same time, tacit, embodied cognition has been increasingly recognized. Accordingly, my model proposes that, since knowledge is difficult to establish, the pursuit of knowing might best be served by embracing all possibilities. However, since their criteria are not simply commensurate, different methodologies cannot simply be equated, though *resonances* might be discerned in their dialogic interrelation.[23]

I propose here to unpack how this model may be of use to practitioner-researchers in relation to the schema above for the various activities to be undertaken, the kinds of evidence each might afford and how the presentation in interrelationship of different kinds of evidence might add up to a 'substantial new insight' or 'new knowledge'. Considerable emphasis is placed on processes to articulate the tacit. It may not

ultimately be possible to make the tacit thoroughly explicit (that is, expressed as propositional knowledge in writing) but, if practitioner-researchers wish their embodied cognitions to be better recognized, means of identifying and disseminating them must be sought.[24] That is what the dynamic, dialogic process of my model seeks to achieve.

Feedback I have received has pointed out that, in its multi-dimensionality, the model might be prismatic rather than triangular and located in a sphere rather than a circle. I accept these observations but find that the more the diagram is made to reflect the complexity of the multi-dimensional process the less easy it is for practitioner-researchers to apprehend and use it. However, I recognize, too, that for pedagogic purposes, it may help some users to have a fuller understanding of what is at stake in the complex process.

Key to my approach to PaR is an acceptance that knowledge is not fixed and absolute. Though I accept that 'the scientific method' with its capacities of experimental testability, repeatability and falsifiability has proved valuable, the fact is that it does not produce absolute truths. Indeed 'the scientific method' has itself developed considerably since the high-point of positivism in the latter half of the nineteenth century (see Chapter 3). Results produced by means of scientific methods often prove inconclusive or contradictory, and quite frequently established positions have to be substantially revised or abandoned in the light of further research. Moreover, in recognizing since Einstein and Heisenberg that subjective elements cannot be ruled out in the process of positioning, analysing and measuring phenomena, twentieth- and twenty-first-century scientists accept that the knowledge they produce is not as 'hard' or 'objective' as nineteenth-century positivism assumed. Indeed, Polanyi has remarked that 'it is futile to seek for strictly impersonal criteria of [a discovery's] validity, as positivistic philosophies of science have been doing for the past eighty years or so'.[25] Thus a more fluid 'knowing' yielded in PaR projects might be located on the spectrum between types of knowledge rather than on the reverse side of an impervious 'knowledge/not knowledge' binary. The scientist-turned-philosopher Polanyi 'always speaks of 'knowing', therefore, to cover practical and theoretical knowledge', and I share this standpoint.[26]

Research in the arts needs, however, to demonstrate a rigour equivalent to that of the sciences. In my view, it is not sufficient simply to assert, on the basis of that common element of subjectivity, that 'we know what we know' and that knowing in the arts is personal, embodied and tacit. Since the eighteenth century, in Hank Slager's reading of Baumgarten, '[e]ven though artistic knowledge understood as *mathesis*

singularis – because of its focus on the singular and the unique – cannot be comprehended in laws, it deals with a form of knowledge'.[27] The challenge for advocates of PaR, then, is to develop a methodology and methods to frame that knowledge not based on the formulation of laws by way of deduction and induction (see Chapter 3) but on a different, but nevertheless equivalently rigorous basis. My model is offered as a move in that direction. Drawing upon contextualization in relation to what is already known, and on critical reflection on what we might call practical experiments, it may indeed appear, as Van Gelder and Baetens have remarked, that 'the research methods of the hard sciences are closer to those of research in the arts than the methods and models of the humanities'.[28]

Praxis

Intelligent practice is at the core of my model and a practice is characteristically submitted as substantial evidence of the research inquiry. In 'know-how', I advocate 'doing-knowing', akin to what Schön, in a seminal study, calls 'knowledge-in-practice'.[29] Knowing how to ride a bike is a knowing-doing largely beyond verbal explanation. Arts practitioners manifest many kinds of know-how of this kind, much learned through practising with others (often in the context of formal education). Reflection upon this process of building knowledge (to be further explicated in Chapter 3) allows for the making visible of an intelligence which nevertheless remains fundamentally located in embodied knowing.[30] Both reading to acquire knowledge as traditionally conceived prior to the practice and critical reflection after the event take their place as methods to this end in my multi-mode PaR methodology, while discovery through doing itself remains key. Reflection on the kinds of knowledge practitioners bring to their workspaces is a useful starting-point to establish what knowledges are in play, and much remains to be understood, through research, of how arts practices function.

Any given instance of somebody iteratively repeating a process such as learning to ride a bike would not constitute research involving new insights. It merely establishes a mode of acquired bodymind knowledge. But the studio practice may also provide the context for devising anew in a process of invention. As Carter puts it:

> The condition of invention – the state of being that allows a state of becoming to emerge – is a perception, or recognition, of the ambiguity of appearances. Invention begins when what signifies exceeds

its signification – when what means one thing, or conventionally functions in one role, discloses other possibilities . . . In general a double movement occurs, in which the found elements are rendered strange, and of recontextualization, in which new families of association and structures of meaning are established.[31]

There is a rigour involved in the double movement of devising processes in arts production: in the gathering of materials, in the juxtaposition of disparate elements, and in the selection and editing to shape the artefact. Both techniques and technologies are involved but, as Raymond Williams has observed, there is a significant difference between them:

A technique is a particular skill or application of a skill. A technical invention is then a development of such a skill or the development or invention of one of its devices. A technology by contrast is, first, the body of knowledge appropriate to the development of such skills and applications and, second, a body of knowledge and conditions for the practical use and application of a range of devices.[32]

Insights in PaR may be in the development of technique. Equally they may be achieved in technology defined as practical use and application. Using algorithms as a new technique digitally to create sounds or visual images might be developed into acoustic music or digital artworks by way of application.[33] Thus practical invention has a public, social character. Indeed, as Bill Worthen, following Williams, has remarked, '[t]ools and technologies exist in a dynamic equilibrium; tools afford different acts in different technologies, which redefine the *affordance* of the tool'.[34] The term 'affordance' signifies the potentiality of an object, or an environment, which allows an individual to perform an action.[35]

It is possible, then, by drawing upon a range of modern shifts in thinking about the fixity of the world and its absolute knowability, to begin to build a case for the validity of PaR knowing on the basis not only of the rigour of its methods but also of the originality of invention and the social impact of its findings.

Know-how

Know-how is sometimes termed 'procedural knowledge' in contrast with the 'propositional knowledge' of know-that.[36] Typically following the 'source-path-goal' schema of learning through doing,[37] procedural knowledge is gained incrementally (in dance technique classes, for

example) and amounts to a set of actions which facilitate complex tasks (such as riding a bike, swimming or driving). But to think of tacit knowledge only in terms of a set of rote-learned motor skills is to underestimate what is going on. In his account of the reflective practitioner and knowing-in-action, Schön suggests that tacit knowledge has the following properties:

- There are actions, recognitions and judgements which we know how to carry out spontaneously; we do not have to think about them.
- We are often unaware of having learned to do these things; we simply find ourselves doing them.
- In some cases, we were once aware of the understandings which were subsequently internalized in our feeling for the stuff of action. In other cases, we may never have been aware of them. In both cases, however, we are usually unable to describe the knowing which our action reveals.[38]

Advanced students engaging in PaR bring with them to the praxis a baggage of prior educational experience and, typically, specialist training. Most hold a first degree and masters-level qualification and many have significant professional experience. Accordingly, they know how to engage in their practice. If they are dancers, they may have trained in ballet, jazz and tap and/or 'contemporary' dance. If they are photographers, video- or film-makers, they will be aware of different-length lenses, shutter speeds, white balance, camera movements, framing and so on. If musical composers or performers, they will have been schooled in a repertoire, are probably able to read and write musical scores and perhaps work with electronic modes of composition on a computer. If they are actors, they will be familiar with the protocols and procedures of rehearsal and probably have training in the mode of a significant practitioner (Stanislavski, Brecht, Grotowski, M. Chekhov, Le Coq, Meisner *et al.*) or in devised practice (e.g. Wooster Group, Forced Entertainment, Goat Island). They all have 'know-how' which manifests Schön's seminal idea of 'knowledge in action' which supposes that praxis involves an intrinsically intelligent 'dialogue with the situation'.

In some instances, their 'know-how' will be inscribed in the body. Perhaps most obviously, a ballet-trained dancer holds his body and moves in specific ways, but 'embodied cognition' is today a broader category which admits many modes of knowing which are inseparable from our being in the world. Polanyi holds that 'by elucidating the way our bodily processes participate in our perceptions we will throw light

on the bodily roots of all thought, including man's highest creative powers'.[39] Neuroscientists Francisco Varela and colleagues explain that

> [b]y using the term *embodied* we mean to highlight two points: first that cognition depends upon the kind of experience that comes from having a body with various sensorimotor capacities, and, second, that these individual sensorimotor capacities are themselves embedded in a more encompassing biological, psychological and cultural context.[40]

In *Action in Perception*, Alva Nöe presses the case for 'enactive' perception in positing that 'perception and perceptual consciousness are types of thoughtful, knowledgeable activity'.[41] He notes that

> Kant famously said that intuitions without concepts are blind. The present point is that intuitions – patterns of stimulation – without knowledge of the sensorimotor significance of those intuitions, are blind. Crucially, the knowledge in question is practical knowledge: it is know-how. To perceive you must be in possession of *sensorimotor bodily skill.*[42]

Nöe, Varela and colleagues emphasize, then, that cognition is not the representation of a pre-given world by a pre-given mind but it is rather the enactment of a world and a mind.

In the light of the 'performance turn' and an increasingly accepted insight into the centrality of 'embodied knowledge' in perception and cognition, there are two practical implications of 'know-how' that need highlighting in a PaR context. First, such knowledge is often taken for granted by arts practitioners and, second, beyond articulation in doing, much of it is not easy otherwise to make manifest. Indeed, one of the key challenges of PaR is to make the 'tacit' more 'explicit'.

Tacit knowledge (to be further explored in Chapter 3) is sometimes seen as either an evasion or an intrinsic problem in the research domain. As Emlyn Jones points out, '[w]e need to be more explicit about what is meant by an enquiring mind in our subject at university level'[43] so as to answer the concerns of conservatives who argue that a theory of tacit knowledge seemingly confirms the unintelligence of art in the sense that is it is mind-less. The unsustainability of the presupposition of a binary divide between body and mind will be addressed further in the next chapter. The embodiment of perception, as briefly marked above, has fundamentally challenged such a view in recent years. It is certainly

the case that it is difficult to make tacit embodied knowledge explicit and it may be that 'performative' knowledge resides ultimately in the doing-thinking. But more might be done in a research context to make the tacit explicit.

Know-what

Know-what, unlike know-how and know-that, is not an established mode but, as I construct it in the model, it covers what can be gleaned through an informed reflexivity about the processes of making and its modes of knowing. The key method used to develop know-what from know-how is that of critical reflection – pausing, standing back and thinking about what you are doing. Put thus, it sounds straightforward, but in the actuality of PaR it demands a rigorous and iterative process.

Schön has recognized that the sedimentation of know-how could render process repetitive and routine. He points out that '[a] practitioner's reflection can serve as corrective to overlearning. Through reflection he can learn and criticize the tacit understandings that have grown up around the repetitive experiences of a specialized practice'.[44] It is thus necessary, as indicated, regularly to step outside involvement in the praxis to monitor and engage with the research inquiry and its articulation. The know-what of PaR resides in knowing what 'works', in teasing out the methods by which 'what works' is achieved and the compositional principles involved. In the documentation of a devising process, for example, it may be possible to capture instances of where things are not getting anywhere alongside moments when things begin to work. Know-what may thus be illustrated (in an annotated DVD, for example), though it might not be expressed in propositional terms (articulated as rules or laws). Though each piece of practice may be individual, an aggregation of instances (such as is currently being established in the PaR community – see Chapter 4) allows for a broader know-what to be established. Informed by the practice review, it is possible gradually to identify what is distinctive about a given practice and the substantial new insights it yields.

In addition, as Haseman and Mafe formulate it, '[t]he reflexive defines a position where the researcher can refer and reflect upon themselves and so be able to give an account of their own position of enunciation'.[45] Reflexivity, then, concerns not only reflecting on what is being achieved and how the specific work is taking shape but also being aware of where you stand ('where you are coming from') in respect of

knowledge traditions more broadly. Reflexivity is particularly necessary in today's relativist intellectual context in which the lack of universal knowledge and limited consensus opens up the field of interpretation. Where, for example, accounts of embodied cognition are based on common human experience, common embodiment and common evolutionary history,[46] it is necessary overtly to recognize that such a position is not universally held. This is where know-that comes into play. Sullivan remarks that '[i]nterpretive acts open up a space among the artist, artwork and the setting as different interests and perspectives are embraced'.[47] The idea of 'standpoint epistemologies' and changing knowledge traditions will be taken up in the next chapter.

To achieve a profoundly critical reflection, an additional dimension is required to dislocate habitual ways of seeing. In my model such a dimension may be mobilized from within, from an element of playfulness in the know-how process, and from without, through engagement with a range of other perspectives and standpoints to promote the interplay with fresh ideas. Smith and Dean have constructed a model of an 'iterative cyclical web' delineating cycles of iterative processes which involve an interplay of 'practice-led research', 'research-led practice' and 'academic research'.[48] Though I insist that doing-thinking in the first two categories is a dimension of 'academic research', the iterative cycles of process they delineate resonate with the dialogical interplay of know-how, know-what and know-that in my model. Marking two possible approaches to research reflecting different mindsets – process-driven and goal-oriented – Smith and Dean note that 'the two ways of working are by no means entirely separate from each other and often interact'.[49] Likewise, my proposal that an open and playful approach to creative process might be offset by aims, objective and a timeline mixes aspects of a more goal-oriented approach with a process-driven one.

Know-that

The setting in play of 'know-that', the equivalent of traditional 'academic knowledge' articulated in words and numbers (propositional discourse) drawn from reading of all kinds, completes the bases of my model. It is added to, particularly in PaR, by knowledge gained through the experiencing of practices intrinsic to any specific research inquiry. The cornerstones of my model are interlinked by the two-way arrows along the axes of Figure 2.2 to mark a dialogic interplay between the bases. Indeed, the dynamics of process characteristic of creative practices

with an emphasis on becoming are crucial to my understanding of knowledge production. Although it might appear so in books and articles which efface the labour it has taken to produce clear utterances, knowledge does not arrive fully formed in neat parcels, clearly bound and visually available to more than one person at a time. All forms of research and knowing involve a process. But as my own model indicates, the process of PaR is perhaps more multi-modal and dynamic than those in other kinds of research.

The accounts of reflective practice by all commentators are characterized by movement. In Schön's account of the reflective practitioner, a play of elements is required, to 'surface and criticize the tacit understandings . . . and make new sense of the situations of uncertainty or uniqueness which he [*sic*] may allow himself to experience'.[50] More obliquely, Polanyi is instructive in conceptualizing the phenomenal movement from tacit know-how to more explicit know-what or, in his terms, a movement from the proximal to the distal:

> The transposition of bodily experiences into the perception of things outside may now appear, therefore, as an instance of the transposition of meaning away from us, which we have found to be present to some extent in all tacit knowing.[51]

Tacit knowledge may be too close (proximal) for it to be fully recognized. Moreover, through non-reflective iteration, it might become habitual. In order both to shake it up a little and to understand it more fully, a required movement away from the proximal towards the distal can be effected through critical reflection. The more embodied experience moves away from the proximal, the more it becomes possible to articulate its import in additional modes, including the intellectual, as patterns 'emerge' into discernible forms. In a number of disciplines, 'emergence' marks the way patterns and complex systems are formed from apparently simple actions and interactions.[52] In Polanyi's formulation, there is a stratified framework in which 'emergence' is defined as the action which produces the next highest level. In all formulations, the oscillation of thought from the proximal concrete to the more distant abstract and back again not only clarifies but also enriches through a layering of multiple resonances as the tacit doing-thinking in the creative process is made explicit.

The rigour involved in different aspects of the dynamic process above differs from that of the traditional (positivist) scientific method but is consonant with more modern conceptions of scientific knowing (such

as complexity and emergence), as they have developed in the twentieth and twenty-first centuries. Haseman and Mafe conclude that

> [t]he creative work is one research output but creative research itself is something that works with the creative component to establish something other, some critical or technological finding for example. So while there are emergent outcomes within creative practice, it is when this potent and somewhat unruly discipline is co-joined with research that creative practice-led research becomes truly emergent in its outcomes.[53]

This chapter has put forward a procedure for undertaking a research inquiry through a practice and has spelt out the additional tasks a practitioner needs to engage in to become a practitioner-researcher. Recognizing the particularity of each PaR project, it has offered not a meta-theory but a model to house distinct, but dynamically interrelated, modes of knowing or knowledge and to show how they may be mobilized in PaR. It has noted that complex ideas may well already be in circulation in the praxis, and that they may additionally be mobilized by activating know-that. It has suggested that much of what is required by way of documentation may already be a part of professional process but that anticipation, preparation and 'sixth-sense' awareness can assist in capturing key insights. Much of the dialogic engagement between the three key modes of knowing is aimed at bringing out in an academic research context what constitutes substantial new insights.

3
Conceptual Frameworks for PaR and Related Pedagogy: From 'Hard Facts' to 'Liquid Knowing'

This chapter seeks to build upon my earlier writings on PaR and the problem of knowledge with a view to confirming PaR as a valid arts research methodology with a distinctive approach to rigour mobilized through a discernible pedagogy. The chapter is initially concerned with shifting knowledge paradigms across the academy which have opened up a space for Haseman's 'performative research paradigm'. The argument is that, if account is seriously taken of the many and various challenges – including those from within science – over the past century to privileging a positivist paradigm, it is no longer tenable to take the methodologies of the sciences as the gold standard of knowledge. Instead we find ourselves in a situation in which different approaches to knowing have different criteria for what is to count as true or valid in respect of valuable insights within a given paradigm. As Brian Eno has remarked:

> Being mystified doesn't frighten us as much as it used to. And the point for me is not to expect perfumery to take its place in some nice reliable, rational world order, but to expect everything else to become like it: the future will be like perfume.[1]

This is not the place for a detailed history of ideas but, in order to bring out some of the resistances to PaR as well as the opportunities it affords for knowledge production, a sketch of key positions and 'turns' is helpful. Arts 'insiders', those within arts communities who take as read the value and intelligence of arts practices, are sometimes shocked to find in the context of the academy that their work is regarded as insubstantial – entertaining and decorative rather than knowledge-producing. For this reason alone it is helpful to have an understanding of the locations

where others are situated and their occasional sense of superiority. But, ultimately, there are more compelling reasons to be open to the methodologies, methods and insights of non-arts disciplines because PaR, as I construct it, tends towards interdisciplinarity.

Historical developments have seen shifts in science away from the order and certainty of the Newtonian and Comtean models to a more circumspect and relativist approach as successively informed by the work of Einstein, Heisenberg, Planck and many others. At the same time as scientific paradigms changed in the first quarter of the twentieth century, qualitative research methodologies emerged, particularly in ethnography, to challenge positivist assumptions about social reality and the study of it. In place of hard facts, Geertz ultimately produced 'thick description'.[2] In respect of performance in this lineage, Goffman's (1959) seminal work, in Leavy's summary, 'developed the term *dramaturgy* to denote the ways in which social life can be conceptualized as a series of on-going performances', and McKenzie has articulated the centrality of the concept to understanding knowledge and power in the twentieth and twenty-first centuries (see Chapter 1).[3] However, the force of 'the scientific method' can still be felt.

The 'scientific method' and methodologies contesting it

I have charted elsewhere the binary rift between theory and practice in the Western intellectual tradition since Plato, so I propose here to pick up the story in the latter half of the nineteenth century when the Enlightenment trajectory culminated in 'scientism'.[4] This is the notion that science gives us certain knowledge and might one day be able to give us settled answers to all our legitimate questions. Its methodology is empiricism.

Empiricism posits that knowledge of an independent reality is obtained through the objective observation by neutral researchers who infer general truths, or laws, from the accumulation of specific instances, according to particular principles of logical reasoning (deduction and induction).[5] In its most intense formulation in the mid nineteenth century, August Comte, the champion of positivism, asserted that the world which science describes is the world, and its method is the method of knowledge itself. In this view, no statement is worthy of credit unless it is testable against the facts of experience as systematically and objectively observed. Presupposing a complete separation between subject and object, empiricism has established methods to underpin it. Rigour is achieved through accredited research project

design, agreed scale of samples, recording and analysis of data, systems of statistics, and so on. By definition, it excludes most PaR and even the qualitative methods which have emerged in the 'softer' social sciences. What exactly counts as an adequate scientific method has, however, been much disputed over centuries and adjustments have been required in the light of fresh insights. Quantum mechanics, for example, effectively challenged the epistemic warrant of the classical Newtonian 'scientific method' as a means to the revelation of truth. Though continuing in pursuit of truth, science in the twentieth and twenty-first centuries has become much more cautious about its findings, particularly in the recognition of an unavoidable interrelation between objects and the subjects who observe them. In respect of the rigour of scientific logic, Popper has been influential in proposing that scientists should specifically seek to falsify their inductive inferences since it is methodologically more secure to challenge the truths we think we know by actively seeking counter-examples.[6]

Though the sciences are now markedly less confident about the certainty both of their findings and of the potential perfectibility of human knowledge about the world than in the time of Comte, the ghost of positivism lingers in academic culture. Physicist David Bohm remarks that

> the notion of the necessary incompleteness of our knowledge runs counter to the commonly accepted scientific tradition, which has generally taken the form of supposing that science seeks to arrive ultimately at absolute truth, or at least a steady approach to that truth, through a series of approximations. This tradition has been maintained, in spite of the fact that the actual history of science fits much better into the notion of unending possibilities for new discoveries approaching no visible limit or end.[7]

Quantitative, data-based knowledge and facts about the world continue to underpin most scientific approaches and to an extent inform the 'know-that' dimension of my PaR model. Data-based approaches are not, however, typical of PaR, and its mode of knowing is not of a propositional (descriptive-declarative) or falsifiable kind. Thus anyone who insists on research undertaken in accord with 'the scientific method' (whatever exactly it might entail) as the sole basis of knowledge is likely not to accept arts PaR.

Despite the various shifts and turns, a hierarchy of paradigms still privileges the quantitative sciences. As Leavy notes, 'qualitative

research is still at times mistakenly judged in quantitative terms and the legitimacy of qualitative evaluation techniques continues to be critiqued more than their quantitative counterparts'.[8] At a conference in 2010 on qualitative research methodology, St Pierre drew attention to the amount of time she and colleagues were still spending 'tracking the effects of and resisting the "naïve and crude positivism" (Elliot, 2001, p. 555) of the scientifically based and evidence based research community, those who missed all the "turns," especially the postmodern'.[9]

Bourdieu puts the point even more forcibly, suggesting there is a questionable self-interest sustaining the privilege of the scientific at the expense of other approaches:

> [T]he most formidable barrier to the constitution of an adequate science of practice no doubt lies in the fact that the solidarity that binds scientists to their science (and to the social privilege which makes it possible and which it justifies or procures) predisposes them to profess the superiority of their knowledge.[10]

Since, in making the case for different modes of knowing generated in PaR, I propose to depart from positivism and 'the scientific method' as the only valid research paradigm and argue that other, 'softer' methodologies should hold at least an equally important place in academic culture, I should make it clear that I am not anti-science. A philosopher colleague once remarked that he would prefer not to fly in an aeroplane designed by a poststructuralist engineer or to visit a postmodern dentist.[11] I am with him on both counts. It is indisputable that, through the application of its established methodologies, science has achieved, and continues to achieve, understanding of apparent principles of operation of the world and of human minds and bodies functioning within it. Science has saved lives in ways to which the arts do not even aspire though, equally, it has contributed to destructive forces, notably warfare and genocide, which put paid to Modernist, and particularly Futurist, optimism about a bright new future achievable by scientific means. My argument, however, is not against science and its established methods of observation, data-gathering, testability and falsifiability but against the notion that 'the scientific method' is the only valid knowledge-producing methodology. In my view, the arts and their modes of knowing enrich lives in ways without which they would not be liveable. I shall argue, moreover, that their methodologies might have a rigour of method equivalent to – though it is not coterminous with – that of the hard sciences.

In response to the increasing recognition that human subjectivity is inevitably involved in the production of knowledge and that not everything about the universe – and the place of human beings within it – can be understood through measurement, a substantial shift away from the data-based, 'quantitative' methods of the natural sciences has indeed taken place over almost a century in the 'softer' social sciences, in educational research and in the arts and humanities. Marina Abramovic reflects that, for her, 'knowledge . . . comes from experience. I call this kind of experience 'liquid knowledge' . . . It is something that runs through your system.'[12] As I see it, a PaR methodology extends the softening trajectory towards liquidity, but developing its own criteria for credibility and rigour. From the standpoint of hard science, questions of rigour in research method and of validity and trustworthiness are nevertheless frequently posed, ignoring the fact that the warrant of that standpoint has itself been called into question.

Several influences have informed the notion of 'standpoint episte-mologies' or 'situated knowledge' in which it proves untenable simply to assume the privilege of neutrality and objectivity of viewpoint.[13] Key in this context is the work of feminist scientists such as Donna Haraway, who argue that gender does – and ought to – influence our conceptions of knowledge, the knowing subject, and practices of inquiry and justification.[14] Such an approach clearly departs from the assumed objectivity of the classical scientific method, calling, in Leavy's summary, for the 'dismantling of the dualisms on which positivism hinges: subject-object, rational-emotional, and concrete-abstract' – and, we might add, theory-practice.[15] The point is that we need finally to exorcise the ghost of positivism as many indicators suggest we should (see below).[16] Once it is accepted that the methodology of the sciences is not sacrosanct, we can begin to consider what constitutes rigour in other warrantable research methodologies. Sinner *et al.* have suggested a shift in evaluation standards from 'rigour' to 'vigour' but, while I recognize the sense of dynamic energy evoked,[17] I hold that a justifi-able PaR rigour might be established in principles of composition, in making the tacit more explicit and in establishing resonances between 'know-what' and 'know-that'.

Familiar research methods such as case studies and interviews are used under the qualitative methodology, and protocols have been established to limit the justifiability of the charge of bias sometimes levelled against them. For example, researchers are now well aware that the results of interviews and questionnaires can be distorted by the kinds of questions asked. In ethnography it is understood that

the limitations of a participant observer's ways of seeing can lead to misinterpretations of an 'other' culture. In hermeneutics, it is recognized that the question asked ultimately determines the answer and thus hermeneutic-interpretative models are not linear but figured as circles, spirals or networks with many points of entry.[18] Such models better suit what many artists perceive as the non-methodical, even chaotic, and iterative journey through a process.[19] Hermeneutic approaches yield insights but there is an awareness that those insights are situated: depending on where you enter, or pause to reflect upon findings, the insights will differ, but this is seen not as a weakness of the model, rather a recognition that knowing is processual and a matter of multiple perspectives.

A modern sense of 'standpoint epistemologies' leads researchers to reflect upon their own ideology and values ('where they are coming from') in relation to the cultural practices of the object of study. Such self-reflexivity is extended in my PaR model in its advocacy of an iterative pattern of critical reflection. In sum, an awareness of an inevitable interrelatedness between subject and object has modified the complete separation supposed between observer and observed in the classical scientific method and requires critical reflection. Before turning to the possibilities of rigour in PaR, it is worth marking some of the key 'turns' in the latter half of the twentieth century which open up a route to validating arts praxis.

The linguistic, poststructuralist, postmodern and practice turns

The 'linguistic turn' significantly modified post-classical understandings of knowledge and broadened the range of research methodologies and methods.[20] Within and beyond the arts and humanities since the 1970s it has become widely recognized that language is not a neutral medium but a structuring agent in the perception of reality. Indeed, in strong formulations from Saussure to Derrida, language is seen to construct and constitute reality in contradiction of the drift of Western science which took language to be transparent. Where objects had been thought to exist independently in the external world and words had been ascribed to them as if sticking on a label, structuralism proposed that differences between the meanings of words depended rather upon the linguistic structure (*langue*) in which they were located. Thus while there may be a brute material world to be engaged with, 'reality' is constructed in accordance with the codes and conventions of language. Furthermore, the endless deferral of meaning in the slipperiness

of language, as posited by some poststructuralists, would render futile any attempt absolutely to fix our knowledge of things.[21] In this view, we have come a long way from the sense of assurance which informed Positivist science.[22]

'Postmodernism', taken as an umbrella term for a range of cultural theories, also militates against fixity in its demands for a reconfiguration of the subject. Emphasizing the plurality of cultures and perspectives and social constructionism, it rejects essentialist accounts of identity, suggesting that not only is 'reality' constructed in discourse but the very identities of the subjects inhabiting it are mutable. In Judith Butler's seminal formulation, for example, gender is not an aspect of nature but rather is socially constructed through repeated performances and thus in principle open to change, though in practice subject to regulatory discourses.[23] A link is discernible here between a conceptual framework and performance as research since gender identity is reconceived as a performance practice. Haseman, following Austin,[24] proposes that

> [P]erformative research represents a move which holds that practice is the principal research activity – rather than *only* the practice of performance – and sees the material outcomes of practice as all-important representations of research findings in their own right.[25]

The shift from modernism into postmodernism marked also a change of conceptual metaphors from a surface/depth model (with a single deep taproot) to Deleuze and Guattari's rhizome (with a tangle of inter-connected roots).[26] The rhizome taken as an 'image of thought' lends itself to multiple strands without hierarchy in contrast to deep mining within a linear tradition. Such a metaphor maps on to my approach to PaR in respect of the opening out of 'disciplines' to each other in today's universities and thus multiperspectival, interdisciplinary read-ings rather than full exploration of a narrow and highly specialist database. Though historical knowledge is not effaced, my notion of a practice review focuses on what other practitioners are achieving in synchronous space and time.

Another aspect of postmodernism to impact upon knowledge para-digms is Lyotard's incredulity towards Grand Narratives (*Grand Récits*) of legitimation such as those of history and science.[27] Put simply, all the great linear metanarratives of progression which informed the Enlightenment up to and including modernism are proclaimed no longer credible. In their place, drawing upon Wittgenstein's 'language games' denoting the multiplicity of communities of meaning, Lyotard

envisages a plurality of micronarratives. Beyond the reinforcement of other challenges to absolute truth and singular meanings, two aspects, analogous to the collapse of grand narratives, have emerged in 'post-dramatic theatre' as highly influential in art practices and arts PaR: the preference in compositional principle in performance for bricolage over linear narrative, and persona at the expense of character.[28] Rather than representing the world and its inhabitants in a representational model analogous to that of traditional science, the presentation of fragmented persona in fluid environments literally plays out a new way of seeing, illustrating another link between a conceptual framework and praxis.

Crucial to my argument however, is the collapse of hierarchy in knowledge paradigms entailed by Lyotard's account of the postmodern condition.

Etherington suggests that

> [d]uring the postmodern era, we have been encouraged to view all that has gone before as important 'stories' that were constructions of their time . . . nothing is fixed; knowledge can only be partial and built upon the culturally defined stocks of knowledge available to us at any given time in history; reality is socially and personally con-structed; there is no fixed or unchanging 'Truth'.[29]

If there is no secure, neutral basis for establishing objective knowledge in any discipline, and if there is no firm ground from which to make a 'truth language' claim of superiority for science, history or philosophy among competing micronarratives, it is incumbent upon all disciplines, including the sciences, to offer a reflexive account of their methodology and the rigour of its internal methods.[30]

In considering PaR PhDs, Elkins remarks that

> the problem of evaluating creative-art PhD simply cannot be solved unless disciplines give up their shapes and readers step outside their normal interpretive habits: exactly what might make the new degree so interesting, and at the same time ensure it cannot be commensu-rate with other degrees.[31]

He is right in recognizing that different disciplines deploy different methodologies and must be judged in their own terms, and it may well be that the standards of rigour are not entirely commensurate across disciplines. But it is only from the standpoint of traditional science that other disciplines are perceived to fall short of the criteria for the

sciences. As Schön has remarked, '[w]e cannot readily treat [practice] as a form of descriptive knowledge of the world, nor can we reduce it to the analytic schemas of logic and mathematics'.[32] But if it is acknowledged that the methodology of the sciences can no longer be taken as a wholly privileged truth language then adjustments of perspective might be made to open up space for what might very well be interesting.

To conclude this brief – and inevitably selective – outline of significant 'turns', it is worth marking two publications, 'The Forum – The Performance Turn – and Toss' (1995) and *The Practice Turn* (2001), both concerned with performance as praxis. The first appears in a prestigious journal of communication,[33] and the second is an edited collection of essays exploring from the perspective of social theory the role of practices in human activity.[34] Though it draws some examples from the performing arts, the collection is concerned with practice in the broadest sense: 'fighting together, hunting together, sailing together, singing together, even, in the present-day world, doing science together'.[35] Its particular relevance to the case here, however, is its undertaking to prove the insufficiency of 'propositional knowledge' in accounting for the realities of practice. Indeed, to repeat Haseman's bold but justifiable claim:

> [W]e stand at a pivotal moment in the history and development of research. Practice-led researchers are formulating a third species of research, one that stands in alignment with, but separate to, the established quantitative and qualitative research traditions.[36]

In Haseman's formulation, artistic praxis is 'performative' in that it impacts upon us, does something to us, changes us in all manner of ways (aesthetically, perceptually, ethically, emotionally, even physically). Because the term 'performative' is itself contested and multi-accented, however, I prefer to construct this paradigm simply in terms of a distinctive PaR methodology that mobilizes particular modes of knowing, some embodied in practices to which I now turn.

Enactive perception, embodied knowledge and the haptic[37]

A further challenge to established research methodologies and methods is posed by the mode of knowing characteristic of – though not exclusive to – arts PaR, namely a practical knowing possibly before or beyond words (when from a hard-line structuralist standpoint, anything outside language is by definition inconceivable). 'Embodied' knowledge

would appear to be subjective (extremely close-up in contrast with science's aspiration to a distanced objectivity). But it is now argued (see below) that all thinking is inexorably embodied. Thus there is a tension (though not a contradiction) between the idea above that the world is constructed through language and the notion that thinking is to some extent physical, formed in the bodymind.[38] The tradition of phenomenology, as I have marked elsewhere, stretches back a century to Husserl and Heidegger, both much cited in some quarters of PaR.[39] A number of accounts of the interrelation between physical and conceptual approaches has recently emerged, to refine understanding of 'embodied knowledge' and to posit 'enactive perception'. They build upon the insights of a realist–idealist tension, suggesting that our concepts might shape the world as much as the physical world shapes our knowledge of it. That human knowledge is built upon touch has long been posited, for example, in Polanyi's account as noted and in Arendt's distinction between *homo faber* and *animal laborans*.[40] More recently, Nöe has developed Varela's notion of 'enactive perception', proposing that 'the relation between perception and action is more complicated than traditional approaches have supposed'.[41] Indeed, Nöe posits that 'perceiving is a way of acting . . . To be a perceiver is to understand, implicitly, the effects of movement on sensory stimulation'.[42]

Though Nöe resists the designation 'tacit knowledge' for this mode of knowing, embodied knowledge nevertheless remains in need of further articulation in the context of any specific PaR project. It is possible to seek means of at least an intersubjective sharing through reflecting on mutual engagements in a practice. Indeed, Nöe is at pains to emphasise that '[t]o perceive is not merely to have sensory stimulation. It is to have sensory stimulation *one understands*'.[43]

Thus individual or collaborative critical reflection on experience, in the form perhaps of a documented conversation, may, through gesturing towards a more abstract conceptualization, assist in disseminating the (initially embodied) mode of knowing. This is not, however, to propose that all explicit knowledge must be propositional (see below). Nöe remarks that we wrongly suppose that all concept-use must take the form of explicit deliberative judgement, and that conceptual skills must rise to the level of a contextual generality. Understanding a concept may be much more like possessing a practical skill.[44] Moreover, '[t]o have an experience is to be confronted with a possible way the world is. For this reason, the experiences themselves, although not judgments, are thoroughly *thoughtful*. Perception is *a way of thinking* about the world'.[45]

Towards a methodological rigour in PaR

Knowing may well be embodied in this way and might be shared close-up by haptic means in a workshop. However, dissemination in a research context may be extended by seeking to make the tacit explicit by the various means proposed. In this way, PaR researchers sometimes aim to *evidence the research inquiry* in writings but not to yield answers in the form of analytic or synthetic propositions. Stanley and Williamson have posited that

knowledge-how is a special kind of knowledge-that. The familiar distinction is preserved, only relocated as a distinction between different ways of grasping or understanding propositions.[46]

Thus the relation between arts practices and any accompanying writing *to articulate and evidence the research inquiry* involves more than a willingness, or otherwise, of practitioner-researchers to write complementary commentaries. It is a question of relations between different modes of knowing which, though in dialogue in my model, are not subject to commensurate criteria of validity but which might affirm each other by way of resonance.

I asserted in Chapter 2 that writing about an arts or media practice is by no means intended as a translation of sounds, images or movements into words, but I have also argued above against artists' claim to a special private knowledge which, based on intuition, is incommunicable other than in the artform. Though I agree that verbal articulations about arts processes are unlikely to yield either analytic or synthetic propositions, I hold that critical reflection does yield insights, some of which might be disseminated in a verbal commentary. Knowing is a continuing process of negotiation between the various modes (know-how, know-what, know-that).

The tension between critical writing and other practices which has characterized one corner of the PaR debate might be dispelled if the traditional opposition between theory and practice is overcome. Nicholas Davey points to the etymology of '*theoria*' (contemplation) and '*theoros*' (participant) in ancient Greek usage and suggests that *theoria* is 'a hermeneutic go-between':

The philosophical attraction of *theoria* is its recognition of the unavoidable and indeed productive tension between art's intellectual and material character'.[47]

Drawing upon Gadamer's hermeneutics,[48] Davey proposes that

> [e]verything that can be said about an artwork and its subject matter
> is incomplete. There is always more to be said. Neither the theoreti-
> cian nor the practitioner has definitive rights to closure over what
> an artwork has to say.[49]

He concludes that

> Aesthetics-as-*theoria* stands on this commitment to the possibility
> of cognitive and perceptual transfer. If concepts and ideas are not
> capable of infusing sensibility with intelligible sense and if sensibility
> is unable to mediate abstract concepts and render them perceptibly
> incarnate, then the ability of an artwork to address us would be
> severely impaired.[50]

Framing arts practices in a research context through the lens of herme-
neutics in this way affirms the necessity of the dialogic dynamic of my
model. It constructs critical commentary as one mode of interpreta-
tion, a means of assisting in the articulation of what arts practices are
and might signify in the range of contexts in which they might be
encountered. The hermeneutic sense in which the praxis is continually
becoming may militate against the idea of a self-identical practice stand-
ing alone, but it accentuates the interplay between doing-thinking and
more abstract modes of knowing where concepts are articulated verbally
in terms of propositions. The impulsion to write critical commentary
comes more perhaps from a research imperative than a motivation
to develop an arts practice, but my experience of PaR evidences that
artists come better to understand their practices in context and that
understanding, in turn, enhances the artists' work.

A traditional 'academic' disposition to avoid bias and distortion may
well remain in PaR but with an awareness, to cite Nagel, that there is
no 'view from nowhere':

> [T]he distinction between more subjective and more objective views
> is really a matter of degree, and it covers a wide spectrum. A view or
> form of thought is more objective than another if it relies less on the
> specifics of the individual's makeup and position in the world.[51]

Approaches to research in the arts have proved challenging, even to
qualitative methodologies, in their emphasis on subjectivity and tacit

knowledge. Accordingly, my model for PaR, while fully recognizing the importance of close-up, tacit, haptic know-how, seeks a means to establish as fully as possible an articulation of 'liquid knowing' and a shift through intersubjectivity into the know-what of shared and corroborated soft knowledge, in turn resonating with the harder know-that of established conceptual frameworks.

The model emphazises a dynamic process with movement along Nagel's spectrum, not seeking an unattainable objectivity but striving to nudge knowing at least into an intersubjectively apprehensible mode of doing-knowing – and perhaps, through resonances and corroboration, into something even further towards the object end of Nagel's spectrum. Hard knowledge and liquid knowing need not be seen as two sides of a binary divide. Polanyi, formulates a movement between the 'proximal' and the 'distal' in a structured interrelation of different modes of

> knowing , of a both more intellectual and more practical kind; both the '*wissen*' and '*können*' of the Germans or the 'knowing what and the knowing how' of Gilbert Ryle. These two aspects of knowledge have a similar structure and neither is ever present without the other. This is particularly clear in the art of diagnosing, which intimately combines skilful testing with expert observation.[52]

In the best PaR, there is an intellectual diagnostic rigour in the critical reflection on practice, in the movement between the tacit know-how and the explicit know-what and in the resonances marked between know-what and know-that. It may be that arts practices cannot be re-formulated in propositional discourse, but that is not the aim. The purpose of critical reflection in a PaR context is better to understand and articulate – by whatever specific means best meet the need in a particular project – what is at stake in the praxis in respect of substantial new insights.

Intelligent practice

Having made an outline case for the validity of a PaR methodology, it is necessary further to consider what might constitute internal rigour within it and to seek a means to distinguish creative practices which do constitute research inquiries from those which do not. The first question to be addressed concerns whether there can be what I call 'intelligent practice' since, as Schön remarks, '[o]nce we put aside the model of Technical Rationality . . . there is nothing strange about the idea that a

kind of knowing is inherent in intelligent action'.[53] Philosophically, the question of intelligent action involves consideration of whether theory precedes intelligent practice or whether intelligent actions are necessarily prefaced by 'regulative propositions'.

In his seminal chapter, 'Knowing How and Knowing That' (1949), Gilbert Ryle summarized how the prevailing doctrine of his time sustained a Cartesian dualism as a 'mythical bifurcation of unwitnessable mental causes and their witnessable mental effects'.[54] He suggests that

[t]he combination of the two assumptions that theorizing is the primary activity of minds and that theorizing is intrinsically a private, silent, or internal operation remains one of the main supports of the dogma of the ghost in the machine.[55]

The philosophical strategies deployed by Ryle to call these assumptions in question need not detain us here but his findings help me to unpack my model of PaR.[56] Ryle concludes that

- to be intelligent is not merely to satisfy criteria but to apply them;[57]
- efficient practice precedes the theory of it;[58]
- it is of the essence of merely habitual practices that one performance is a replica of its predecessors. It is of the essence of intelligent practices that one performance is modified by its predecessors. The agent is still learning;[59]
- knowing *how* then is a disposition, but not a single-track disposition;[60]
- overt intelligent performances are not clues to the workings of the minds; they are those workings.[61]

In sum, Ryle established the ground for what in arts and other cultural practices I call 'doing-thinking'. In passing, he also marks an important distinction between habitual (or formulaic) practices and those in which intelligence and innovation are manifest and I take this as the basis of a distinction between arts practices which may be research and those which are not.

Ryle was by no means the first person to allow for intelligent doing-thinking to precede abstract thought or articulation in words. In 1934, Vygotsky proposed that the route to knowledge is through interactive, collaborative engagements based in doing (*Tätigkeit*), but interacting with more abstract thought (words and intellectual ideas). Vygotsky argues that 'thought and speech have different roots, merging only at a certain moment in ontogenesis, after which these two functions

develop together under reciprocal influence'.[62] He neither identifies thought with speech nor asserts their absolute difference; instead he notes their 'interfunctional' relation. He recognizes 'preintellectual speech' in a child's development as well as non-verbal thought, arguing that 'only with the establishment of interfunctional systemic unity does thought become verbal, and speech become intellectual'.[63] In what he calls the 'dialogical character of learning' a reciprocal material-ideal engagement 'from action to thought' is in play.[64] 'Spontaneous concepts, in working their way "upward" toward greater abstractness, clear a path for scientific concepts in their "downward" development toward greater concreteness'.[65]

A key observation to reiterate in respect of my epistemological model, then, is that the whole is dynamic and interactive (the arrows along the axes of the triangle consciously point both ways). Theory, that is to say, is not prior to practice, functioning to inform it, but theory and practice are rather 'imbricated within each other' in praxis. Where the prevailing view assailed by Ryle assumed that intelligence is a special faculty, the exercises of which are those specific internal acts which are called acts of thinking, I follow Vygotsky and Ryle in positing that intelligence may be manifest in arts practices, in the product, in the processes which produce the practices and in complementary writings. In my model, arts practices (dancing, music- or theatre-making, writing, painting, sculpting, filming) might be seen, particularly in a research context, as gesturing towards the articulation of thought. Indeed writings of all kinds and arts practices of all kinds might equally be seen as modes of articulating thinking, where 'thinking' is not constrained to the abstract and propositional but embraces embodied passions.

Discerning some parallels between knowing *how* and knowing *that*, Ryle ultimately concludes that the former is processual:

> Learning *how* or improving in ability is not like learning *that* or acquiring information. Truths can be imparted, procedures can only be inculcated, and while inculcation is a gradual process, imparting is relatively sudden.[66]

I noted in Chapter 2 that insights in PaR have proved to arise as much in the process as in the product, and I emphazised the value of documenting process and critical reflection along the axis aiming to make the tacit more explicit. Though Ryle acknowledges that some practices have a regulatory framework, he is clear that they may be learned through observation and doing. He regards it as 'quite possible for a boy [*sic*] to

learn chess without even hearing or reading the rules at all . . . We learn *how* by practice, schooled indeed by criticism and example, but often quite unaided by any lessons in the theory'.[67] Ryle thinks that such a performer may be 'incapable of the difficult task of describing in words' the principles involved.[68] This is a similar example to riding a bike or swimming and, though I agree that it may be a difficult task, where a research inquiry is concerned, I propose that it is illuminating to try to discern the principles of action or composition.

This is not a matter of reducing a complex arts practice to a set of propositions. I agree with Ryle that the dispositions involved are 'not single-track . . . but indefinitely heterogeneous'. Critical reflection on moments which 'work' in the process of making or where innovations come into play can assist in the articulation (in words or by other documentary means) to disseminate the findings of the research in a manner analogous to the requirement of the scientific method.[69] Documentation and presentation of process as evidence of PaR research have an importance which is similar to showing the workings, rather than simply the conclusion, of a mathematical calculation. The difference, perhaps, is that the mathematical problem also has an answer while an arts practice is not analytic in this way. It may not be possible to emulate the scientific method in respect of the repeat of experiments, falsifiablity or predictability about future events, but it is possible to mark and articulate findings in a way which might share insights and inform pedagogy.

I have noted above that some practitioners are reluctant critically to reflect upon their process and practice or to share their ways of working. Some firmly believe that such analysis will undermine an 'intuitive' approach to creative practice and it may be that such practitioners are not cut out to be formal practitioner-researchers in the academy. I acknowledge that I am as sceptical of the romantic myth of intuition as Ryle is sceptical of the 'Descartes' myth'. But Schön's deployment of *seeing-as*

> suggests a direction of inquiry into processes which tend otherwise to be mystified and dismissed in terms of 'intuition' and 'creativity', and it suggests how these processes might be placed within the framework of reflective conversation with the situation.[70]

Indeed, some past performances have been reconstructed from documentary traces.[71]

Since my model rests considerably on a willingness to be critically reflective and to embrace ideas from a range of sources, I would find

it difficult to advise, or even engage with, somebody who insisted that everything was intuitive (in the sense of inspired by a muse) since it would seem to place everything beyond pedagogy, indeed beyond analysis.[72] The only way forward in a formal academic context would be to subject the creative practice to expert peer review. Ryle appears to have some sympathy with this approach since he observes that

> [u]nderstanding is a part of knowing *how*. The knowledge that is required for understanding intelligent performances of a specific kind is some degree of competence in performances of that kind.[73]

While I strongly support peer review as a cornerstone of any audit process, such as REA, REF, RQF, in my view it is a brittle strategy in most instances to present only a final product in an assessment context since, if the reviewer does not find the practice intrinsically intelligent and insightful, there is no other means of access and negotiation. As Ryle acknowledges, 'the examiner cannot award marks to operations which the candidate successfully keeps to himself'.[74] Another argument against submitting the product alone is the inability of an artwork to take account of its own context. It is not necessary to be a committed postmodernist to recognize that artworks are variously read from different perspectives. As Davey remarks:

> it is the nature of art practice to be always more than it knows itself to be . . . it is only by attempting to think differently about art practice that many of its hidden assumptions can be recovered . . . One role of theory is to uncover the possibilities that remain inherent within practices and thereby liberate them towards futures already latent within them.[75]

PaR research rigour and arts knowing

In my model, research design for PaR projects involves a range of methods in a multi-mode inquiry. Rigour may be exercised in the design and in the various dimensions of the overall process. First, there is potential for rigour in the making of whatever arts praxis is involved, ranging from craft techniques to the gathering, selecting and editing of materials in a piece of postmodern devised theatre. The precise criteria for rigour depend upon the kind of work undertaken: aesthetic criteria of an individual signature for a modernist work, for example, will differ from those for bricolage. In the latter, there is a discernible difference

between the offering of elements randomly thrown together and a piece involving careful selection and construction and the presentational knowing of its mode of address. These are aesthetic choices but are relative to mode rather than of a single standard.

In Schön's view, 'the dilemma of rigor or relevance may be dissolved if we can adopt an epistemology of practice which places technical problem solving within a broader context of reflective inquiry'.[76] Research rigour should be exercised in the process of critical reflection – in turning know-how into know-what – including an awareness of the paradigm and context in which one is working in order to establish the appropriate criteria for judgement. According to Schön, a practitioner-researcher may reflect on

> the tacit norms and appreciations which underlie a judgment, or on the strategies and theories implicit in a pattern of behavior. He may reflect on a feeling which has led him to adopt a particular course of action, on the way he has framed the problem he is trying to solve, or on the role he has constructed for himself within a larger institutional context.[77]

Rigour should also be exercised in the programme of intellectual exploration, including reading, by which the conceptual framework is established, and particularly in identifying key resonances in the overall praxis between know-how, know-what and know-that. It is not quite a matter of triangulation (as used with a more positivist emphasis in some social sciences), but my model does draw upon discovery of correspondence and corroboration, resulting in what in some disciplines is termed a 'convergence of evidence'. Though, for example, a recording of a post-presentation discussion with peers may not amount in itself to convincing evidence of the way a piece works, when mapped onto insider accounts and a conceptual analysis of a mode of knowing it assists in building a sense of conviction.

Because PaR projects are many and various, the test of conviction must to some extent be on any given project's own terms. As Schön puts it, '[w]hen someone reflects-in-action, he becomes a researcher in the practice context. He is not dependent on the categories of established theory and technique, but constructs a new theory of the unique case'.[78] But research design frameworks such as that offered in this book afford an outline structure for establishing coherence and a degree of commensurability. Case law may then be built over time upon this structure of inquiry.[79] Finally, a rigour needs to be exercised in the research

submission, presenting findings in a manner which demonstrates coherence by way of resonances across a range of discursive practices. Because of the multi-mode approach, the final submission is likely to include different modes of writing, ranging in principle from the poetic to the traditionally passive academic voice, alongside other practices (see Chapter 4).

There are a number of ways in which research in the arts might produce *new knowledge* or *substantial new insights*. First, within each of the established arts disciplines it is possible to follow a modernist edict, to 'make it new'. Alternatively, at the interdisciplinary junctions of a postmodernist paradigm, there is scope for fundamentally interrogating canonical traditions. In either case, critical reflection upon the processes of making as part of the multi-mode approach to PaR proposed might produce insights into the know-how of practices. Locating the work in a lineage and drawing upon the know-that of contemporary thinking allows the specificity of the practice to be understood in its own context.

At the 'performance turn' it is now widely recognized that we 'do' knowledge, we don't just think it. This important insight mobilizes for PaR a number of aspects of new circumstances in which first the subjectivity of the agent – the person performing – becomes a critical factor in the research. In performances, kinds of space and spatial relationships have become key areas of inquiry. Thus, in engaging with an object of research, the identity of the perceiver and where they are standing have come to be important considerations in framing any findings of the inquiry. Where, historically, the study of acting has been concerned with realizing characters on stages in marked theatre spaces, the broader notion of performance, following Goffman (1959), extends the frame of analysis to embrace us all presenting ourselves in everyday life. Furthermore, in what has been termed 'the crisis of representation', a sense of multiple modes of being in the world displaces any defined sense of representing a stable persona both in the theatre and in life. Denzin, for example, has called for 'texts that move beyond the purely representational and towards the presentational'.[80]

In outlining heuristic research, Moustakas refers to

a process of internal search through which one discovers the nature and meaning of experience and develops methods and procedures for further investigation and analysis. The self of the researcher is present throughout the process and, while understanding the phenomenon with increasing depth, the researcher also experiences growing self-awareness and self-knowledge.[81]

Drawing upon, and citing, the findings of Varela *et al.* (1993), Kozel fleshes out how a heuristic approach might function in respect of a sensitive relation between the researcher and researched. She suggests that

> the strength of the researcher is precisely the ability to give up the guise of detachment and to understand the source . . . the researcher is an 'emphatic resonator with experiences that are familiar to him and which find in himself a resonant chord.' Although some degree of critical distance is required, the intention is not that of a neutral observer but 'to meet on the same ground, as members of the same kind . . . ' In particular they [Varela *et al.*] indicate that sensitivity to another's 'phrasing, body language and expressiveness' is integral to this sort of second-person methodology.[82]

Thought is involved in doing-thinking to effect such change but it is not overtly propositional. Kozel affirms the necessity of thinking about thinking in a phenomenological tradition, observing that

> [t]he first moment of phenomenology originates in doing, but accompanying this doing is a weaving in and out of a line of thought, a line of questioning. The thought as it emerges is non-homogenizing, and sometimes goes quiet. In this sense it is different from normal analytic thought.[83]

Much PaR work does not involve the creation of new artworks but applications of art or arts processes in social circumstances beyond a marked performance space. A powerful strategy is afforded by the idea of doing-knowing in applied performance practices through the insight that interventions might be made in actual behaviour by changing the performance of the participants. In many instances, the dissemination of research findings will be through practice in workshops since they involve a doing-knowing. However, to parallel the broader dissemination of 'scientific' research findings traditionally articulated in words in an analytical paper, documentation in a form more readily transmissible by modern communication means (digitally via the internet or on DVD) is typically required (see Chapter 4).[84]

Pedagogy and supervision: can PaR be taught?

As suggested in Chapter 1, a sound approach to PaR can be mobilized at undergraduate level by ensuring that the curriculum design involves

strategies for engaging with a range of ideas alongside practice, as well as within it. A specific module of work might be designed and run as suggested to look at a range of examples and to introduce methods of critical analysis informed by explicit ideas (know-that).

At taught masters level, a project-based approach might allow each student to develop her own practice while a taught component might address a number of matters to develop the practitioner-researcher. A brief – and inevitably selective – approach to the history of ideas similar to that above allows students to achieve a sense of the place of their own work in a broader intellectual context. Consideration should be given to the range of research paradigms such that students are aware, within an academic context, of the different approaches taken to validating knowledge. Engagement with reading might take the form of seminars on an article (book chapter, or book) annotated by the students in advance. Each student should give a short seminar-demonstration *to articulate and evidence her research inquiry*.

Because the potential frame of reference for a wide range of conceptual frameworks is vast, there can be no specific bibliography (though there might be some core sources). After initial selection by the tutor, the choice of reading for discussion might be drawn from the students' own interests. Bearing in mind that many students embarking on practitioner-researcher trajectories will not be as schooled as humanities students in traditional modes of writing that draw upon book-based research, it may be necessary to introduce traditional strategies (how to read critically; how to take notes; how to construct a bibliography; the function of endnotes; publishing style sheets). It is certainly a good idea for students to develop writing skills of all kinds, making students aware in the process of the difference between discursive modes and when each might most appropriately be used (see Chapter 4). At doctoral level, all the above aspects should be engaged with the specificities outlined in Chapter 2.

Supervisors of PhDs may, as noted, draw upon their specialist knowledge but equally they may need to be open to broad interdisciplinary territories introduced by their students. Certainly, supervisors accustomed to the more traditional art theory or art history thesis may be called upon to make significant adjustments in their approach. It is likely to be necessary to engage with the studio practice alongside more traditional tutorials. Suggesting reading and other sources may not be a straightforward matter in the early stages when a student is surveying a broad (possibly interdisciplinary) domain in search of resonances with key influences. Once these are found, the process of thickening

description requires a more directed strategy. One of the excitements of supervising PaR PhDs is that you are at times drawn out of your comfort zone into new, and occasionally risky, territory (see the *Partly Cloudy, Chance of Rain* project in Chapter 4). Depending on the complexity of the process, it may be advisable to have a tutorial team with a range of different skills.

Though it is important to monitor the progress and conduct formal review of all PhD students, it is particularly important for PaR PhD students. at somewhere between 12 and 18 months (or equivalent for part-time students) a formal review (or upgrade from MPhil to PhD) should ensure that the student has not only identified but refined her research inquiry, and has identified the key aspects of the conceptual framework with which the practice resonates. A draft practice review should demonstrate location in a lineage and at least indicate a space in which substantial new insights may be achievable. Documentation strategies should be in place to gather data, by whatever appropriate means, to support such evidence as the candidate may wish to adduce at the submission stage. Where claims about the impact of a strategy are implicit or explicit in the project, a method should be in place to secure evidence for the claim (though not to the extent of a social-science warrantable reception study amounting to a second PhD). Sufficient writing should be presented to demonstrate proficiency in whatever discursive forms the candidate is likely to use in final submission (typically including the traditional third-person, passive-voice mode of written presentation).

To conclude, in reviewing the developments which brought the 'hard knowledge' of positivism to prominence in the academy and subsequently called it into question with the successive development of 'softer' methodologies, I have located PaR and made a case for its distinctive methodology. Though it is typically not a matter of 'right answers' or repeatable experiments, findings might inform future practices and/ or practitioner research, and knowing may be shared not only within an arts community but across the academy and thence out to broader communities through the modes of dissemination proposed.

In advocating the 'performative research paradigm', Haseman reminds us that arts practitioner-researchers argue that

> a continued insistence that practice-led research be reported primarily in the traditional forms of research (words or numbers) can only result in the dilution and ultimately the impoverishment of the epistemological content embedded and embodied in practice. Thus the

researcher-composer asserts the primacy of the music; for the poet it is the sonnet; for the choreographer it is the dance, for the designer it is the material forms and for the 3-D interaction designer it is the computer code and the experience of playing the game which stands as the research outcome.[85]

Though practice is at the heart of my model, I hope to have shown that documentation and complementary writings are not translations of the artwork but serve to augment the *articulating and evidencing of the research inquiry*. I recognize, however, the impulse towards faith in 'embedded and embodied knowledge' and appreciate that images, performances, and artefacts are accepted for submission in formal UK research audits. However, the key criteria of 'substantially improved insights' and 'substantially improved materials, devices products and processes'[86] suggest to me that the accommodation my model makes with more traditional articulations is justified. It may well be that over time praxis knowing will be better understood but, even at the performance turn, a mixed-mode approach seems at least advisable and some aspects of my argument suggest it might remain so on principled grounds.

4
Supervision, Documentation and Other Aspects of Praxis

The documentation of arts practices, and particularly of ephemeral performance, is a contested issue because strong and apparently conflicting views are held on its possibility, necessity and worth. Those who deem the ontology of performance to lie in its very ephemerality and disappearance may even see attempts to save and retrieve the fleeting moment of the live event as a betrayal.[1] At one extreme of the spectrum of viewpoints, the live experience (both of creators and witnesses) is considered to lie beyond representation or articulation – inexpressible to the point of the sublime. At the same time there are those who have an equivalent conviction that significant moments in the history of arts events should not be allowed to disappear but need somehow to be saved for posterity. As Reason has remarked in summary of these discursive positions, 'articulations of both the value of transience and the duty of documentation possess their own political and moral imperatives and perceptions'.[2]

Though not insensitive to the issues and to the sheer difficulty of capturing process and event, the approach of this chapter is pragmatic, assuming the necessity of documentation in PaR, but noting also that much of the material is already yielded by established arts-making practices. Reason's book cited gives a detailed account of the professional self-documentation of the British performance company Forced Entertainment. Very aware of the problematic of neutral, immediate representation, the company explores documentation in various forms for various purposes, including the demands of students wishing to gain access to work performed before they were even born. Thus, though much of Forced Entertainment's documentation tends towards the fragmented and hypertextual, broadly reflecting their mode of postdramatic performance, the company is aware of the occasional need for as

'faithful' a representation as possible, however that might be achieved. I hold, furthermore, that the critical engagement entailed in the process of documentation in PaR can yield valuable insights into the processes of making in different arts, and ultimately leads to more refined arts practices.

The availability of technological media as means of recording ephemeral events may well, as some commentators have claimed, have spurred the impulse to document.[3] But new technologies by no means solve all the issues – and the scoring of music and such modes as Laban notation in dance suggest, moreover, that the impulse has a history. A key challenge of PaR as I construct it is dissemination by way of the articulation and evidencing not so much of the practice itself (though the practice is a crucial mode of evidence) but of an overall research inquiry. In institutional contexts, documentation of various kinds is necessary but Reason is right to note that 'there can be no concept of documentation without a sense of that which is not (or cannot be) documented'.[4] A mature PaR community will recognize both the necessity and the limitations of documentation and this must be taken into account in the building of a constituency of experienced supervisors and assessors.

In this chapter I draw first on some specific aspects of praxis as they have arisen in my experience of working with, assessing and auditing PaR projects and supervising and examining PaR PhDs. It is thus a situated account aimed at supervisors and regulators as much as practitioner-researchers themselves, with the objective of affording insights through illustration of a range of issues. It has been suggested that PaR PhDs afford an opportunity 'to rethink the supervisor's role', and in what follows it is evident how I have developed my own supervisory practice through engagement with PhD students.[5]

Rather than relate the projects by way of full case studies, I home in on those aspects which have illuminated the processes and issues involved in undertaking a PaR project. Matters of documentation are given a section of their own since they have been a particularly contested aspect of PaR and because, in my model, documentation is integral to *articulating and evidencing the research inquiry*. Though it is now customary to download documentation of product and process – and even, in some instances, complementary writings – to a DVD, the capture of product involves different issues from those of process, so, in the second section of this chapter they will be treated in turn. For the most part, I will not name names in discussing projects, with the exception of my first, most fully explored, example, *Partly Cloudy, Chance of Rain*, which is now so well known – I might say infamous – that there

is no masking its makers, Joanne 'Bob' Whalley and Lee Miller. Though the project overall has been well documented, there are several aspects from an institutional and supervisor's point of view which are worth adding to the account.[6]

PaR PhD pedagogy in development

Partly Cloudy, Chance of Rain: the supervisor's tale

When, in 1999, I took on Lee Miller and Bob Whalley as bursaried PhD students, we agreed from the outset that a collaborative performance project would form a substantial part of their submission.[7] It was, in short, to be a PaR project. As they have related elsewhere, they had no specific performance practice.[8] Both had completed the masters degree in theatre studies at Lancaster University, which I knew to be open to various approaches in making and documenting performance, and they had previous backgrounds in visual arts and drama respectively. This was initially significant since, in my institutional understanding of what would be required of two PhD submissions with a common performance outcome, it was agreed that they would take different perspectives on the praxis in their complementary writing. It was only subsequently that we addressed the matter of a complete collaboration which ultimately resulted in one joint submission for which each was awarded a PhD.[9]

From a supervisory point of view, their project presented many challenges: conceptual, processual, regulatory, logistical, ethical. As Kershaw notes, the

> contrast between a highly focused discursive enquiry and a creative event that was wonderfully multi-faceted – in, for example, its predictably producing several accidental motorway audiences and unpredictably bringing a busy motorway almost to a standstill without accident – serves to illustrate some deep and highly challenging tensions of method in performance practice as research.[10]

Looking back, such a project was even more of a risk than I was aware of at the time, but its successful completion opened up new possibilities for approaching the PaR PhD. Above all, it was the open-ended, quirky artistic inquiry and the energy and enthusiasm of the artists which persuaded me to take them on, working initially on Kershaw's 'hunch', rather than a research problem or question.[11] In the coming together of professional artists and 'the academy' at the time (see Chapter 1),

the imputation from some artists was that the requirements of method and methodology of the PhD were incompatible with – if not inimical to – openly exploratory arts processes. Interested as I was, and am, in development of PaR PhDs, I saw an opportunity to test out how a truly quirky but genuine line of inquiry might be fleshed out into a research process and forged into a PhD.

Ethical dimensions

The germinal idea for the project – collecting bottles of urine discarded by truck drivers on motorway journeys on the M6 between Penrith and Lancaster and leaving gifts by way of barter – has been recounted by Whalley and Miller in several publications. But another aspect of their early explorations has received less attention, namely the picking up of hitch-hikers on the motorway and recording their stories as part of what subsequently emerged as tracing the narratives of alleged non-places. Both the performance of stopping to make gift exchanges and the picking up of strangers were risky to the point of being potentially dangerous. In the way of their enthusiastic imaginative curiosity, Lee and Bob had few worries on this score – though their performance of a mechanical breakdown was knowingly to mask the questionable legality of their stopping on a motorway to make exchanges. As supervisor in an institutional context, however, I was properly required to ensure students reflected on ethical considerations in their research design and methods.

Though it would overstate things to claim I had sleepless nights, it is the case that I had disturbing visions of headlines reading 'PHD STUDENTS MOWED DOWN ON MOTORWAY VERGE' or 'PHD STUDENTS VIOLENTLY ATTACKED BY HITCH-HIKER'. My own fertile imagination saw me in the dock explaining their activities to be justifiable as a research method in a multi-mode PaR PhD research methodology. From such perspectives I was aware early on that, from the outside, Lee and Bob's – and, indeed other – PaR projects might appear bizarre, when from the inside it made sense. Coming from no specific discipline, Lee and Bob were not even structuring a regular practice-based arts PhD and their approach was not exactly in the tradition of 'the scientific method'. But it is here that an aspect of my own notion of 'insider-outsider' perspectives in the process began to take shape.

In respect of ethics, the gift exchanges were already largely complete and the hitch-hiker narratives proved early on to be less interesting than hoped, so it was possible to alleviate my ethical sensitivities by shifting to an alternative strategy. This involved leaving objects and

disposable cameras around the sites of motorway services as a means of collecting more 'data' for the project. I was relieved insofar as the ethical requirement to minimize any risk of harm to participants in the research process – not to mention the researchers themselves – had been indirectly achieved. For the remainder of the project, despite sensitivities around the renewal of the marriage vows at Sandbach Motorway Services at the core of the performance, no further exceptional ethical issues emerged. It is worth emphazising, however, that all research projects need to undergo appropriate scrutiny in an institutional context and that PaR projects, precisely because they often entail work with and upon others, may throw up more ethical issues than traditional book-based study.[12]

On the day of the PhD examination performance of *Partly Cloudy, Chance of Rain*, I became a bit concerned about the build-up of traffic on the M6 as passing trucks, spying a panoply of brides and grooms in Victorian wedding attire, slowed down to see what was going on. Fortunately no accidents occurred and it was fitting that truck drivers were involved from the outset to the endgame, even if they were unaware that they had motivated and mobilized a PhD inquiry. Moreover, the idea of hitch-hiker narratives was not lost in that all invitees to the final performance were furnished with a tape or CD with narratives covering the time span of their particular journey from home to the Sandbach services destination. One notion of 'rigour' in PaR is the worked-through-ness of ideas in process, and this attention to detail in *Partly Cloudy, Chance of Rain* illustrates such rigour.

Conceptual frameworks

Unlike more traditional PhDs, Bob and Lee's project was not definable in terms of a specific domain of knowledge with a proscribed frame of reference. There was, of course, a literature of performance arts (Goldberg, 1979, 1998, 2001; Howell, 1999), of performance studies (Schechner, 1977, 2002; Carlson, 1996) and of postmodernism (Jencks, 1989; Hutcheon, 1988, 1989; Kaye, 1994) as cited in their bibliography. From the outset, Augé's notion of 'non-place' was a key reference point with Bachelard (1958), Lefebvre (1971, 1974) and Soja (1996) affording additional perspectives on conceptions of space and place as things developed. There was a lineage of context-specific projects though more typically in cityscapes than on rural stretches of motorway (Fiona Templeton; Blast Theory, Wrights and Sites). In retrospect, and in the light of remarks made by the external examiners, I now place overt emphasis as noted on a practice review alongside – in some cases in

preference to – a literature review. In the role of supervisor, it is less easy to offer a reading programme than it is with a more traditional PhD, let alone to demand a traditional literature review (see Chapters 2 and 5). What has emerged in my approach to supervising PaR PhDs is an insistence that reading takes place from the outset within a cognate interdisciplinary frame such as that sketched above. From there, it is a matter of trust that reading will lead to further reading until resonances emerge between the praxis in process and a conceptual framework. In my experience so far, it always has.

In the case of Bob and Lee, a refinement of Augé led them to develop the praxis of 'operational knowledge'.[13] Another key point arose from their reading of Deleuze and Guattari, but initially in an unexpected way concerned with collaboration (see below). Subsequently the concepts of 'two-fold thinking' and 'territorialization' (Deleuze and Guattari) and 'dialogism' and 'heteroglossia' (Bakhtin) became significant in the PhD as key to reflections on the nature of collaboration and what they term 'an exoteric-esoteric aesthetic'.[14] In the latter formulation, they found a concept in literature which they better understood for it having been independently formed in their practice and, reciprocally, it served to help them articulate their research inquiry. That reciprocal process is what I signify with the arrows pointing both ways between insider and outsider knowledge on my model (Figure 2.2), and what I mean by resonance in praxis.

Similarly, the notions of postmodernism and performativity are defined verbally in the complementary writing (with reference to Hutcheon and Butler among others) but made manifest in the conceit at the heart of *Partly Cloudy, Chance of Rain* in the performance and actual renewal of Bob and Lee's marriage vows. In an actualization of 'both-and' thinking, this act, in Hutcheon's formulation, subverted while it affirmed. Unlike in the bogus marriage of Audrey and Touchstone in Shakespeare's *As You Like It*, the chaplain here was genuine and the vows sanctioned and valid in the terms of an Austinian performative. At the same time, however, this was a theatrical performance in the Costa Coffee bar at Sandbach services on the M6 motorway. In Chapter 1, I observed that the projects of PaR PhD students must necessarily involve a practice of ideas in action. The moment of the marriage vow in this project affords a definitive example.

Collaboration

In a tutorial a few months into their project, Lee and Bob tentatively and politely (as is their way) raised with me the question of why they

could make a performance and submit it collaboratively but were being asked to take different perspectives in their complementary writing. No doubt I rehearsed again the requirement for each of their PhD submissions to be distinctive, and they acknowledged that this was the basis of our initial 'contract'. But, in practice, they said, they read and wrote together as much as they made performance together: there was no meaningful separation in the different aspects of their work. And was it not the case, they asked, that many writers – even much-cited sources such as Gilles Deleuze and Félix Guattari – published together synthezising perspectives from different disciplines? In short, I was persuaded and proposed to take the matter to the faculty and university research degrees committees to seek approval of a joint submission. As it transpired, there was less resistance to the proposal than I had anticipated. Indeed in sport science (a strong research area in the university) and in the sociology of education (the specialism of the then chair of the university research committee), co-authorship was not only commonplace but deemed to be desirable. Teams of researchers in those more established research traditions regularly designed research projects, worked together in laboratories and published their findings under joint names.

This is, as Kershaw records, 'the first ever fully collaborative UK performance practice-as-research PhD'.[15] The project's complexity has since stimulated debate about research approaches to and methods in PaR. Though the full implications of awarding two PhDs for one collaborative performance project may not have been fully understood, the project of Lee'n'Bob (as they became known from that point even prior to the affirmation of marriage vows) was approved. Again the concept was made manifest in the doing-thinking: part of the 'contribution to knowledge' afforded by this project is in the understanding of collaboration in research. The successful completion of the PhD in 2003 paved the way for subsequent collaborative arts PaR PhDs. Indeed, the issue of assessing individuals in the context of collaborative work has been further thought through in the academy since then. In the context of the forthcoming REF research audit in the UK (2014), the protocols state that assessing panels may wish to be assured of 'the substantial and distinctive contribution of each of the submitting authors' but, once this is done, the 'quality of the output as a whole' is to be assessed, in recognition that collaborative work, as Bob'n'Lee persuaded me, is not reducible to discrete contributions but is dialogically collaborative.[16] This part of the process serves also as a good example of dialogic engagement in the supervisory process on a number of fronts.

Aspects of praxis in other projects

Quality and originality of the practice

Though not absolutely without precedent in respect of site-specific and context-specific performance projects exploring space and place, Bob'n'Lee's PhD performance was unquestionably original. The organization of the complex event itself was of a high standard with every detail thoroughly worked through, as noted. Given the core event, the question of the quality of the performances (in terms, for example, of sincerity or authenticity) seems inappropriate in this instance. With other projects and discussions in which I have been involved, however, the questions of the need for work to be 'original' and to manifest the highest professional standards have quite frequently been raised.

At issue, here, I believe, is a misunderstanding of PaR in an institutional context. Though I am committed to the idea of arts (and other cultural-material) practices as a research method, when it comes to judgement, what is being assessed, as with any other research project, is the research inquiry and its findings – not the creative practice as such, though I recognize that, at times, the line between them is thin. At an early symposium on PaR, a professional practitioner challenged a PhD candidate's presentation on the grounds that the practice was not entirely original. But the research inquiry concerned an aspect of the viscerality of exchange between the performers themselves and between performance and 'experiencers' of it, and thus did not rest on the mode of presentation itself being without precedent.[17]

The practice involved a manifestation of Merleau-Ponty's 'Chiasm' and the complementary writing philosophically exploring this notion resonated with the practice. My key metaphor of 'resonance' between ideas in action and the more abstract and propositional formulation of ideas in words has emerged in reflection on how thinking functions in the work of my tutees. It informs my considered approach as a supervisor in challenging practitioners to reflect on the doing-thinking in their process and practice and in seeking resonances in their reading programme. I find the term apt and useful. Indeed, in the presentation of the practice cited – and also in a voice project I examined elsewhere – 'resonance' is literal in that part of the experience was transmitted through the vibration of the physical space. Though, as we shall see in the discussion of documentation, much of a research inquiry might be disseminated in a range of recorded forms, it is acknowledged that there are experiential aspects of many PaR performance projects which can only be thought-felt live in the here and now.

The claim of the research inquiry of some PaR projects does rest on the creative practice being entirely original. But it is the rare example of artwork in any form which is truly ground-breaking in terms of introducing a new code or language. It is partly for this reason that I suggested in Chapter 2 that any demand for PaR submissions to be paradigm-shifting sets the bar higher than it would be set in other disciplines. Such originality is rare in any field but, of course, notable when it occurs.

In respect of technical quality, my 'bottom line' is that the present-ation needs to be proficient enough to convey the research inquiry (see the section 'Documentation' below). If, in the above example, the performers had not been able to convey the viscerality involved, the presentation would not have served its research purpose. It is not quite as brittle as to say that had the space not been felt to vibrate then the presentation would have failed, but this crude assumption might serve to promote understanding of the approach to the research inquiry. If the experiment had failed, an account as to why would be required, recognizing that failure can promote new insights in research terms where a failed creative practice might just disappear without trace.

There is in some projects a need for high levels of performance skill. It would be impossible for a pianist to undertake a research inquiry into reinterpreting Beethoven's piano concertos unless she had high-order skills in playing the instrument. To give an actual example, I co- supervised the PhD project of a jazz pianist colleague which explored the limits of jazz improvisation in respect of a lineage of codes and 'signifyin' (*sic*) tropes variously mixed according to a dialogic principle. Though the final submission involved a sophisticated writ-ten articulation of the conceptual framework, the project in addition overtly manifested a practising musician's know-how. Thus the thesis involved a live performance by way of practical demonstration of the inter-playful reworking of codes. Without high-order skills as a jazz pianist, the candidate would not have been able to make the research inquiry fully manifest. Interestingly (and sustaining the music tradition of allowing practice to speak for itself), the examiners of this project took the view that the performance alone would have been PhD-worthy in its articulation of the research imperative without the substantial complementary writing.

On only one occasion in my experience has the practice been scarcely adequate in terms of making manifest the claims of the research inquiry but I know of colleagues who have required the practical part of a PhD submission to be reworked for re-examination. The 'bottom line' here is

that the practice did not in any sense embody the research imperatives as presented (see Chapter 5).

Praxis not practice – the integration of theory into (professional) practice

Though this book strongly advocates the acceptance of research inquiry located in arts practices, it does not take the view that all arts practices, including professional practices, entail research (with the academic accent on the word). As Carlson observes in his reflection on attitudes to theatre in the US (see Chapter 1), the majority perceive performance – and perhaps the arts more broadly – to be a mode of entertainment. And it is tempting, in order to make a point, to add the adjective 'mindless'. The broad question of the social functions of the arts is patently beyond the scope of this book but, since I am making the case for 'thoughtful' arts, there is an obligation to address the distinction between those arts practices which might be knowledge-producing and thus meet the basic requirement of academic research, and those which do not.

Much has been written about formulaic and commodified approaches to arts practice which seek, possibly for commercial gain, merely to reproduce with minor variation products that have proved successful with substantial audiences and viewers.[18] Such work is unlikely in itself to embody a research inquiry however effective it might be at the box office. A revival of *Oklahoma*, for example, may be visually splendid and sonically powerful with set design and performances of the highest professional standard but may not be original in any respect, notwithstanding that it may be uplifting to those who experience it. But, as noted, it is not centrally, or necessarily, the originality of the creative work which is at issue. It may be that the putative production of *Oklahoma* uses for the first time a form of low-energy, LED lighting set to transform the industry in a greening of the entertainment environment. This might well entail a research inquiry on technological and aesthetic levels. To figure something more precise, it may be an inquiry into how lower-temperature lighting than that traditionally used in professional theatre practice impacts on the colour values of set and costumes. Such research could fully integrate theory and practice in the articulation and dissemination of its findings. Thus even standard professional practice is not precluded from research; it is a matter, as ever, of *identifying and articulating the specific research inquiry*.

More commonly problematic among PaR PhDs, in my experience, is the submission in which the inquiry has been identified but on a grander scale than the project will bear. Most often this is the result of a lack of understanding that practical inquiry is just as valid as theoretical, or a lack of confidence (sometimes on the part of supervisors) in the praxis. Though the search for resonances between one discipline and another – say, between choreography and neuroscience or post-classical physics – is to be encouraged in accordance with my model and approach, it cannot simply be assumed that insights achieved in one domain correspond directly with explorations in another.

The new understandings of time and space of post-classical physicists, such as those of Bohm cited in Chapter 3, might seem to resonate with movement in time and space as explored by choreographers. In the aftermath of shifts from Newtonian physics to quantum mechanics, Simon Jones has justifiably remarked that practitioner-researchers should not 'be afraid to propose resonances between events and ideas, however absurd they may now appear'.[19] But, in order to achieve a resonance of the kind advocated, the choreographic practice itself would need to evidence a specificity of treatment of these grand ideas. It is not enough, perhaps, to draw attention to the common concern of both domains with the interrelationship between time and space. Otherwise all dance would be consonant with the concerns of post-classical physics, which it is not, other than in the most general terms of an analogy which at the most abstract level conceives everything to be in flux. What I wish to clarify through this example is the institutional research need for the arts praxis to have the capacity to undertake an inquiry which yields insights of its own, not just to claim resonance by analogy with ideas circulating in another domain. This is another aspect of 'rigour' in the PaR PhD inquiry.

To promote a praxis and avoid a disjunction between theory and practice, it is important that a programme of reading runs in parallel with the studio practice from the outset, not after the event. In frequently reflecting on the research inquiry as it becomes more defined and refined, the capacity – indeed, the need – for this specific inquiry to be undertaken through an arts practice must be established. This is a matter of constant cross-referral as indicated in the two-way arrows on the axes of my model. The ideas in action must be evident primarily in the doing-thinking of the practice. If interesting ideas emerge in the reading towards a conceptual framework, it must reflexively be asked if they are truly manifest in the practice. On occasion, however, reading might motivate a practice. For example, Burgin recalls a student who,

after reading Bachelard on the concept of space, 'made an installation of stuffed toys that he turned inside out – so that all their electronics, and other hidden details, became their exterior surface'.[20] Furthermore, the conceptual framework established overall does not need to be grand.

It is better if a project is conceptually more modest with the ideas rigorously worked through in the praxis than for a grand theory to be grasped and applied in retrospect once the practical project has been undertaken. It is understandable with a new, and as yet not fully accepted, mode of research that students and tutors are disposed to reach out to the most challenging of abstract ideas in philosophy, neuroscience or post-classical physics. Where the resonances are truly established, fine; but in PaR it is probably better to trust a more modest, and rigorously worked, praxis.

In some cases, it is possible to build a critical perspective into the PaR project. In performances given specifically in an institutional context of PaR, students have projected quotations from critical sources as part of the presentation of a praxis. Similarly, in a professional art context, Grayson Perry inscribes such critical commentaries into his ceramic pots.[21] In a screen media submission concerning a transgendered clubbing practice, one PhD candidate built interviews with participants into the film to afford a commentary both enacting and inviting a dialogic engagement. Burgin makes a distinction between a film and a written exposition suggesting that film might afford the basis of an argument but 'does not *make* the argument'. He recalls also Derrida's somewhat equivocal rejection of audio-visual essays submitted to him not on principle but because he felt the argument might be better made in words.[22] Though, in both cases, there seems to me to be a residual over-estimation of the logos, it is notable that Derrida (and Stiegler, his interlocutor) accept the possibility of images making an argument and foresee the moment of 'a scholarly, if not scientific, practice of the image'.[23] In respect of some of the PaR I have indicated, that time has arrived.

This said, I reiterate that I am not against writing – indeed typically I require it in a PaR PhD process – but as complementary to a practice, not standing in for it. In the history of early submissions of PaR PhDs in the UK, although presentation of the practice was allowed, it was perceived most often to be subordinate to the exegesis in words (see also Chapter 8). In several instances, there was a strong suspicion post the viva voce examination that the examiners had not looked at the practice at all (see Chapter 5). It is the hierarchy of theory over practice and the logos (the written argument) over praxis which PaR challenges.

It is not that PaR is subjective, let alone irrational, but that it bespeaks a context in which knowing is possible in a variety of modes. Derrida was rightly concerned about rigour; this book proposes that a rigour equivalent to that of a good argument is possible in well-worked praxis.

Section 2: Documentation

As noted, the issue of documentation in PaR has been contentious from the outset for a number of reasons. Primarily, however, under the tension between writing and other modes of articulation of ideas in a multi-mode approach, arts practitioner-researchers have been concerned that their practice will ultimately be subjugated to writing in accord with the long Western tradition of privileging the logos (see Chapter 7). There has been a specific concern in respect of ephemeral performing arts. In creative writing and the visual arts – and to a considerable extent in music where scored and recorded forms have become an accepted part of culture – an object remains for consideration after the moment of production. However, in dance, theatre and performance, the work, in Phelan's formulation, 'is a representation without reproduction'; '[p]erformance's being becomes itself through disappearance'.[24]

Since PaR in my conception entails the presentation of the artwork as substantial evidence of the research inquiry, unless the work itself can be experienced first hand, there would appear to be a problem. New media technologies increasingly afford accessible and inexpensive means of preserving the artwork or event. But the recording is always in one sense a reconstruction and not the thing itself. Indeed, at worst the DVD record becomes, as Caroline Rye puts it, 'a substitute that cannot provide evidence of exactly the thing it purports to record'.[25] DVD documentation – as now typically submitted at least as the 'permanent record' of research towards a PhD – is evidently not coterminous with the work itself and its primary reception. It is nevertheless not only useful, but necessary, in PaR projects and, in Reason's summary, there are 'numerous possible practical and functional relationships between video and live performance, ranging in a continuum scale from the 'pure' documentation, to the for-the-camera stage re-performance, the studio reworking, the liberal adaptation and beyond'.[26]

Documentation of product

Auslander has famously contested Phelan's ontology of liveness and questioned whether 'any cultural discourse can actually stand outside

the ideologies of capital and reproduction that define a mediatized culture'.[27] There is no need to rehearse this debate again here, but it is important to recognize that opinions on both sides remain strong, and that sensitivity about the direct experience of ephemeral work remains an issue for some.[28] But, as Reason has pointed out, there is an important distinction to be made between repetition and reproduction:

> The difference between repetition and reproduction is crucial, something that can be seen in the relationship between live and non-live media of performance. Although it is largely neither useful or necessarily [sic] to pursue hard and fast, ontological differentiations, an appropriate and meaningful distinction does exist in the way that live events are re-performed, while non-live performances are re-played.[29]

A DVD record of an actual event cannot capture, in Rye's words, 'those qualities of the live encounter and the production of embodied knowledges which can not, by definition, be embedded, reproduced or demonstrated in any recorded document'.[30] This is why, in the UK, examiners of PaR PhDs typically visit twice to experience the practice live. Most practitioner-researchers within the academy, however, have accepted, if reluctantly, recorded forms, but on the understanding that these are traces of the performance and that expert peer reviewers know this and are experienced in reading documents of this kind. As explained in Chapter 2, it is important in this context that written accounts are seen as complementary rather than explicatory of the work itself. But the different aspects of my multi-mode model afford an opportunity to build a fuller account by cross-referring different kinds of evidence. Gay McAuley has similarly argued that the incompleteness or partiality of any one medium or document can be buttressed by information gathered from another.[31]

Video recording of a full performance needs careful preparation. Notwithstanding her philosophical reservations, Caroline Rye, who has made a special study of documentation of live performances, acknowledges that

> [i]n a video we can see a version of the space that the event inhabited, albeit rendered from 3 dimensions into 2; we can see performers in relation to one another, their gestures, movements, other details. Importantly we can also hear an approximation of the sound (because the argument for the photographic image is equally potent

for recorded sound): we can hear the sound in the performance environment synchronized with its accompanying stage action. The differences of speech and music balances, the flows and rhythms of the performance, perhaps even something of a residual 'atmosphere' of the show, all can be shown in a video. These are all qualities that video inherits from the indexical images and sounds that form the basis of its 'reality effect'.[32]

Rye's account (which I strongly recommend the reader to consult in full) distinguishes between a selected and fragmented (re)construction of angles of vision from the now outmoded practice of capturing on video from the back of the space, a wide-angle document which typically affords such a poor and distant image as to be almost worthless. Reason observes that

saturated colour, low resolution and degraded footage almost instinctively encourage viewers to read the image as a self-authenticating document but . . . [t]he more faithful the video representation, and the less it adapts the performance for the new medium, the less watchable it becomes as an artefact in its own right.[33]

In short, if the aim is to make a documentary record of an entire event, a number of cameras, and camera positions, are required. The footage might then be edited together in post-production to achieve some semblance of the 'feel' of the event. Rye points out, however, the draw of the established conventions of continuity editing which tend towards a construction of linear time and a monocular view of space when, in fact, the experience of the event may well have been disjointed, fragmented and multi-perspectival.

In editing videotape, she adopted the strategies of superimposition or split screen in attempt to convey 'events that occur in parallel taking place in the same space'.[34] But the advent of DVD in digital format afforded more flexibility with a greater range of types of data useful to the multi-mode approach to evidence in PaR. As Rye notes, 'DVD as a medium does not presuppose a single, progressive, narrative structure for its texts; and provides the potential for multiple and parallel constructs delivered via a degree of interactivity with the viewer'.[35] The cited article affords an illustration of documenting Bodies in Flight's piece, *Double Happiness*, and Rye's own PaR PhD project which demonstrates the capacities of the DVD medium to militate against video's monocularism to afford not only a range of viewpoints simultaneously

but, importantly in the context of documentation of live events, a sense that things might have been seen otherwise from the positions of other experiencers.

As with Forced Entertainment's documentation, it effectively draws attention to the device of construction rather than presuming immediacy. As Piccini and Rye have summarized:

> The restless shifting between perspectives never allows the video text to be reduced to one version but remains forever constructed and partial. Paradoxically, with every new view added to the DVD an additional awareness of what is not seen by the camera is created – a sense of what the document cannot document.[36]

With this constant reminder, audio-visual evidence of the ephemeral event can never be mistaken for the practice itself, but insights into how it might have been variously experienced as a sequence of moments in time might nevertheless be imaginatively understood.

Documentation of process

Over the course of three decades of discussion of PaR in the UK (and elsewhere) practitioner-researchers have increasingly accepted that the work itself is just one mode – albeit the most significant aspect – of evidence of a research inquiry in a multi-mode submission. Other traces of the knowledge-producing capacity of a project also remain and can be mobilized as part of the thesis. Documentation does not take only the form of the video or the written word. Sketches, scrapbooks, objects of material culture, photographs, video and audio recordings and exhibitions have all been mobilized not only to support but also to make the case by way of *evidencing the research inquiry*. Reason suggests that

> archives can consist of almost anything, including but not limited to theatre programmes, brochures, leaflets, photographs, video and sound recordings, press releases and press cuttings, details of marketing strategies, figures of ticket sales, contracts with performers and confidential budgets, correspondence, descriptions of sponsorship arrangements, venue plans, set and costume designs, stage properties, and so on.[37]

Consider the following examples of documentation in the process of professional practice, the first from a professional exhibition of an artist of exceptional standing in the history of Western art and science.

Recently, visiting the 'Leonardo da Vinci: Painter at the Court of Milan' exhibition, I was particularly struck by the insights into process afforded by the many small sketches – in some instance a dozen sketches to the equivalent of an A4 sheet of paper.[38] The rehearsal of detail, for example a fold in the sleeve of a disciple's gown for *The Last Supper*, was astonishing. I use the word rehearsal because the resonance between the sketch and the full articulation in painting was such that it seemed as if the sketcher was practising the gestures to be repeated by the painter (and in French, of course, *la répétition* is the rehearsal). Though there are examples among the Leonardo cartoons of processes of tracing from sketch to painting – some sketches being pin-pricked to allow a carbon dot-matrix outline – a strong sense was elsewhere conveyed of the rehearsal of an action which informed the doing of the painting. The sketches, in sum, afforded insights to Leonardo's preparatory drawing from life as a process of embodiment of a gesture subsequently to be used in the performance of painting.

There can be no doubt that artists' sketchbooks and notebooks made as part of their practice might similarly serve in PaR as documentation of insights into process. In many instances, as with Leonardo, documentation of process is not an additional imposition of PaR but something integral to artistic practice. In some instances today, however, artists consciously construct additional documentation, making a show-reel of their past practice, for example, primarily as a means to demonstrate the quality of work to potential future funding bodies. My model for PaR draws attention to, and advocates, the usefulness of such documentation in *articulating and evidencing the research inquiry* and invites practitioner-researchers to be aware of the various means of documentation available to them.

However, some means of capturing process have their own sensitivities in respect of making the work. To record an entire rehearsal or compositional process on video, for example, would not only make excessive logistical demands, it might interfere with the process itself. Although in a surveillance culture, we are accustomed to the omnipresence of cameras, the focus and sensitive interchange between practitioners in some projects can be unhelpfully distracted by any interruption to 'extra-daily'[39] performance in marked time and space. However, in reflecting upon, and seeking to evidence a process, practitioner-researchers in my experience have looked back and wished they had captured that special moment of breakthrough when things began to work.

Awareness of the value of such documentation to the research inquiry at the outset can foster that anticipatory sixth sense foreseeing

those points on the timeline when an explicit mode of documentation might usefully be mobilized. Researcher-practitioners can then be ready to document, having at hand whatever means are necessary to that end. If it is possible for somebody beyond the solo artist or deviser-director to take responsibility for documentation, it allows the 'artist' to focus on the process of making although the 'practitioner-researcher' will need to be in dialogue with the documenter. But this is a luxury that not all can afford. To take another common example of artists' documentation, a physical performance duo in one project worked without a director but needed, in the process of selection and refinement of devised material, to see the impact of their constructions. They recorded rehearsals on video to this end and took time after each session of improvization critically to reflect on what they had produced before selecting and organizing material.

The use of relatively unobtrusive palmcorders has proved effective for a range of informal interviews. The visceral theatre project cited above used palmcorders to interview both the performers and the participant observers to collect 'fresh' data from the discrete but interrelated groups immediately after the experience. The preciousness of a beloved jacket of one of the participants emerged in a discussion and informed the ultimate choice of asking participant-experiencers to bring a special piece of their own clothing which was worn, and danced in, by one of the performers with the individual participant-experiencer. In a music project in which the performers 'danced' with, and in response to the sounds of, big-scale, home-made instruments, palmcorder interviews with the instrument-makers in their workshop informed the documentation of process. In these instances the recording process is quick and simple and quality needs only to be sufficiently good to convey the information which becomes a form of data to evidence a point in the thesis.

Palmcorders have also been used to capture post-presentation response to the final showing, or product. Not infrequently, PaR PhD products make claims about the impact on experiencers of the particular approach taken. Though it is not possible in this context to undertake a full audience study in accordance with established social-science methodology, it is incumbent upon candidates who make this claim to seek some evidence for it. Questionnaires offer one means but have their own methodological shortcomings and are frequently not completed in sufficient numbers to be useful. Post-presentation interviews with experiencers can readily capture a range of responses. Research integrity requires the reporting of those (hopefully few) who did not experience

the piece as the makers hoped, but it may be that the balance of responses bears out the claim for its impact. It can also be useful to think through implied reader responses, and relatively old technologies sometimes serve. When challenged to think about prospective reactions, Bob'n'Lee, for instance, produced a *Last Supper* poster prior to the performance event with thought bubbles indicating the likely response of the different key guests at their motorway marriage.

Though DVD affords interactivity, like video it primarily offers an 'outsider' view of the work from the perspective of the spectator when used in a documentary context. Valuable as this is in allowing a wider range of people to access the work than may have been possible directly, it is most effective as evidence of a research inquiry when mobilized alongside other documents. Particularly effective is the juxtaposition of 'insider' with 'outsider' accounts. As Melrose has remarked, the majority of documents available in the arts domain are effectively 'outsider', spectatorship studies in the form of written accounts of those who have seen the work.[40] PaR has begun to reveal, however, the value of the 'insider' accounts of those who make and circulate the work. Not only do these afford a relatively new perspective valuable to practitioners in learning about other processes and compositional strategies; they also foster, in combination with other evidence, a much fuller understanding about what is at stake in creative arts practice and the experience of it.

Mining a rich seam, research inquiry into how the arts function in production, composition and reception has great potential to produce new knowledge. The resonance – or dissonance – between insider and outsider accounts can be very illuminating. Diderot's seminal essay 'The Paradox of Acting' (namely that in order to move the audience the actor must himself remain unmoved) might be considered a proto 'insider' document, opening up for debate the possible disjunction between what an actor feels and what the audience experiences.[41] Indeed, in modern times, the question of the most valid approach to training performers to undertake specific preparatory processes has become an area in itself for PaR inquiry.

A range of documentary means is being developed with the aid of new technologies to deal with insider and outsider – indeed, multiple – perspectives. Though typically downloaded to DVD for convenience of distribution, annotated sound and vision recordings, PowerPoints and interactive platforms can all afford readily negotiable means for the range of evidence arising from a mixed-mode inquiry. Still or moving images can be edited and juxtaposed with analytic commentary, possibly with

a voice-over commentary or instructive titles. New digital means afford variable ways of navigating through material militating against traditional linearity. Some PhDs have been submitted on interactive DVDs and recently some PhDs have been submitted in the form of blogs.[42]

In respect of complementary writings, which may also be included in DVDs, it is likely to be necessary to utilize a range of discursive modes. In documenting process in a diary or notebook, the first person is much more appropriate than a quasi-objective passive voice. Quite often it is the subjective experience of making and performing which needs to be captured here and the literal, indexical function of words is less useful that more poetic modes. Nor is this a casual use of verbal documentation: it is a challenge to find the right form of words, even in informal documentation of this kind, to capture the experience in the moment. So there is a rigour here also in the attempt to find a verbal correlate. In the write-up of process for submission which will draw upon diaries and notebooks, the first-person narrative is frequently the most appropriate, while other discursive modes are more suited to other aspects (the impersonal, third-person passive for conceptual frameworks, perhaps – see Chapter 2).

To reaffirm, the function of what in Australia is called 'the exegesis' is to assist in *articulating and evidencing the research inquiry* and, since the inquiry is multi-mode, so the documentation and writing-up of the inquiry is likely to be multi-mode. It is the resonance between the various kinds of evidence – documentation of practice and conceptual frameworks – which ultimately makes the tacit explicit and, together, yields new insights.

Documentation and complementary writing are now so widely accepted in the context of PaR that it sometimes seems as if they are of supreme importance, marginalizing the practice itself. In the UK at least, as the next research audit (REF, 2014) looms large, documentation has become the aspect of PaR most discussed and developed. At a recent symposium, Simon Ellis playfully drew attention to an almost manic disposition to document everything such that (as evidenced in my hyphenated hybrid term) practitioner-researchers had become 'slashies'. He rightly drew attention to the fact that

> the critical skills in PaR are not so much collecting, gathering, and storing details and experiences, but rather deep reflection, synthesis, narrow and/or broad foci and contexts (both inter- and intra-disciplinary), and a dogged ability to navigate practice-led ideas and activities through complex epistemological terrain'.[43]

While it would be a mistake to allow any one aspect of the multi-mode model, other than the praxis itself, to become predominant in a mixed-mode inquiry, the flexibility and variability of PaR projects is such that some require more documentation than others. I have acknowledged that, in rare instances, the practice itself might stand alone. But precisely because it is the research inquiry which requires articulation in a PaR context as subtly distinct from the quality of the creative practice, documentation of process is typically illuminating. Reason even contends that 'it is the archive, along with various representations of performance contained within the archive, which give performance form and meaning and that speak about performance'.[44]

In recent years, a number of inventive advances has been made to assist research and documentation both by way of archives and interactive websites. In the UK, the Live Art Collection is maintained by the British Library whilst the Live Arts archive, now located at University of Bristol, is currently working with JISC Digital Media to digitize the material held in the Digital Performance Archive and extend its scope with the Performing Documents project.[45] The AVPhD and PARIP websites also hold useful data expressly on PaR, the latter with some interactive features.[46] Websites increasingly afford interactive spaces in recognition of the provisional and perspectival qualities of documentation. The 'Performing Presence' project, for example, aimed 'to create an evolving document that explores concepts or practices of presence in relation to development or installation of a work'.[47] Paul Stapleton's *LiveArchives* project functions as a 'wiki' to afford collaborative creation and documentation.[48] Sarah Whatley and colleagues have produced an on-line interactive Dance Digital Archive which provides users with access to dance archive collections including videos of performance, photographs, and a wide range of text-based documents, allowing researchers to draw upon an archive and juxtapose clips for analysis.[49] Smartlab is developing a Smartshell, 'enabling students, artists, and what might be described as 'cultural interventionists' to make their own meanings and share their own stories and images with their own selected audiences'.[50] Jane Linden has developed a *Curating Knowledge* website based initially on a series of residencies for artists to engage in an exploratory praxis with a view to articulating their research inquiry by various means, but inviting 'outsider' critical contributions.[51] In Australia, the ARC has invested $1.5 million dollar in *Ausstage*, a research facility and online archive built by an extensive consortium of universities and industry partners to record information on live performance.[52] *Screenworks* has been developed as a DVD publication adjunct of the

Journal of Media Practice and the STARS (Semantic Tools for Screen Arts Research) project augmented PARIP Explorer with powerful new tools. As Piccini and Rye summarize, 'screen arts researchers will be able to browse and replay moving image content and both generate and understand thematic links between and among the people and communities involved in aspects of its creation'.[53] Among other international institutions, International Federation of Theatre Research (IFTR), Performance Studies International (PSi) and American Society for Theatre Research (ASTR) all have working groups on PaR.

In sum, there is now a body of experience and resources to support the pedagogy and practice of PaR at various formal HE levels. Because each project is different and there is no single approach such as might be found in other disciplines, it may seem that PaR is hard to pin down. What this book has proposed is a model of a methodology with accompanying illustration of methods, practices and issues which falls within its paradigm. The next chapter turns to regulatory frameworks.

5
PaR PhDs: A Guideline/*Clew* to a Successful Outcome for All (Candidates, Examiners, Administrators, Regulators)

A decade ago, I undertook (with Stuart Andrews) a small research project into the regulatory frameworks of PaR PhDs in the UK and the experiences of students undertaking them.[1] At that time the findings on the latter aspect particularly made somewhat sorry reading. It became clear that many British HE institutions did not understand – or in some cases acknowledge – PaR, even though they had registered students to undertake PhDs on this basis. Students who had completed their programmes reported that the practice (typically submitted on a DVD) had been totally ignored by the examiners: the viva voce had referred only to the written submission. Some institutions discovered, as noted in Chapter 3, that their regulations required study in accordance with 'the scientific method' and thus effectively precluded the submission of creative practice. This chapter speaks directly in the first person to prospective PaR PhD students, though it is hoped that supervisors and regulators will also draw some insights from it.

The situation today is much improved, with an increased level of understanding all round. Indeed, Professor Sir Christopher Frayling, one of the first to explore artistic research, has recently observed that

> It is timely, in my view, to redefine and re-evaluate the academy – which, like it or not, is where many of us are for much of our time – to emphasise the radical nature of some of its elements. Towards a radical academy. Towards a distinctive research culture within it, a culture which understands its own assumptions, which produces new knowledge and which is no longer ashamed to be located within the academy.[2]

Neverthless, I have encountered instances over the past decade in which registrars, chairs of examiners, examiners themselves, supervising tutors and sometimes even candidates did not have a full grasp of the idea of a PaR PhD and its implications. This is understandable in so far as new ways of doing things take time to be assimilated and colleagues were feeling their way. But it is scarcely satisfactory. Through the proliferation of successful candidates over time by this mode of submission, however, protocols have now been broadly established (drawing considerably on the findings and recommendations of the various research projects) such that serious misunderstandings are, fortunately, becoming rarer. In what follows, I update the earlier project bringing to bear what I have since learned from experience and by exploring a range of issues which have caused concern. This chapter, then, primarily addresses protocols and regulatory matters. At the end of the chapter I refine what I dubbed the 'ten steps to the perfect PhD', but what follows is a 'clew' through the stages of the process.

Pre-registration

Before approaching an institution, prospective candidates should establish whether the university – and perhaps specific tutors within it – have experience of PaR PhDs. Several in the UK (and elsewhere) now have significant experience of, and an evident interest in, developing advanced study by this mode. Some have developed a taught masters programme to explore this domain and to prepare candidates for independent PhD study.[3] Depending on the area of your proposed research, you need to consider whether there is an established community of postgraduate students. If, for example, your work is collaborative, you will need student colleagues (who may by arrangement be undergraduates) with whom you might work. Individual study, such as music composition or creative writing, does not so obviously need a community but the common practice, in such domains of sharing work with peers and receiving constructive critical feedback, also requires engagement with others. If the PhD community is small, might it be possible to work within a broader taught-masters framework, or even a dynamic undergraduate community with appropriate capacity?

Interview

Following application to your chosen institution, you may face rejection on a number of grounds which do not necessarily reflect your

potential to achieve a PhD. Responsible institutions rightfully consider the resource base for students' work before they take them on. It may be that an established and experienced department simply has too many PaR students to take on others at that time, or has decided to privilege a specific aspect of practice outwith your application. Should you be under consideration, however, you should be invited for interview; though a formal interview may follow, some informal exchanges may aim initially to establish the fit between your interests and those of the institution or department. At least one of the proposed supervisors should be involved in the formal interview alongside the research degrees coordinator (or equivalent).

At interview, it is vital that your expectations of support and resources are discussed and agreed. If you are to be a full-time student in a practice, you might assume that the resources of the institution will be at your disposal whenever you need them. This is not the case. Postgraduate students need to work around the undergraduate programmes whose usually numerous students make heavy demands on resources in their term times, particularly where the department is practice-based throughout. Typically, institutions ask PhD students to plan their work so as to use spaces substantially outside undergraduate term times. If work is well planned, this should not cause problems, but planning and communication are essential. Be aware that any undergraduates you are working with may disappear during their vacations. The technical support team and those who administer space bookings will need to be consulted about – not simply told – when you want to draw upon which resources. If the institution takes on PaR PhD students, it has a responsibility to ensure they can research through practice in ways that draw more heavily on resources such as space than traditional book-based PhDs. But a mutual understanding from the outset of what is desired in relation to what is available is crucial. I would even go so far as to say that the agreed support and resource should be put in writing as a quasi-contract. Small sound/music rehearsal carrels, editing suites and IT resources all need consideration. Though it is not possible entirely to anticipate your needs before you undertake the research project, you do need to think ahead and envisage possibilities at this pre-registration stage.

Registration

The procedures for registration vary slightly in different universities but the principles are common. Typically, you will be asked to submit

to the research degrees committee (or equivalent) a formal research proposal. In some instances this is required before you enrol; in others, formal registration follows enrolment affording you a short period to work with your tutor on refining your research proposal. The proposal is likely to require a statement of: aims; objectives; methodology; key sources; and outcomes. It should also list the supervisory team and its members' roles in the project, and may also require a short contextual overview of research in your specific area of interest.

The initial response to this request – particularly from artists who like to work in open, exploratory, 'intuitive' ways – is that they cannot know at this early stage where their research is going to take them. The response is at once understandable and unhelpful. It is understandable because all research should involve a journey of inquiry and many researchers, across the disciplines, end up at a destination different from that initially envisaged. It is unhelpful because institutional constraints require a formal proposal for registration and there are compelling reasons why.

First, as noted above, institutions need to ensure that they have the resources to supervise the project and that the supervisory team is suitably experienced with appropriate expertise. There is increasing pressure on universities to ensure that students complete their programme within the specified timescale and there are penalties for not doing so.[4] This requirement is to the benefit of candidates since the history of universities is littered with those who never did achieve a PhD award. But, most important, it is a useful, though by no means easy, challenge to articulate at the outset where you think you are heading. Though it should not close down an open investigation, a thought-through account of your *research inquiry*, and what approaches (methods) you plan to use to achieve your findings, will save you time in avoiding sidetracks leading nowhere. Though it may not take you in a straight line to your destination it will lead you more directly into the interesting areas of your research.

Research question?

Partly because aspects of 'the scientific method' are occasionally enshrined in the discourse of university bureaucracy as noted, you may be asked to define your research question. This may involve no more than formulating in an interrogative form your inquiry as you have established it. However, as indicated, I prefer the term *'research*

inquiry' to 'research question' since questions may imply answers and the kinds of work typically undertaken in the PaR PhD context, while they yield findings, do not typically produce solutions to problems in the mode of answers. It is, however, essential to determine the domain of your *research inquiry* in order clearly to mark this aspect of your project from the creative practice you may customarily undertake. As indicated throughout this book, many things you do in a PaR process will be very similar to what you habitually do in making work. The key difference is that you will simultaneously and consciously be pursuing a research inquiry which is likely to require small additional tasks.

Aims and objectives

It is sometimes difficult to distinguish clearly between aims and objectives. For the purpose of a research proposal, the aims should articulate the core of the research inquiry while the objectives cover the various dimensions of activities to be undertaken to achieve the aims. Both might be expressed as bullet-points. For example:

The aim of this PaR PhD project is:

• To explore how theatre practice might be inflected to enhance the experience of those who are visually impaired or hard of hearing.

The objectives include:

• Establishing the attendance levels of the visually impaired and hard of hearing at theatre events and the levels of appreciation.
• Setting up a focus group to discuss factors influencing enjoyment or the lack of it at theatre events.
• Undertaking an investigation of arts strategies to counter sensory deprivation with particular reference to sonic and visual spectrums.
• Engagement in practical exploration of sounds and images to enhance the experience of the hard of hearing without detracting from that of the established theatre audience.
• Making theatre works to embrace findings from the experiments above.
• Testing, through the experience of inflected performances, the findings of the praxis.

Methodology and methods

The report of the UKCGE working party on research training in the creative and performing arts and design suggests that the question of methodology may simply be avoided:

> It was broadly recognised by the group that defining structured approaches to creative enquiry, and establishing methods of documentation, recording and presentation appropriate to the various arts might be more fruitful than extended philosophical debate on methodologies.[5]

Arts candidates are indeed frequently puzzled by the request to articulate a methodology. This may be because the word resonates with 'methodical' and artists prefer to conceive their work more in terms of 'intuition' and 'play' than 'method' understood as orderliness of thought. As Wilson has remarked, however,

> method and methodology are sometimes used as though they were synonyms – they aren't. Methodology is the study of methods and deals with the philosophical assumptions underlying the research process, while a method is a specific technique for data collection under those philosophical assumptions.[6]

The overall approach proposed in this book is itself a PaR methodology framed in the model (in Chapter 2) in that it involves philosophical principles and a description of generic processes. It is distinct from the quantitative methodology (of the numerical data-based sciences), and the qualitative methodology of interpretative research of the 'softer' social sciences and humanities (in which the assumption is that social reality can only be understood through social constructions such as language, consciousness and shared meanings). Like the latter, however, PaR methodology draws upon such approaches as hermeneutics and phenomenology but places even more emphasis on enactive perception in the experience of 'doing-knowing', Indeed, it is, as in Haseman's formulation, 'performative'. Taking 'method' to be distinct from 'methodology' and used in its slightly weaker sense of 'a way of proceeding or doing something', established artists have not only a PaR methodology but a range of methods.[7] However, they often overlook their methods partly because they do not typically talk about them in these terms but also because their processes are familiar, enculturated through formal and informal education.

PaR typically involves a multi-mode inquiry drawing upon a range of methods. The first is the way of proceeding with the practice itself, which may be quite precisely defined in respect, for example, of a movement praxis (based on Martha Graham, say) or the aleatory compositional method of Cunningham, Cage and Rauschenberg. For the purpose of a research inquiry, consciously disorderly or chance approaches are methods. In addition to the praxis, there is a book-based inquiry with related writings. There may be interviews, questionnaires or focus groups to establish the impact of the praxis. Modes of documentation constitute methods of capturing evidence. Though quantitative data analysis is rare in such work, qualitative data analysis is common, even if it amounts to little more than the anecdotal, drawn from post-show discussions or chats in the bar. In short, there is actually quite a bit to say about the methods of a multi-mode PaR PhD inquiry.

Research context

Research does not take place in a vacuum, however idiosyncratic your particular project. Even Bob'n'Lee's performative reiteration of their wedding vows can, as indicated in Chapter 4, be located in seminal accounts of twice-restored behaviour, theories of space/place, site-specific performance practices and so on. In a more traditional model of research, the aim is to add another small stone to the cairn built up over the years. That model is progressive and incremental and thus it is absolutely necessary to establish what is already known and what opportunity new research might have to make an additional contribution. Though my model for PaR differs in approach, there is nevertheless a context for the research. Other practitioners will undoubtedly be working in territory similar to yours. Philosophers may have opened debates which require practical inquiry or with which your investigation might resonate. Your interest in the topic may well arise from an aspect of contemporary culture. Thus it is perfectly possible, and indeed necessary, in PaR to sketch the intellectual and practical context in which your work will be undertaken.

Collaborations and industry links

Current government policy in the UK (and elsewhere), rolled out through funding mechanisms, is for research to have 'impact' in the 'real world' (as if HE institutions are the ivory towers of Arthurian

mythology). The AHRC brief for collaborative doctoral awards scheme 2012, for example, is as follows:

> Collaborative awards are intended to encourage and develop collabo-
> ration between Higher Education Institution (HEI) departments and
> non-academic organisations and businesses.
> Collaborative research studentships provide opportunities for
> doctoral students to gain first hand experience of work outside an aca-
> demic environment. The support provided by both an academic and
> non-academic supervisor enhances the employment-related skills and
> training a research student gains during the course of their award.
> The studentships also encourage and establish links that can have
> benefits for both collaborating partners, providing access to resources
> and materials, knowledge and expertise that may not otherwise
> have been available and also provide social, cultural and economic
> benefits to wider society.[8]

Though the apparent binary between an 'academic' environment and the practical world of work might be challenged along the lines of this book's advocacy of practical knowing, there are opportunities for arts PaR projects in such schemes, as instanced by an inquiry into audience immersion located at the University of Exeter.[9] Haseman has recog-nized opportunities in Australia for PaR to be, 'adopted as the principal research methodology for fields as diverse as online education, creative retail, cultural tourism, and business-to-consumer interaction'.[10]

Some academic aspects of collaboration have been discussed in respect of *Partly Cloudy, Chance of Rain* (see Chapter 4) but there are other con-cerns in respect of partnerships with university 'outsiders'. Candidates may be positioned in a range of different ways in relation to industry collaborators at different stages of a project. However complex the work required of other personnel involved during the making of an examina-ble creative artefact, it is essential that the formally enrolled candidate(s) can effectively establish their credentials with regard to the knowledge claims they are making. Clear agreements with regard to such matters as collaborators' roles, intellectual property, and creative rights should be put in place early in the project in order to forestall any later problems.

Outcomes and outcome balance

Because the submission of a thesis, bound in the form of a 'black book', is traditional for PhDs, it has not been necessary historically to state the

outcomes on registration. In arts PaR – and other multi-mode contexts – it is necessary to do so because there are variables. The final submission typically includes a written dimension bound in the traditional way. However, a substantial part of the research inquiry may have been conducted through practice with documentation of the process and product included in recorded form. The question of the proportion of writing to process/practice has been a conceptually vexed one for reasons discussed. But it is undoubtedly helpful to record the intended outcomes at the outset; for example: a written submission (including documentation of process) 30,000 to 40,000 words plus a devised theatre performance of c. 60 minutes duration. It is then clear to all that the practice is to be submitted as substantial evidence of the research inquiry.

In principle, as discussed, it is possible to submit the practice alone though, in respect of most submissions in my view, this is a brittle strategy. Music has historically been regarded as something of a special case in the UK. For a DMus or PhD in music, it has been customary, prior to the emergence of the concept of PaR, for composition or performance to constitute the substantial part of the submission accompanied by as few as 3,000 to 5,000 words by way of a commentary. But, particularly in the context of UK national research audits (RAE, REF), the various arts subject domains (Dance, Drama/Theatre, Music, Performing Arts, Visual Arts and Writing) have been drawn together to establish equivalent, if not common, approaches. For good or ill, the *evidencing of a clearly articulated research inquiry* has become the common standard and it is generally accepted that, in most submissions, there will be a significant written complement at least involving 'an exposition of the creative process' (UKCGE, 1997: 16) or 'exegesis', as it is more commonly called in Australia.[11]

Thus the balance of 50:50 (complementary writing to practice) proposed as long ago as 1997 by the UK Council for Graduate Education entailing 30,000 to 40,000 words (with the possible exception of music) has become a key marker from which different proportions might be argued. It may be, however, that the submission of a novel of 100,000 words or a series of music compositions could justifiably be accompanied by minimal (10,000 to 15,000) words – hence the need for the proportions overtly to be established and recorded at the time of formal registration. In the absence of a clear understanding of the parameters of the research inquiry and multi-mode approach, the possibility arises of undertaking two PhDs, the one involving a substantial practical inquiry and the other equivalent to a full book-based study. It is important to get a balance set at the outset (even it is subsequently adjusted)

such that there are shared expectations between student, supervisor(s) and regulators of awards.

There are instances where institutions – perhaps with an over-ardent zeal to show their commitment to PaR – have changed their regulations to limit complementary writing to a maximum of *c.*15,000 words. In my view such a limit imposes an unhelpful constraint on some candidates. Paradoxically perhaps, even those most committed to having their practice seen as the key evidence of their research inquiry find, once they begin to write about their process and contextualize it, that they have quite a bit to articulate in words. Thus, in my experience, 30,000 to 40,000 words afford a workable dimension. Much beyond this, however, the submission borders on a traditional PhD submission which may have the effect of marginalizing the practice. If, of necessity, the writing extends to 70,000 to 80,000 words it might be helpful to refigure the submission as 'practice-based' (in my taxonomy: see Chapter 1). A decision would then be needed about whether or not to submit the practice as such (live and/or recorded) based upon the question of whether experience of the practice is necessary if the research inquiry is to be fully evidenced.

Key sources (literature and practice reviews)

In research methods training, a literature review is typically proposed as a standard practice, often the first thing to be undertaken. There is a logic at work here: if a key criterion for academic research is to produce new knowledge of substantial new insights, it is necessary to know what has previously been established. Indeed, in a narrow and specific field of inquiry, it is assumed that everything previously published on the topic will be known by the researcher, and a thorough literature review is traditionally the means to achieve this end. A good literature review will, however, go beyond mere record to engage with source material and to develop a critique of previous work such that new avenues of research might be opened up.

In PaR, there are, however, two reasons why a literature review may not be the best approach. First, the field of the conceptual framework of PaR, as noted, is more typically wide and interdisciplinary rather than narrow and specific. In Chapter 4, I have addressed how such a field might be mapped, engaged with and contained. Thus, at the outset before the specificity of the research inquiry has been secured, it is difficult to locate exactly which book-based sources will prove most useful and influential. Second, to follow the logic of the literature review, it

might be more helpful, as noted, to undertake a 'practice review' to see who else is working in the chosen field and what insights their work has produced. In the requirement of my model to locate praxis in a lineage, a survey of similar practices to your own, as well as establishing the domain knowledge, assists in identifying the specificity of your praxis insights.

Whether or not you present a formal literature review in the submission, you will be expected to read and absorb the key publications (including practices in the public domain) in respect of your research inquiry. Since this is likely to be one of the first tasks to be mobilized in the research project, it is acknowledged that you will not know fully what sources will influence your work as it develops. Nevertheless, if you are registering for a PhD you will have a substantial background in the area of research and should have identified key references which you can list. Where you may be less clear is in the broader conceptual framework with the eclectic range of sources of multi-disciplinary, multi-modal PaR work. The requirement to list key sources at the outset is not, however, intended as a constraint but just an indication of the scope of the inquiry as perceived at this stage. If future praxis and reading in the process of research takes you elsewhere, the institution will not point back to your initial reference list and demand you return to it. If, however, your project takes you into a significantly different area of inquiry, it might be prudent to inform the Research Degrees Committee such that a revised title might be registered.

The programme of reading must be undertaken from the outset in parallel with other methods of research such that resonances between the practice and the reading can emerge into a conceptual framework. As Bolt summarizes this process of dialogic engagement:

> rather than operating as a solipsistic reflection on one's own practice, the particular situated knowledge that emerges through the research process has the potential to be generalized so that it sets wobbling the existing paradigms operating within a discipline. In other words, through the vehicle of exegesis, practice becomes theory generating.[12]

In my approach, ideas emerging from the programme of reading resonate with the material thinking in practice. Though abstract ideas may be more readily disseminated in words, reading and writing are not the singular vehicles for articulating ideas. The multi-mode approach of PaR

utilizes both. As Haseman and Mafe summarize, drawing on responses from their candidates:

> Around each creative work there is a wide field of possible interpretive contexts and it is in the exegesis that some of these fields can be delimited. This delimiting act, which is seldom comfortably arrived at, is the gesture which enables the candidate to make a discursive claim for the significance of his or her study.[13]

Supervision

For reasons which primarily promote the development of staff, universities are increasingly keen on teams of supervisors where, historically, PhD students typically had just one supervisor. While it is better to avoid too many people on a team because their voices may conflict unhelpfully and it is likely to prove difficult to get them all together, for PaR it may be helpful to have a couple of supervisors with different kinds of expertise. There may, for example, be a supervisor with good experience of the kind of practice in which you will be engaged and another who can help develop a structure and conceptual framework. Because practice-based advance study is relatively new in higher education, there are fewer tutors who themselves hold PaR doctorates as distinct from other arts and humanities methodologies and disciplines. At least one person on the supervisory team should hold a doctorate and ideally the team overall should have significant experience of supervising PhDs to completion (most registration procedures require the latter).

To achieve the right balance for a PaR PhD project, it might be necessary to have a team of two or three supervisors, one of whom might act as a mentor to the tutors and/or an advisor on the project rather than a full supervisor. There is no fixed standard for the number of tutorial meetings but, in the first six months while your project is getting under way, you might expect to have a tutorial about once per month. A difference from standard written PhDs is that tutors will, on occasion, see practical work in progress in addition to reviewing drafts of writing as a basis for tutorials.[14] A working relationship needs to be established which suits all parties but tutors are not – and cannot properly be – collaborators, so they should not be expected to be contributing to the development of the practice to any great extent.

A key function of the supervisor of any PhD project is to ask the right questions at the right time and assist the candidate in seeing the line through the research inquiry which is leading to new insights. This is

particularly important in a PaR PhD because of its multi-modality and complexity. Assisting in making the tacit explicit by gently but persistently ensuring profound reflexivity, and guiding towards establishing the resonances between the praxis at the heart of the PhD and its other dimensions, partly by suggesting reading, are key. Supervisors need to make parallel moves from insider to outsider, understanding the practice to some extent from within but sustaining a critical distance to afford outsider perspectives (not just how they see it but how others might experience it).

Given that PaR PhDs pose challenges to supervisors as well as students as this book has pointed out, it would be helpful if universities had an available system of 'relationship counselling' available to address what to do if it looks as if things might go badly wrong.[15]

Monitoring

Once you are registered and your project is under way, your progress will be kept under review. Most institutions have a set process for this purpose, with an annual review typically involving somebody outwith the supervisory team such that, if things are not progressing well, an outside view can be taken to protect the interests of both the university and the candidate. If there are problems of any kind, the earlier they can be identified and addressed the better. Quite often the initial registration is for MPhil/PhD such that an upgrade to full PhD registration is required, again typically with a published procedure for the purpose within each institution.

Submission for examination

By an informal consensus in the UK, ephemeral practice in the context of PaR PhD must be experienced live by the examiners. A permanent record (typically on DVD) is bound into the hard-copy 'black-book' submission, usually in the front to distinguish it from an appendix and to militate against its marginalization in these terms. Since it is customary for the practice to be shown live perhaps six months prior to the final viva voce, examiners must be appointed earlier than for traditional written PhDs.

Appointment of examiners

The protocols for appointing examiners in most institutions are traditional, possible examiners being formally proposed to research degrees

committees three months prior to the anticipated submission. In PaR, however, the showing of the practice with examiners present may take place some time before the submission of the complementary writing, and thus examiners need to be appointed significantly earlier. Though it is the institution's and the tutors' responsibility to ensure the appointments are made according to due procedure but at the appropriate time, it is as well that students are aware of the issues. Typically, no additional fee is paid to examiners to visit twice, once for the showing of work and a second time for the viva voce, though expenses for both visits are usually paid. Prospective examiners must thus be prepared to commit additional time and take on extra work, as it were. Indeed, it is important to appoint examiners who are known to be sympathetic to PaR, particularly since some individuals even within the arts community remain sceptical about, if not actually hostile to, such projects. By 'sympathetic', I do not mean examiners who will give the candidates an easy time but those who accept that modes of knowledge or knowing are possible through praxis. Both the PARIP and AVPhD initiatives in the UK sought to establish directories of such people and, though they were never fully achieved, the websites might afford some indication of people who have been active in the PaR initiative.

Time lag between showing of practice and the submission of complementary writing

It is very important that the time between the showing of work and the submission of the complementary writing (and subsequent viva voce) does not exceed much more than six months, with a twelve-month gap an absolute maximum. In one very unhappy experience where I was an external examiner, more than two years elapsed. Assuming the candidate had withdrawn, I was astonished suddenly to get a letter informing me that I should shortly be receiving the complementary writing, as if this were not a problem. In actuality, had the practice been less profound, the examiners might well have forgotten it, and, after such a time, the freshness of impact of the experience had, of course, diminished. If we believe ephemeral work must be experienced live in the light of its singularity and that, in Phelan's formulation, it is characterized by 'disappearance', then it makes little sense to allow a substantial time lapse in a PaR PhD context.[16] For the sake of the (strong) student who was by no means solely responsible for the delay, we proceeded with the *viva* to a successful outcome, but it was necessary formally to register with the institution that this was not 'best practice'.

In my view it is wholly unacceptable practice unless serious illness, or some other major mitigating factor, is at issue. Indeed, the more I think about it, the less convinced I am about the need for a time lapse. The tacit argument has been that time is needed prior to a viva voce examination for reflection after the absorbing business of rehearsing and showing the practice. While there might be something in this, many of the research insights come from reflection on the process. In most cases, the piece has been shown prior to the examination event to audiences who have given feedback on their experience. So, even where claims needing documentation are made about the impact of the work, this is possible in advance of the final showing to examiners and might already be written up.

Thus, the ideal model might be the submission of the complementary writing prior to the showing of the work live, with the viva voce the following day. In the single instance of this approach in my own experience, a music PaR PhD involving a piano performance, the compositions, treatment and performance were recorded in advance on CD and submitted with the complementary writing, though the examiners also experienced the performance live. The viva voce, on the following day, found all those involved on top of all the material of the thesis, there having been a minimal time lag. The candidate had recovered overnight from the exigencies of performance, and it is clearly necessary to leave a little time between the showing – even if the candidate is not actually performing – and the oral examination. In addition to audio playback, a keyboard was made available, and considerably used, in the examination room, in the process of the interrogation and defence of the thesis. The outcome was successful in the literal sense of the recommendation of the award of PhD but also in terms of a good experience for all concerned, including the independent chair who, though not a musician, was fascinated by the discussion and practical investigation being taken right through to the oral examination. Though by no means the driver of this procedure, involving the examiners in only one visit and not disrupting established protocols of examiner appointments are additional benefits.

Though the above model may not suit all situations, I strongly recommend that, as a community, we revisit the now sedimenting habit of holding the viva voce some time after the showing of work. If, as I advocate in Chapter 2, reading and writing are intertwined in the other practices throughout the research inquiry, it may well be possible for the written submission to precede the showing as in the model above. I repeat my note of warning that the only methodologically problematic

PaR PhDs I have encountered are those where the conceptual framework appears not to have been interwoven into the research praxis, but sought somewhat after the event of the practice. Given that many PhDs, by all modes, are subject to minor modifications, or small rewrites, as a result of the viva voce, anything of significance to emerge from the oral examination might be added subsequently, to the satisfaction of both the candidate and the examiners.

Protocols for post-showing conversations

Assuming, however, that examiners visit to experience the work on an occasion earlier than the final viva voce examination, questions have emerged about the formal status of any post-show conversation. Without undue disregard of proprieties – and because candidates and examiners alike are human beings – it is typically deemed appropriate for a brief meeting between examiners and the candidate to afford an opportunity for points of clarification to be made. It should be clearly established in advance that this meeting is not the place for the robust interrogation and defence of the thesis, which is the business of the final viva voce examination. But, in my experience, it is helpful to have a brief conversation (15 minutes at most).

Suppose, for example, that in a dance piece a performer twists an ankle in the opening of the piece and is forced to withdraw leaving the other performers to improvise; or suppose that in a piece heavily dependent upon precise visual style a lamp has blown in the course of the showing leaving the space in semi-darkness; or suppose an internet connection has dropped during a piece exploring intermedial relations between the live and the mediated through telematics. In a tried and tested practice of examination of final-year undergraduate arts practices, the opening post-presentation question was always: 'Did that showing go technically as intended?' My sense is that candidates welcome the opportunity to inform the examiners of any factors adversely affecting the event as they would want it to be experienced. Should they have no contact whatsoever with the examiners, they may be left anxious for some months about what they will imagine to be a false impression of their work. And the conversation might go a little beyond pure technicalities in this respect.

The above procedure takes the human angle. A more instrumental procedural perspective rife in today's university contexts is based in institutional fear of appeals against failure in an increasingly litigious society – hence the requirement for an 'independent chair' or even

recordings of viva voce examinations. From such a perspective, the informal conversation recounted above is fraught with dangers. Indeed, on one occasion, my fellow external examiner and I were chaperoned and, though a conversation with the candidate was allowed, some of our (innocuous) questions were interrupted and disallowed. In my view this was unnecessary and inappropriate. But, having sat on appeals panels where the candidate arrives with her solicitor, I do understand the institutional concern. According to typical university rules, appeals can be made only against procedure, not against judgements, which makes it all the more important that procedures – including those for informal meetings such as the above – are made clear in advance and understood, and adhered to, by all parties. All this said, I still prefer to have an informal meeting and to trust the professionalism of the examiners not to overstep the mark between post-showing conversation and robust interrogation and defence of the thesis.

Viva voce examinations

As indicated, a practice has emerged of either recording viva voce examinations or having an 'independent chair', typically somebody from within the candidate's institution but from another discipline. The key point is that the chairperson has had no involvement with the candidate and the supervision of her thesis. Personally, I should not be prepared to conduct a viva voce examination before a video camera because I hold that it might well inhibit the process. Others must make their own judgements. Independent chairs, in contrast, can be helpful in moving things on if it becomes evident that a sustained line of questioning is not likely to produce any further helpful response.

It must be acknowledged that some examiners can, on occasion, become preoccupied with their own agenda (with the thesis they might have produced) rather than with the candidate's submission. On rare occasions, the examiners might take different perspectives on the thesis or, indeed, the broader intellectual agenda. If the viva voce is drifting off course, it is helpful to all, but particularly to the candidate, for the independent chair lightly to intervene. The role of the independent chair is to ensure 'fair play' and that the examination is conducted in accordance with the university's published procedure. Chairs will have undergone training to this end and will be experienced in viva voce examination. Thus, while there is an element of the institution protecting itself from any possible appeal against the final judgement of the examiners, the candidate might take reassurance from the proper

exercise of the independent chair role which is, in part, to support and, if necessary, protect them through this ordeal.

All this said, most PaR PhD viva voce examinations involve robust and productive conversations, sometimes with bits of practical demonstration (sometimes live as in the example above) or the replaying of audio or visual material. Thus, another difference from traditional book-based PhDs is that that the examination space may need to have playback kit available, and this needs to be mobilized initially in a dialogue between candidates and supervisors. It usually falls to the director of studies to book the space, ensure that such kit is available, and that water and any other appropriate refreshments are ordered in advance.

Mock viva voce examinations

Many universities now require students to be afforded a 'mock *viva*' prior to the formal event itself. Best held perhaps a week before the oral examination proper, the mock *viva* is not intended as a prefiguration of the actual *viva* in respect of precise questions but more in terms of rehearsing the experience of a rigorous conversation. Nevertheless, it might expose areas of the thesis open to an interrogation from perspectives the candidate has not considered and it may avoid a sense of panic on the day to be aware of such questions and be prepared to deal with them. No PhD can be expected to have all the answers or all the angles covered. A week allows the candidate time to look into any directly relevant fresh angles and to get a sense of her own achievement, knowing it is legitimate to acknowledge gaps or areas for further research in future. If a mock *viva* accordingly affords confidence, it must be a helpful part of the process.

Collaborative practice vivas

Much professional contemporary arts practice involves collaboration. From devised performance companies who make their work through a collaborative exploration of materials (Wooster Group, Forced Entertainment, Complicité) through to interdisciplinary collaborations between, for example, dancers and musicians/technologists (Shobana Jeyasingh with Michael Nyman/ Graham Fitkin/Laurie Booth, or Robert Lepage with Ex Machina), contemporary artists work together and across disciplinary boundaries. It is thus surprising not that there have been collaborative PhDs but that, to date, there are relatively few. The reason may well be that knowledge in an individualist tradition is assumed to be created and owned by individuals and PhDs are customarily awarded

to individuals even though, in the experimental science tradition, for example, many people may work together on a research project.

For the examination of Lee'n'Bob's PhDs (see Chapter 4), the university rules required an internal and external examiner for each candidate. Because of the challenging mode, it was prudent to appoint esteemed and experienced external examiners (Professors Baz Kershaw and Mike Pearson) who, along with the internal examiners, attended the event. The examining team members subsequently agreed among themselves that they wished to conduct viva voce examinations separately with each of the candidates (each was seen by a separate pair of examiners) and to establish that both candidates had made a distinctive PhD-worthy contribution, and together (the two candidates with all the examiners), to probe the workings of the collaboration. Though it was a slightly protracted process for all concerned, justice was both done and seen to be done. We were all conscious that we might be setting a pattern for any such collaborative submissions in future. There is one bound 'black book' with Joanne Whalley and Lee Miller named in gold on its spine, which incorporates a DVD record of the multi-dimensional performance across different locations (on the M6 motorway services site) with supporting material. Prior to the formal examination, the examiners were invited to peruse an exhibition of documentation mounted by Bob'n'Lee on campus.

Rewrites/resubmission of practice

As noted, it is not uncommon for minor amendments and/or minor rewrites to be required before formal recommendation by the examiners of the award of PhD, with resubmission usually within six months. Most regulatory frameworks also allow for a more substantial rewrite of part of the thesis, typically with resubmission within twelve months. The question then arises with PaR PhDs of whether a resubmission of the practice might legitimately be required. Given the emphasis on the integrity of the practice and the complementary writing together constituting the thesis, the answer must be affirmative. Though I have not been directly involved in making such a requirement, I know of examiners who have done so and support their action as a matter of principle. We cannot refuse this option because it may be logistically very challenging since we wish to claim that the thesis is evidenced in the practice. It may be that recognition of deficiencies in the practice might be satisfactorily accounted for in the critical reflection of the complementary writing, but it has to be allowed that the practice might

be inadequate and need to be revised and resubmitted, particularly if the research inquiry is not evident in the practice.

Technique, technical proficiency, virtuosity

Because there is a small but significant difference between the *research inquiry* and the arts practice, the practice itself does not necessarily need to be original (in the sense that nothing like it has ever been previously experienced) nor at the highest level of professional production values. For some projects, high levels of technical skill are required among other qualities. For example, in Irving's clavichord performance of Mozart cited in Chapter 1, deep practical knowing through experience of playing the Mozart canon and keyboard expertise well beyond basic proficiency are necessary to appreciate the 'feel' of the instrument and interpret its implications. Without such advanced knowledge and technique, the research inquiry simply could not be successfully conducted. Other projects require neither high levels of technique nor the highest professional production values, though approximation to these might typically be expected. Mastery of technique needs to be adequate to the *articulation of the research inquiry*, and the need for the highest levels of proficiency will depend upon the nature of the inquiry and the kinds of evidence required.

Ten steps to the perfect PhD

In the report written ten years ago, we concluded with ten steps to the perfect PhD. The headlines were as follows:

- Agree terms of research with department.
- Ensure relevant institutional guidelines.
- Select appropriate supervisors.
- Research a basic grounding of PaR issues.
- Be a proactive student.
- Identify how practical inquiry will relate to the research.
- Be aware of practical constraints on a PhD.
- Beware of submission demands.
- Ensure that examiners recognize the definition of PaR being used by the institution and the student.

From the account above, it will be apparent that these all still hold good, though they reflect their time in placing emphasis on the need

to be clear about regulatory frameworks and protocols. After a decade of development of the domain and of personal experience of supervising and examining a number of PaR PhDs, I formulate them slightly differently:

1. Identify a research inquiry which can only be articulated through a practice (but is not necessarily coterminous with that practice).
2. Identify an appropriate institution, and ideally a specific supervisor, for the location of your PhD.
3. Be aware of the national (and global) arts PaR initiative, recognizing that it remains in development and that your specific project may make a contribution to the overall domain (in addition to other specific research findings).
4. Ask yourself before you make an application if your project is, of necessity, a PaR PhD and what kinds of 'substantial new insight' it might produce. PaR is not an easy option.
5. Think ahead about your likely requirements by way of institutional support and ensure agreement (ideally in writing) prior to enrolment.
6. Alongside drawing up your research proposal, map out a timeline for the duration of your proposed study. It should mark: periods of small-scale experimental practice and of more intensive practice; strategies of documentation; periods of book-based research and exploration of practices similar to your own; periods of critical reflection aiming to make connections between the dimensions of your inquiry; an intended date of showing and final examination.
7. Engage throughout in praxis (theory imbricated within practice) by ensuring that your book-based inquiry runs in parallel with your practical inquiry such that different modes of knowing can resonate with each other.
8. Prepare for documentation by a range of different modes, editing as you proceed wherever possible.
9. Review your progress at six-monthly intervals to ensure that you are producing evidence of your research inquiry and avoiding undertaking more than one PhD both in respect of overall scope and in respect of multidimensionality. In the final year, clarify the 'substantial new insights' you have produced.
10. Be aware of: the possible need to appoint examiners early; the need to appoint 'sympathetic' examiners; the need to avoid undue delay between the showing of praxis, the submission of complementary writing and the final viva voce examination.

At the beginning of this book, I proposed to be as direct and clear as possible about the phenomenon of 'Practice as Research'. In giving a detailed account of the range of considerations and the potential pitfalls, I hope that I have not made PaR seem too daunting an undertaking. Any PhD project requires commitment and the right conditions in which to work. PaR simply has specificities of its own in respect of facilities and working conditions. If these are established at the outset, progress should be relatively smooth and, if the scope of the project is defined and refined under monitoring, the aim should be readily achievable in the allotted time span.

The very positive aspect of PaR is that it allows a broader range of people to engage in scholarly activity once the possibility of practical knowing is recognized. It affords arts practitioners the opportunity to undertake study at the highest level and to achieve the award of PhD without abandoning their practice for an entirely logocentric approach. In my view PaR has accordingly enriched 'the academy' in the process of embracing an additional range of highly intelligent and creative people whose articulation of their understanding happens to be made manifest better in actions rather than in words. As I hope to have shown, though the methodology may be different from that of the sciences, the rigour of PaR can be equivalent to that of more established knowledge-producing traditions.

Though the processes of PaR undoubtedly involve having fun, I would not want to claim enjoyment as a merit confined solely to this approach. All researchers, through their deep interests in their chosen domain of study, should derive pleasure from their efforts, even if, to outside observers, the pleasures may on occasion seem perverse. Because of their colourfulness and overt connection with leisure and pleasure, however, arts practices may appear primarily delightful. It is for this reason, perhaps, that research in this domain has been deemed to be frivolous in contrast with the seriousness of science. Much contemporary thought has, however, shown us that dualities are unhelpful. In a complex world, 'complexity thinking' is required to deal with conditions which are not merely undecidable but which simultaneously involve inhabiting two conflicting states – virtual and actual worlds, for example.

Increasing recognition that knowing is a matter of doing as much as a matter of facts has opened spaces for knowing in which performatives can make substantial contributions, both conceptual and actual. PaR has moved into these spaces to the benefit of all those whose minds and bodies are open to new modes of perception and new ways of understanding how knowledge might be generated and disseminated beyond (though not excluding) the written word.

Part II
Regional Perspectives

6
Aotearoa/New Zealand and Practice as Research

Suzanne Little

As I write this chapter, arts academics throughout Aotearoa/New Zealand are preparing their 'evidence portfolios' (EPs) for the 2012 Performance-Based Research Fund (PBRF) round as instituted by the national Tertiary Education Organisation (TEO). The performance referred to in PBRF is the more prosaic meaning of the word, referring to working effectiveness and assessable accomplishments. In PBRF this is measured through 'quality evaluation' of research outputs, the number of student degree completions within departments and the wider university and, the amount of external research income attracted within the given five-year period. A large percentage of government funding and overall university rankings is determined through the PBRF process. As such, universities are pitted against each other in a race for the best funding and the most prestigious ranking. The process invariably filters down to individual academic staff with the pressure to procure the highest possible individual grade for their own research and in turn lift the ranking of their university. At the moment to be considered non-research-active in an Aotearoa/New Zealand university may be tantamount to being *persona non grata*. With seemingly every university and academic focused on research ranking and assessment it is an appropriate time to pause and reflect on Practice as Research (hereafter PaR) and its place within Aotearoa/New Zealand.

In this chapter, I offer a broad picture of PaR activity and its level of acceptance in Aotearoa/New Zealand, moving from discussion of how research is assessed on a national level through to instances of PaR practices in the visual and performing arts. Unlike the United Kingdom and our close neighbour, Australia, little has been written about PaR and its proponents and methods in Aotearoa/New Zealand as a whole. In fact there is no sense of a national PaR community despite the

comparatively small size of the country. In many ways, PaR is still in its infancy here, or a practice that occurs behind the closed doors of select university departments. The possible reasons for this are numerous but perhaps the most obvious can be found at the national level in the culture of the aforementioned PBRF assessment and ranking system.

Practice as Research (PAR) and the Performance-Based Research Fund (PBRF)

While it is increasingly possible to undertake a PaR PhD, a masters (MA) and in some cases an honours and undergraduate project in Aotearoa/ New Zealand, it is very difficult for practitioner academics to have their own post-degree PaR work recognized as 'quality outputs' within the current PBRF system. This creates an odd split or short-circuiting of PaR, placing it as something that can be done within a formal degree system but not something that can be done and readily recognized and accepted beyond that system. This is not a problem unique to Aotearoa/ New Zealand. Luke Jaaniste and Bradley Haseman identify similar issues arising within Australia and advocate the possibility for PaR arts research to fulfil an important role in the broader realm of contemporary innovation.[1] This may prove to be a valuable pathway. However, it is not the only pathway open to Australian PaR academics. The current Australian Excellence in Research Initiative (ERA), responsible for ranking researching outputs, does recognize PaR work within its assessment guidelines. In recent rounds, non-traditional research outputs (NTROs), which include performance and other art works, featured strongly in assessments of academics in the creative and performing arts. The situation in Aotearoa/New Zealand is different.

In his 2008 review of PBRF, Adams described 'the model underlying the PBRF assessment' as 'one that resonates most strongly with a conventional western scientific paradigm'.[2] While Adams did not consider this a criticism, he did suggest that it might be 'less consonant' with research and cultural practices that are outside that paradigm including Māori and Pasifica, the social sciences and the 'humanities and creative arts'.[3] Perhaps unsurprisingly, the national research assessment authority seems to favour traditional written peer-reviewed forms of research. Performance and other creative works are, however, viewed as valid nominated research outputs (NROs). But the ways in which these are measured are problematic and arguably in direct opposition to a PaR ethos.

The Creative and Performing Arts (CPA) PBRF panel assesses design, ranging from fashion through to game design; music, literary and

other arts, including a diverse array from performance through to programming film festivals; theatre, dance, film and multimedia, the visual arts and crafts; as well as pedagogy, history and other studies related to each discipline. The CPA panel-specific guidelines document for the upcoming round contains conflicting ideas:

> Original creative work is in and of itself considered to be research and fulfils the criteria of the PBRF definition of research where it results in the generation of new knowledge, in an enriched sense of the possibilities of the art form, or communicates in a meaningful and profound way through an artistic medium.[4]

The above statement would appear to be inclusive of PaR projects but later paragraphs suggest otherwise. The Australian ERA system requires researchers to provide peer reviews and a statement outlining the research background, contribution to new knowledge or innovation, and evidence of research significance and excellence. The Aotearoa/ New Zealand equivalent, however, warns:

> It is the excellence of the creative output itself which is relevant to PBRF. Documented links to orthodox academic research, where relevant in some way to the character of a particular NRO, may be useful but they are not always necessary and are of secondary importance.[5]

This may be read as a bold assertion that the creative work is a research output capable of embodying knowledge and therefore requiring no written support. However, while a short accompanying text is required in PBRF assessment, the reality is that the 'excellence' referred to in the above statement is narrowly assessed according to criteria that for the most part place quality assurance processes outside the academic realm.

The official *Performance-Based Research Fund Quality Evaluation Guidelines 2012* for the CPA panel provides a list of examples of quality-assurance criteria:

- Exhibitions in or acquisition by national or international institutions.
- Inclusion in national or international festivals, biennales, etc.
- Publication in credible literary journals or by credible publishers. broadcast on national or international television or radio.

- Performances with or by a major professional ensemble.
- Concerts promoted within an established professional series.
- CDs on recognized labels.
- Patents.
- Exhibition in a recognized dealer gallery.
- Commission by a recognized institution.
- Commercialisation of a design.
- Recognized awards and prizes.[6]

The examples for non-quality-assured research outputs are listed as including:

- Web design on the internet.
- Presentation in alternative fora.
- Documented ephemera.
- Concerts in series that contain a high proportion of amateur groups.
- Concerts presented by, or exhibitions within, the staff member's own institution.[7]

As such, the research requirement appears to be overlooked in favour of outputs that demonstrate excellence through commercial success, industry esteem and/or the perceived 'quality' of the performance or exhibition venue. The assessment also excludes any performances or exhibitions taking place in the academic's own institution (unless such works also meet the criteria in the approved assurance category). This is a particularly strange ruling given that universities are usually the national centres for performance and creative arts research and afford staff members the facilities to conduct laboratory arts research.

The problem appears to be at a definitional level and reflects some of the difficulties involved in identifying the differences between PaR and art per se. Nelson argues that PaR activity may be 'identical with art activity in key and necessary aspects' and that the differences between the two appear more commonly in 'such matters as intention and context'.[8] The 'reflective and reflexive intent of Practice as Research is directed within and at the academy rather than within and at the art world itself, even though the boundary between the domains may be increasingly blurred'.[9] Where artistic practice may serve singularly to develop the personal practice of the individual artist or be used purely to create an art object, PaR activity involves an aim to conduct research, adoption of certain strategies and methods and usually the intention

and requirement to add to a shared knowledge.[10] As such, the objectives, focus, outcomes and audience for PaR projects are shaped by a research imperative and context. Both the Australian (ERA) and United Kingdom (RAE/REF) equivalents of PBRF assess creative- and performing-arts PaR outputs broadly in terms of significance, originality and rigour in keeping with the same criteria used for examining doctoral projects. While these aspects are key in assessing the majority of other PBRF outcomes in Aotearoa/New Zealand, different criteria, drawn from the art world and industry, as listed above, apply to nominated performances and artworks.

It should be noted that the current CPA guidelines do not appear to favour those who would benefit from an industry esteem/commercial success system of quality either. In Adams 2008 external review of PBRF, a head of department in the creative arts was quoted as saying 'the best Jazz musician in the country doesn't get above "C".'

Undoubtedly, PaR challenges traditional ideas of research and we are yet to see whether Haseman's more controversial identification of a third research paradigm, that of 'performative research', will enter the wider research vocabulary (2006). Nevertheless, PaR is an accepted form of research inquiry in postgraduate and undergraduate arts degrees in a number of Aotearoa/New Zealand universities and technical colleges. The schism at PBRF level is odd and, I would argue, is partly indicative of the mixed definitions, understandings and applications of PaR in this country and the lack of an integrated PaR academic community capable of lobbying for changes. Until recently, there was no specialist representative for theatre studies on the CPA panel and there has never been a dedicated dance specialist. More still needs to be done to ensure not only adequate representation for all the arts on the panel but also, and perhaps more pressingly, to address the definitional inconsistencies and inappropriate assessment criteria.

Practice and performance as research in Aotearoa/ New Zealand creative- and performing-arts degree programmes

The inability of the current PBRF system to accommodate PaR has an impact on how it is perceived, valued and accommodated in undergraduate and postgraduate degrees in Aotearoa/New Zealand universities and polytechnics and vice versa. While in the UK and Australia the terms 'Practice as Research', 'Practice as Research in Performance' and 'Practice-Led Research' are consistently used, in this country there is no agreed

overall term for this type of methodology. While dance academics tend to talk in terms of 'practice-led' research, those in theatre refer more to PaR or PARIP, often to describe the same or similar practices and philosophies. All usages are sympathetic to the definition of PaR outlined in this book. Official university documents and regulations for degrees often do not use such terms at all, referring instead to 'creative practice' as study, such as described in the postgraduate prospectus for the National Institute of Creative Arts and Industries within Auckland University.

A creative-practice PhD differs from a standard PhD in that it allows new cultural and artistic knowledge to be embodied or expressed through media other than text, along with a rigorous scholarly analysis of the significance of this knowledge in a 60,000-word thesis.[11]

This suggests unease with the terminology and to an extent also ideas of quantifiable knowledge and a traditional reliance on the assumed immediacy of words. The latter is reflected, in Auckland's case, in the requirement of such a large verbal exegesis and lack of faith in other practices (see Chapter 8). It is worth noting that the University of Auckland only introduced the option to undertake assessable creative practice within a postgraduate degree in January 2011, suggesting it has taken some time for PaR to be recognized at all within that institution. Other universities, such as Victoria and Otago, where PaR has been established for a longer period, do not require such large written components. A PhD in creative writing at Victoria typically involves a 60:40 split between the creative component and the exegesis respectively, with the word count for the latter estimated at about 30,000 words.

This disparity may be partly attributable to the 1960s national policy decision to allow music to be taught in a vocational or professional conservatoire setting within the university, while other arts such as theatre and dance would adhere to more traditional academic study modes. This split between 'practical' and 'academic' study is perhaps best illustrated within the University of Otago's Department of Music and Theatre Studies. While it is possible to undertake PaR masters degrees and PhDs within either music or theatre studies, to date there have been no PaR graduates in music. Those wishing to undertake practice as part of their degree enrol instead in the 'professionally' oriented Doctor of Musical Arts course. The theatre studies course, in the same department, however, actively promotes the PaR route.

The University of Canterbury's theatre and film studies programme is another interesting example. The programme is progressive and its practitioner-researchers regularly produce some of the most interesting

contemporary performance in the country. As with most theatre studies courses in Aotearoa/New Zealand, at Canterbury there is a roughly even balance between practical and written assessment with the expectation that each dimension is imbricated within the other, as in Nelson's model. The head of programme at Canterbury, Sharon Mazer, explains:

> All of our courses, beginning at stage one, carry an expectation that students will use the theories and models presented in lectures, tutorials and readings, etc., as a basis for their practical experiments in theatre and film. And vice versa.[12]

While this may be setting the preliminary ground for developing PaR or PARIP postgraduate study, Canterbury paradoxically stops short of allowing students to undertake a fully realized PaR MA or PhD. While Canterbury film and theatre postgraduate students 'often develop practical projects as the experimental portion of their thesis research, generating material for a chapter (or more)', Mazer explains, it is only 'the written thesis that is assessed'.[13] For Canterbury theatre academics, the place to assess postgraduate performance is strictly within a proposed Master of Fine Arts (MFA), which Mazer claims would 'reverse this practice for selected candidates'.[14] Thus while students undertake research into and about performance, PaR as it is defined in this book is not yet considered a viable option and indeed, in ways similar to the PBRF principles, there is a division between research and performance.

Other Aotearoa/New Zealand theatre studies programmes such as those at Victoria University in Wellington and the University of Otago in Dunedin do offer PaR as a viable study option at honours, masters and doctorate levels. As with their counterparts at Canterbury and Auckland Universities, students at Victoria and Otago undertake undergraduate degrees that combine practical performance research with written research. Victoria University, working in conjunction with the national drama school, Toi Whakari, offers a two-year Master of Theatre Arts degree (MTA), which accommodates PaR outcomes.

In recent years Otago and Victoria universities have produced a few PaR MA and PhD students in theatre or performance-related studies. In an email to the author, Victoria University lecturers Megan Evans and David O'Donnell described PaR student work at their university. Recent projects have including a dance-related MA involving reconstructing Baroque dance from contemporary notation and a PhD where the student created site-specific work and submitted this alongside a video recording of development workshops and a written exegesis.

More recently, at the University of Otago one student, Erica Newlands, submitted a PaR MA in which she worked to develop a new bicultural theatre devising process and ethos in conjunction with a '*kaupapa Māori*' (Māori platform or philosophy) research philosophy and framework. Aotearoa/New Zealand is considered a bicultural nation and the influence of Māori philosophy and research practices can be found in a number of PaR projects, including those conducted by '*Pākehā*' (those identified as being of European descent). I will return to this context in the next section.

In sum, the employment of PaR in theatre studies degree programmes is still in its emergent stage and differs in uptake from university to university. Thus, expertise and support are somewhat limited, meaning that assessors for the projects are typically drawn from Otago and Victoria universities or Australian universities.

The situation in dance and the visual arts is a little different. At the top of Aotearoa/New Zealand's North Island, Massey University's School of Visual and Material Culture offers an MPhil by thesis or written exegesis combined with 'informed creative work' but offers a PhD by thesis only. Otago Polytechnic offers a visual art MFA in which a studio research project and written dissertation are submitted. Students undertaking postgraduate dance degrees at Auckland or Otago universities are able to undertake a PaR PhD. Auckland University's faculty, the National Institute of Creative Arts and Industries (NICAI), has a reputation for producing PaR work in dance. Senior Lecturer Carol Brown completed one of the first doctorates through practice at Surrey University in the United Kingdom in 1994. She has supervised five other doctorates through practice in Aotearoa/New Zealand and the United Kingdom since then. Mark Harvey, Brown's colleague in dance at NICAI, explained that they have offered a 'practice-led' Masters since 2000 and are now offering the option at PhD level.[15] Harvey and another colleague, Alys Longley, have recently completed their own doctorates using practice-led research and continue to use PaR in ongoing creative projects.[16]

PaR pedagogies and methodologies in bicultural Aotearoa/ New Zealand

The lack of a coherent PaR community and support from the national Performance-Based Research Fund (PBRF) assessment scheme has meant that full development of an emergent PaR in this country has been stifled. This situation might have a double negative impact. The work of

some practitioner-researchers in Aotearoa/New Zealand resonates with what might be called European models of PaR and might have further impact worldwide but other work consciously draws upon indigenous culture. Indeed, a case might be made for the particular appropriateness of PaR approaches to enhance a distinctive culture in bicultural Aotearoa/New Zealand.

Hilary Halba, a University of Otago theatre studies lecturer, has conducted extensive research into Aotearoa/New Zealand's bicultural status and her work provides an interesting example as to how bicultural practices and philosophies can underpin and inspire culturally responsible and responsive research approaches. Halba's research into biculturalism and its foundations in Māori protocols and beliefs has led her to develop PaR projects which explore how biculturalism may inform intercultural processes and performances[17] and, how it may be embedded in pedagogical practices such as those employed in her own Bicultural Theatre course.[18]

The Treaty of Waitangi, signed by Māori chiefs and the British crown representative William Hobson in 1840, is a contested text in terms of translation. Nevertheless, the treaty remains a 'foundational document' for Aotearaoa/New Zealand and 'an instrument for defining bicultural processes – and arguably in defining any processes — that occur in this country'.[19] Halba explains the principles of the Treaty and how she has embedded these within her teaching and research practice:

> The Treaty encodes a way for two cultures to share a land in that spirit of reciprocity. I argue that principles of partnership, consultation, active protection and, indeed reciprocity are fundamental in any bicultural enactment in Aotearoa . . . I propose a means whereby they are acknowledged in teaching bicultural theatre, which method hinges on valuing and adhering to 'tikanga Māori' (Māori protocols, the correct way to do things in Māori contexts) and *kaupapa Māori* alongside aspects of theatre praxis and theory.[20]

Kaupapa Māori is counter-hegemonic in its aim to challenge, question and critique '*Pākehā* culture'.[21] It is sceptical about words, preferring the palpability of deeds and thus Nelson's PaR model involving a dialogic negotiation between practices of all kinds including writing without privileging one over the other has specific potential in Aotearoa/New Zealand's bicultural context.

In preparing to apply a Māori framework to the teaching of Bicultural Theatre, Halba consulted with staff within the university's School of

Māori, Pacific and Indigenous Studies, *'tāngata whenua'* (indigenous owners of the land) and a representative of the local *'iwi'* (tribal group).[22] In the course, students introduce themselves to the group through the Māori process of *'mihimihi'* (speeches) by indicating their 'affiliated landforms and ancestors'.[23] There is a strong emphasis on embodied knowledge in *kaupapa Māori* which lends itself to a PaR approach progressively deepened in the course, where students are 'invited to use their bodies to examine and perform discourse, including ideas to do with the Treaty itself'.[24] PaR can mobilize the introduction of a non-Western research lens and the ethos and practices of collaborative, community-centred practice to address the urgent cultural need to 'refocus students' assumptions to do with knowledge acquisition'.[25] The final assignment is a class-devised piece of theatre, a praxis articulating 'personal and cultural identity or identities'.[26]

PaR has great potential for facilitating cultural cohesion within bicultural Aotearoa/New Zealand through bringing differing discursive modes into negotiation. But there are other effective deployments of the performative paradigm also in play in respect of intercultural relations. Where Halba pursues PaR from the position of one born in Aotearoa/New Zealand, Peter Falkenberg of Canterbury University conducts PaR from the perspective of a German immigrant. Falkenberg also addresses issues of Māori and national identity. In the 2001 bicultural opera *Footprints/Tapuawae*, Falkenberg set his own interpretation of a Germanic myth, contained in Wagner's *Ring* cycle, alongside Taiporoutu Huata's staging of a Māori myth with the intention 'to create a dialectical theatre in which the otherness of Māori and European cultural identity — both in myth and aesthetic form — became strands to be interwoven but not merged'.[27]

Where Halba's bicultural work is more aimed at counter-hegemonic integration or facilitation, Falkenberg sought firmly to retain the 'bi' in bicultural and structured the piece as two separate performances. He explained that this is so that

> the two cultures could talk to, without necessarily understanding, each other, using two completely different languages, performance practices and theatrical companies, counterpointing, echoing, but never fusing . . . the European side represented itself as decadent and self-destructive . . . whereas the Māori side represented itself as in the process of return and revival.[28]

Falkenberg's 2011 work *The Earthquake in Chile* was also a direct attempt to address specific cultural ideas and events. His adaptation of Heinrich

von Kleist's short story of the same name was designed to 'serve' the traumatized post-earthquake community of Christchurch city. It was an exploration of the 'sense of communion and community that emerged in the wake of the Christchurch earthquakes'.[29] In the performance, participants attended a 'church service' and then engaged in community discussions over a shared meal.[30] In a city where all the theatres had been destroyed or damaged by earthquakes, the performance necessarily became site-specific and was staged in the alternative venue of St Mary's Anglican church and its grounds. The project is testament to the way in which PaR can work to articulate and serve communities through performance.

Carol Brown's interdisciplinary performance is on one level transnational and interdisciplinary, rather than intercultural, in traversing territories between science, digital technology, architecture, media art, ecology and dance. Her research nevertheless draws upon the Māori disposition to common ways of knowing. The Standing Waves project, for example, though it grew out of a workshop with neuroscientists (see below), bears a hallmark of *kaupapa Māori* approaches in its open, collective approach to research to achieve common knowing. In an effort to 'facilitate reaching out across disciplinary and cultural boundaries' the group began their incubator workshop by spending the first night on the Te Kuratini *marae*.[31] A *marae* is a sacred Māori meeting area and communal building. It is not uncommon for visitors of non-Māori descent (*Pākehā*) to be invited onto the *marae* (sometimes for an overnight stay) and often, as in the case of Brown's research team, groups will seek out the *marae* experience to align themselves with bicultural practices and philosophies.

In 2010, Brown worked with scientists and media and design artists in a workshop setting at the Sleep/Wake Research Centre in Wellington, Aotearoa/New Zealand. The aim was to 'create a unique performance ecology, by bringing together elements of the collaborators' respective disciplines and expertise and experimenting within the areas of intersection'.[32] The project explores scientific data about the phenomena underlying sleep and its related patterns and cycles, 'with sensor-based technology for synaesthetic performance'.[33] A 'sensor suit' was created which senses the body, its gestures and its environment through the measurement of light and acceleration', allowing

[t]he dancer to intuitively control sound. In turn, the sonic feedback influences the emerging choreographic score, inducing constraints and generative cyclic patterns for movement. This feedback loop between

movement and sonic state creates waves of sensation heightening the experience of the space as a perceptible field of embodied technology. The performance exists at the threshold between the figurative and the factual as it takes data and information from the lab practice of a sleep scientist and reinterprets this within the condition of a performance environment, effectively making visible the dynamic processes of subtle physiological phenomena.[34]

The project exemplifies a trend towards emergent and hybrid design in creative and performance PaR. The transdisciplinary research group characterizes a disposition in arts PaR to recognize and articulate knowledges that can be found in the body or to use the body to embody non-literal knowledge. The notion that arts PaR methods may 'enable thinking and articulating with the whole body' is not new and indeed, as Mercer and Robson have pointed out, it is a common strategic method in PaR work to place 'the body at the centre of the inquiry',[35] a concern which links PaR not only with wider trends within the Humanities and other disciplines but with *kaupapa Māori*.

Much of the PaR taking place in the visual arts in Aotearoa/ New Zealand engages in material cultural practices, influenced by the work of Paul Carter. The journal *Studies in Material Thinking* takes its name from Carter's seminal work and Nancy de Freitas of Auckland University of Technology is the editor-in-chief; de Freitas has also published a number of articles outlining a practice-based research context for art and design practice and also proposed a method for using documentation as a tool in PaR work.[36]

In conclusion, there are individuals, groups and, indeed, university departments in Aotearoa/New Zealand making significant contributions to the development and understanding of PaR. Key practices – such as placing the body at the centre of the inquiry and the development of hybridized forms – echo strategies and concerns adopted elsewhere in the world. But they have a particular significance in relation to *kaupapa Māori* and, if only PaR might be institutionally recognized and supported, there is perhaps even greater potential than elsewhere in the world for the development of a praxis forging productive critical methods and pedagogies in this distinctive bicultural context.

7
Artists in Australian Academies: Performance in the Labyrinth of Practice-Led Research

Julie Robson

Beginnings

The practice-led-research phenomenon began in Australian academies over two decades ago and it has maintained strong momentum since. The first studio/practice doctoral programme was established in 1984 at the University of Wollongong, supporting scholars of visual arts, graphic design, music, performance, drama, creative writing and journalism in research using practice modalities. The mid to late 1990s saw five other institutions follow this lead. Four more followed suit in the first few years of the new century and now thirty institutions offer creative arts doctorates.[1] Concurrently, there has been considerable debate over the rationale and regulations that should govern such an innovative and challenging mode of research. The performance studies peak body, the Australasian Drama, Theatre and Performance Studies Association (ADSA), played an instrumental role in advocating for its formalization and recognition, with Alison Richards and Bill Dunstone leading the vision and testing the framework that still holds relevance and insight today.[2] The maturation of the practice-led-research field, however, came about from the significant contribution of many individuals, consortiums and peak bodies across the range of creative arts disciplines. Drawing from this body of work, and that of various practice-led researchers in theatre and performance, this chapter revisits the confidence and conflicts that characterise the field in Australia today, both in the postgraduate context and beyond. At its heart, the story is an interweaving narrative about *rigour* in the search for nomenclature, models and methods, *recognition* of their validity, impact and measurability, and the subsequent *renewal* of institutions, programmes and professional pathways.

Notes on nomenclature

Although the field of creative arts research is burgeoning in Australian universities, consensus on definitions remains difficult and conflicted. 'Practice-based' and 'practice-led' are familiar terms but the range of names and their subtle inflections can (as Nelson notes in Chapter 1) vary considerably according to institutional contexts or art disciplines. The approach is variously called 'Practice as Research', 'Studio Research', 'Artistic Research', 'Practice-Based Research' and 'Practice-Led Research'. Under the influence of social-science and humanities traditions, other method descriptors can include artography, arts-informed research, action research, action learning, narrative inquiry, grounded theory, participant observation, ethnography or reflective practice. While each may employ artistic methods for research purposes, the differences in nomenclature are the result of efforts to define more accurately the precise positioning of the art practice within the inquiry – that is, the extent to which the research question is pursued and presented in the discourse of the artform and its associated practices. In Australia, Haseman's term 'performative research' is gaining increasing popularity as a way of describing the methodology at large, denoting a third research paradigm distinct from qualitative or quantitative research modes owing to its use of creative and symbolic languages.[3]

Beyond formal titles, a wave of linguistic renewal is occurring as academic and arts-industry vocabularies collide, resist, marinate and jostle in order to capture the liveliness and authentic character of creative practice when put to work in formal research contexts. It is one of the more exciting developments in academia, and even the delivery of a conference paper might take a decisively performative turn. Strategically commingling her theatre-making with her feminist theorizing, artist and doctoral candidate Dawn Albinger, for example, *performed* her 2009 ADSA conference paper. Oscillating between the voice of a Performer-Researcher and those of a Master Builder, Old Woman Storyteller, Handless Maiden, and Diva, she presented creative work-in-progress excerpts that illuminated her investigation into mythologies of romantic love and women's sublimated patterns of abuse. She prefaced the presentation with the rationale that

> [d]espite the seduction offered by the siren song of theorists, the feminist practitioner can also experience a stultifying asphyxiation or amputation if she loses her connection with her own body of knowledge.[4]

The paper, which was subsequently published, was a dance as much as a verbal critique, moving swiftly through the range of classical and contemporary manoeuvres she had been taking to explore her research terrain. It also served as a kind of manifesto for 'the way the author, as a practice-led researcher, can enter, re-enter, reiterate and transform the violent self-effacement that can characterise the practitioner's engagement with theory'.[5]

Given the relative newness of performance-driven research in Australian academies – epitomized by the fledgling, unstable lexicon – artists who enter are inevitably challenged with the problem of how to hold their own emergent methodological and philosophical ground as they engage with and build upon the intellectual canon. In dealing with this, a certain resistance to established theory can be useful, elevating the practical, experiential and tacit knowledge elements at play. Maxwell calls it a form of 'practitioner agency and/or reflection on practice' that now typifies Australia's second generation of doctorates,[6] and which implies that the specificity of nomenclature is politically and epistemologically charged. Nelson's model of 'praxis', imbricating theory within practice, affords a means of overcoming the traditional binary divide.

Kroll has tracked much of the Australian debate over terminology, particularly in the discipline of creative writing, arguing that '[i]n order to design more effective higher degree programmes, to supervise successfully and to pursue our own (properly-funded) research, we can only benefit from a consistent nomenclature describing what we do'.[7] The view is corroborated in Baker and Buckley's 2009 report, *Future-Proofing the Creative Arts in Higher Education: Scoping for Quality in Creative Arts Doctoral Programs* (2009) published by the Australian Council of University Art and Design Schools (ACUADS). They note that '[t]hese are all crucial matters to resolve in the endeavor of creating confident and empowered research communities in the creative arts disciplines'.[8] Phillips *et al.*, in discussing the contingency of definitions in relation to Australian postgraduate degrees in dance, have comprehensively reviewed existing taxonomies and their distinctions.[9] Their report points to similar linguistic disputes in the UK, ranging from PARIP's primary use of 'Practice as Research' to what Melrose prefers to call 'mixed-mode disciplinary practices'.[10] Eliding the dispute to an extent, my co-researchers and I chose to call a multidisciplinary seminar series and symposium 'live research'. As well as implying the immediacy of performance-driven investigations, we thought it captured Barrett's idea that 'artistic practice be viewed as the production of knowledge or philosophy in action',[11] or what Nelson refers to as a form of

'doing-thinking'.[12] That there is no consensual use of terms in Australia, however, was an obvious tension at the 2011 colloquium held by ADSA, where staff and students expressed concern and anxiety over contradictory, interchangeable or messy definitions.[13]

Given the still new and highly exploratory nature of the field, it may be healthy that multiple and fragmented descriptors are still being trialled and rationalized. Rather than perceiving it as a crisis of language, it is perhaps indicative of the field's ongoing need to discover, define and refine itself. Taking a Darwinian view, the community of stakeholders will no doubt arrive at the strongest and most meaningful vernacular, leaving only the fittest of terms to survive. Whatever terms are used to classify and nuance creative arts inquiry, Haseman reminds us that, for all its uniqueness, the genre still adheres to the general rubric of research required of any discipline. That is, projects must: 'clearly establish the research question or inquiry; convincingly articulate a transparent set of methods under the performative paradigm methodology; locate the study in its field and associated conceptual terrain; report the knowledge claims and benefit; and, finally, to make these available for sustained and verifiable peer review'.[14] As this book confirms, whatever one's journey through the labyrinth of academia, the researcher's thread must weave through these core elements.

Milestones in measuring

Where codes and classifications for practice-led inquiry have significant consequences for and impact on Australian arts academics is in the annual audit and rewarding of research. Significantly, the last five years have seen the Australian government design and implement a new system for measuring research output by the country's 41 universities known as the Excellence for Research Australia (ERA) schema. Most importantly, as well as acknowledging 'traditional research outputs' (TROs) such as books and journals and conference papers, ERA formally recognizes 'non-traditional research outputs' (NTROs), which can include curated or exhibited event, live performance, original creative work and recorded rendered work. Trialed in 2009, the Australian Research Council conducted the first full ERA evaluation across all eight disciplinary clusters in 2010. This updated framework was long overdue, for, as Hutchison notes:

> Despite the mountain of material debating the question of research in the Creative Arts, and the passing of 20 years since the Dawkins revolution, the notion of primarily practice-led research, common

within the creative arts sector, has not yet been fully incorporated into universities' research recognition and funding frameworks . . . Specifically, distinct discrepancies remain in the training, assessment and funding of creative arts research and elements of the humanities. For example, the Higher Education Research Data Collection (HERDC) has for the past decade not recognised creative work or non-traditional scholarly publications in its process for collating and auditing research outputs.[15]

Under ERA, NTROs can now be registered with a 250-word statement outlining the research background, contribution and significance of each output. Universities also lodge more detailed documentation for their top 30 per cent of claims, which are ranked against a series of indicators for quality control. The *ERA 2010 National Report* reveals that, in the 'Humanities and Creative Arts' disciplinary cluster, the 'Performing Arts and Creative Writing' subcategory registered over 6000 outputs. A staggering 74 per cent of these were NTROs (that is, previously unrecognized research outputs), with 1705 works listed under 'Live Performance'.[16]

While it is evidence that creative arts are increasingly acknowledged for their 'benefits in wider university, professional and communal contexts',[17] the auditing system has not been deemed flawless. Features such as the 'expert review committee' and accompanying 'esteem measures' have been deemed inadequate or problematic,[18] and questions have also been raised about transparency and substance of the auditing approach. Nevertheless, ERA still represents a landmark achievement for the nation's practice-led researchers.

Postgraduate models and methods

The basic model that Nelson speaks of, where a thesis weaves together creative practice, documentation of process and conceptual frameworks in 'complementary writing', also characterizes the dominant form of practice-led research in Australia. The interrelationship of practical, theoretical and methodological elements is 'alchemical' in that together they forge and illuminate the philosopher's stone.[19] For postgraduate awards, no Australian institution currently accepts the submission of creative work alone, with each university stipulating a written complement that fortifies and situates the creative work in its relevant context. What can differ significantly between these programmes, however, is the weighting accorded to the various components. In some cases this is because a

Doctorate of Creative Arts or similar professional doctorate programme places a stronger emphasis on technical and creative production, while a Doctorate of Philosophy may insist on an equal or higher emphasis on the theoretical and discursive aspects. Both degrees are subject to formal standards of rigour, yet, speaking anecdotally, perceptions of their 'true' value as 'real' research can vary according to academic or industry allegiances or bias. Baker and Buckley articulate the primary difference of the professional doctorate to the doctorate of philosophy as 'research which enables a significant contribution to knowledge and practice *in a professional context*'.[20] From their empirical analysis, they also report that

> Essentially, the length of the written component for the PhD appears to be most commonly around 40,000 words although there is great variation from 20,000 to 65,000 words, whilst the typical length of an exegesis as part of a professional doctorate is more difficult to establish ranging from 8,000 to 35,000 words which is usually in addition to coursework.[21]

Some institutions such as Queensland University of Technology and Wollongong University, for example, allow doctoral candidates to self-nominate the weightings between the creative and exegetical parts, which may range from a 30:70 or 80:20 split. Murdoch University, in contrast, makes no distinction between the creative and written work, and the entire body of research is submitted for examination as a whole.[22] With such disparities, it is not surprising that there is high anxiety and experimentation around the form and function of exegetical and dissertational writing.[23] This theme has been an ongoing focus of critical commentary across art disciplines but has been led most strongly by creative and visual arts academics, especially via the Australian journal *TEXT*.

Given the breadth of drama, theatre and performance modalities, it is to be expected that the nature of the creative works for submission can differ considerably, be it in style, length or number. A popular doctoral format is to submit a major live performance work that has had a public season and is later accompanied by a written component. Yet as well as the 'product plus exegesis' model, artist-researchers may also submit a series or cycle of performance works, or 'portfolio of linked outcomes'.[24] Catherine Fharger,[25] for example, submitted a series of nine related works that ranged from radio play to puppetry to installation-based and bio-tech performance each of which informed her themes of mutation, inheritance and cross-fertilization within hybrid arts research. Angela

Campbell,[26] on the other hand, submitted an entirely text-based document made up of a performative lecture, a play script, and a case-study-driven dissertation, which best suited her analysis of the ways theatre makes place, and what kind of a place contemporary theatre creators have been making of Australia.[27] Demonstrating another interpretative possibility, Donna Jackson[28] put forward a multi-artform community festival as proof of her original contribution to effective models of community renewal and engagement.[29] Such diversity of project submissions is testimony to the different kinds of knowledges being made visible and the range of methods pioneered with them. It also points to the challenges that candidates can face in terms of funding their creative endeavour. While some institutions offer practice-led candidates modest cash support to assist with presentation costs, funding must be independently sourced, which obviously determines the project's scale and the level of professional production values.

In spite of the disparity between projects, Mercer and Robson have observed there is still commonality in the practice-led approaches in performance research. In particular, they note seven characteristics of method. To paraphrase what is detailed elsewhere,[30] the methods employed are, first, underpinned by the artist-researcher's pre-existing arts practice, which can usually be linked with industry lineages and traditions. Second, rather than being prescriptive, rigid or predefined, the methods are typically multimodal, hybridized and plastic, morphing as necessary throughout the study so as to be genuinely led by the current practice. Third, the methods tend to be highly idiosyncratic, in that they are per-sonal, instinctual and compelling, and arising out of what Haseman has now famously called 'an enthusiasm of practice'.[31] Fourth, the methods inevitably evolve through (cycles of) failure and generosity, frequently dashing preconceived ideas and continuously asking to be reinvented, adding to the dynamics of 'emergence and complexity' that Haseman and Mafe speak of.[32] To describe and theorize such expert-intuitive artistic processes, it is not uncommon for arts researchers to extend the reliance on a symbolic language. Thus, fifth, accounts of method will often resound effectively through strategic use of metaphor. In the sixth instance, methods are governed by variable temporal and situational factors, dynamic and contingent according to time (for example, it may only be named retroactively) and (re)made in place (for example, it can change based on academic, cultural or physical settings). Finally, as is now commonly acknowledged, practice-led methods are characterized by their inherent capacity to enable thinking and articulating with the whole body, asserting the primacy of sensory and somatic ways of knowing.

Validity and assessment

The anxiety expressed by gatekeepers at the early stages of artists entering the academy was the fear that they would simply make art and not research. There was also suspicion of what Biggs has described as the implicit, tacit and ineffable knowledges that experiential and non-linguistic research modalities produce.[33] The tenacity of engagement by practice-led arts researchers with existing, relevant fields of philosophy and methodology has done much to alleviate this concern, keeping at bay some of the fears, risks and accusations of the 'soft, silly and otherwise suspect' doctorate that McWilliam *et al.* have written on.[34] Tethering investigations to established bodies of theory has not however necessarily staved off other tensions regarding the level of artistic 'excellence' in the examinable creative work. Green writes: 'In the words of the assessors' conundrum: Can bad art be good research, and vice versa?' Her answer is 'yes', but with the qualification that in spite of the subjectivities and relativities that can be imbued in such research, it is assumed that 'assessors have been honing their skills and developing their frames of reference alongside pioneer practice-led researchers', and that 'a community of learning has developed around the various art forms through which practice the research questions are interrogated'.[35]

Examiners themselves are still coming to terms with assessing the practice-led submission. Australian institutions currently require two to four examiners for a doctoral work, who may be a combination of relevant industry professionals and specialized academics. Although the preference is that examiners will view the creative work live, the country's geographical challenges and limited university budgets mean this is not always possible, whereupon documentation of the kinds marked in Chapter 4 must function as a substitute. A study by Holbrook *et al.*[36] observed that examiner reports on practice-led submissions in the fine arts frequently included statements about being tentative, given the 'newness' of the examination mode and its lack of historical precedents. Also, and perhaps consequently, there was a tendency to be over-reliant and more assessment-centred on the written work. From the creative writing discipline, Kroll also acknowledges unresolved anxieties around assessment procedures:

> As artists and academics we still face that thorny question of verification, authentication, validation. Who testifies to the work's quality as well as to its research outcomes? Those questions still remain to

be untangled, particularly in creative writing's experimental, hybrid or multidisciplinary projects.[37]

These comments are evidence that the Australian debate is still preoccupied with the question of what constitutes a satisfactory and distinctive level of 'doctoral-ness'. This is where documentation asserts itself as a necessity, for, as Green reminds us, '[t]he record of the practice-led research becomes an important element of (some might claim proxy for) the rigour associated with a conventional qualitative research project'.[38] As well as dispelling the romanticism too often associated with the artists and their 'muse', the documentation also begins to capture many of the performance practices that have largely been oral traditions, laying bare the pragmatics as much as the poetry in an artist-researcher's knowledge pursuits.

Motivations and impact

When an artist enters academia on a scholarship, a modest government stipend equates to $28,715 per annum,[39] although this can often be boosted by university supplements and competitive scholarship schemes, or additional part-time work. This can take the figure close to the average median income of Australian artists, which was most recently calculated as $35,900 It is not entirely cynical to say that some artists have found refuge in the academy as a way of continuing to practise, by learning and embracing the research aspects and interest in their work. But the increasing entries of mid-career and senior artists entering the academy are usually in order to consolidate, refresh and/or expand their existing knowledge and expertise, a form of professional development that offers a generous period of reflection and experimentation.

This is not to say that the research benefits are simply for the artist and the sustainability of their practice. In some instances, the practice-led researcher may be leading the discovery of entirely new forms of cultural expression. Sarah Jane Pell,[40] for example, cultivated a brand new genre of underwater performance, 'aquabatics', while David Fenton[41] deepened approaches to directing in line with the advent of post-dramatic theatre. Practice-led research will also commonly incorporate other disciplinary contributions beyond the theatre and performance sector. In the case of Teresa Izzard's work,[42] her study crosses industry and education needs for more relevant and accessible applications of Laban's historical system of physical movement for contemporary

directors and teachers.[43] To give a different example again, the work of Brenda Downing[44] benefits women and health professionals by pioneering innovative ways of working with the survivors of childhood rape. In her research, adverse and long-term trauma symptoms are addressed through a process of creating autobiographical, somatic narratives.

Putting these new knowledge contributions into a context beyond performing arts and their associate realms, the work can also be framed as part of Australia's growing creative industries and innovation ecology.[45] As an overwhelming number of national policy reports reveal,[46] creativity and innovation have been a substantial policy focus for over the last two decades, forming part of the worldwide interest in ways to foster new ideas and ways of doing things. With the rise of the creative industries as a discipline, and a broadening of innovation systems thinking beyond science and technology domains, the contributions of the arts and humanities are being increasingly recognized for their impact on the health of social, economic and environmental economies. *Transforming Australia's Higher Education System* (2009) and *Powering Ideas: An Innovation Agenda for the 21st Century* (2009) are two recent governments reports highlighting that artists in the academy are part of a larger vision for a more educated and creative nation, one that is capable of competing in a global knowledge-based economy and driving a national innovation system.

Professional pathways

Since the advent of the practice-led degree, a persistent question has been where do its graduates go? Stock says:

> One could argue that PhDs have two practical purposes: as a research training ground for entering the world of academia and/or to train professional researchers for an external environment. Professional doctorates, on the other hand, are conferred when there is demonstrated evidence of high-level expertise, innovation in, and deep knowledge of a professional field and where the site of investigation is predominantly in a professional work-place rather than an academic setting.[47]

New academic positions advertised in the creative arts now commonly request expertise in practice-led research as requisite criteria. Successful 'new-bloods' that join the ranks of full-time teaching and research staff must then learn to juggle the multiple demands of such a role while

maintaining their creative-practice approach to scholarship. In the increasingly commercially driven environment, this is not an easy task, especially when the demands of making live performance often require significantly more time and resources then some other research pursuits. Existing staff, particularly those in production-based programmes where they might write, direct or play a creative function, are being pressured to learn how to turn as many of their performance works resulting from teaching into research output.

For independent research, the challenge is emphazised by the rates of success for the highly competitive 'Discovery' and 'Linkage' grants awarded by the Australia Research Council (ARC). Although insistent on innovative methodologies, not one of the eleven drama, theatre and performance research projects awarded in the last five years employed practice-led approaches.[48] but, rather, were based on traditional forms of historical, cultural and critical analysis.[49] But then, one might ask, how many were actually proposed? Music projects have been more successful in this regard, with researchers arguably embodying the new breed of the professional, practice-led academic.[50] Buckley and Conomos have been highly critical of the ARC funding model, saying it discourages the arts researcher and has debilitating implications on the capacity of art schools to generate research revenue:

> As well as the obvious disadvantage that individuals face through not having their creative work funded, a manipulative climate has grown up in which they are encouraged to develop research projects that do not represent their primary intellectual concerns as artists but do fit neatly into the ARC funding categories.[51]

A boon for the performance sector, however, has been the ARC's $1.5-million infrastructure funding for *AusStage*[52] – a research facility and online archive built by an extensive consortium of universities and industry partners that records information on live performance in Australia. It captures venues, organizations and artists in relation to performance events, with links to related articles, items and collections, and, in some cases, digitized texts image and video. It also has features such as time mapping, network visualizations and audience blogging that each can assist with data interpretations.[53] These all have implications for the generation, application and dissemination of practice-led research, providing ways of tangibly mapping the field.

It is also worth noting that, in Australia, the majority of full-time positions in drama, theatre and performance studies are tenured, and

staff turnover is slow. However, it has been acknowledged, not just in the arts and humanities, but also across the university sector at large, that a significant wave of retirement is approaching: the largest to be seen in three decades.[54] Given the mature age profile of arts academics, the coming ten to fifteen years will see at least half of the staff in drama, theatre and performance domains retire, an opportunity that will potentially redress the lack of younger academics currently in the sector. With a doctorate now a prerequisite qualification for most positions, and the increasing popularity of the practice-led higher degree, it is not hard to imagine that this newer breed of arts researchers will continue to transform the institution and its programmes.

New threads

The environment of Australian universities is a very different place given the last twenty years of reform. With the corporatization of universities and the growing emphasis on the commercialization of research, the undergraduate degree in many institutions has become more introductory and general in its focus, with specialty areas increasingly expected to be cultivated in postgraduate realms. In theatre and performance the direct articulation from undergraduate arts programmes to postgraduate study is currently not always a pathway pursued or encouraged, often because of the level of artist maturity and lack of early research training. This issue raises the relevance of the professionalism and skills born of working in the arts industry before embarking on practice-led research in the higher degree context. What we tend to see are mid-career or senior artists returning to the academy, those who have an established and competent practice that is pursued and rigorously theorized within its historical, cultural and/or aesthetic context. The role of coursework and supervision is thus largely skewed towards inducting the artist into formal research traditions and protocols, which, until the last few decades, have not been arts-orientated. While Australian arts industry members may be unaware of the quiet revolution occurring in universities,[55] the practice-led research phenomenon is bridging the gap between these traditionally polarized sectors.

When Ariadne gave Theseus the ball of thread it enabled him to reach the Minotaur in the heart of the labyrinth, conquer it, and still find his way back out. While Australian academics are busy slaying various conundrums in the labyrinth of practice-led research – disparities in vocabulary, standards and assessment for example – there is little doubt that fresh and productive pathways to new knowledge are opening up.

As this chapter has illustrated, the plethora of doctoral programmes that now exist, the interpretative possibilities of the practice-led models and methodologies, and the advent of the ERA auditing system are all testimony to the field's growing creativity, confidence and innovation. As well as forging new knowledge, the species of practice-led research has given rise to a new breed of Australian academics and artists.

8
PaR in Continental Europe: A Site of Many Contests

Dieter Lesage

For some years now, and particularly since the Bologna Declaration of 1999, the key issue in continental European arts higher education is an obligation to become 'academic'.[1] Ironically, since the classic representative institution of arts Higher Education has typically been called an 'academy', a pressing question concerns how academies should become 'academic'. As distinct from universities, 'academies' refers here to all specialist institutions of arts higher education, whether they teach visual or fine arts, film, drama or music, and whether or not they are indeed titled 'Academy'.

Particularly confusing for academies post-Bologna was that many of them had previously been engaged precisely in pedagogical efforts to ensure that learning and teaching at academies would become less 'academic' than it used to be. Whereas at universities the adjective 'academic' sounds like a generic quality label, at academies the term had become an insult, a signifier of a lack of artistic quality. Thus, at the very moment that many European academies had become very anxious not to teach their students to produce academic art, they were required, post-Bologna, to 'academicize' in order to get accreditation for their artistic programmes. Though in one sense a play on words is involved in this shift – the 'academic' art of which modernism wanted to dispose is not 'academic' in the sense used in universities to indicate 'scientifically rigorous' – important issues of differing epistemologies, codes and conventions are at stake.

However, this is not the only reason why the academization process launched in 1999 by the Bologna Declaration and its various national and regional implementations has met with a great variety of resistances.[2] Several critiques have addressed the issue of Bologna's hidden (or not too hidden) neo-liberal agenda. Indeed, although in postwar

Italian political history Bologna had been notorious as a bastion of communism, in more recent European political history, 'Bologna', rightly or wrongly, became the signifier par excellence of the imposition of a neo-liberal agenda in educational matters. Since its meeting in Prague in 2001, the Bologna Follow-Up Group has at least paid lip-service to this criticism by both stressing the social dimensions of higher education and acknowledging the responsibility of public authorities for it. At the same time, however, many countries participating in the Bologna Process used 'Bologna' as an excuse for reforms in higher education that were not strictly part of the Bologna Declaration.[3] For instance, in many German *Länder*, university study fees were raised simultaneously with the introduction of the Bologna Process and thus, for German students, 'Bologna' became a synonym of elitism. Local authorities did not directly challenge this perception, as it was much easier to deal with the criticism of their young voters by telling them it was, as usual, all Europe's fault, rather than explaining the proper motives for this national or regional political decision.

In educational terms, the academization process was felt by many arts higher-education institutions as a verdict, effectively declaring: 'Although you call yourself by the name of Academy, you aren't academic – yet.' The change required, however, was not to restore the academy's original character. Arts academies were being requested neither to engage in critical self-analysis nor to recall the highlights of their histories. The academies were instead required to listen to their big other, the universities, who in some countries and regions in Europe proposed to tell academies how to become academic. Universities which had no experience of teaching practice-based arts in the many decades or even centuries of their venerable existence supposed that they could assess whether art academies had reached an acceptable academic level in teaching art.

Though the universities stressed that the evaluation of teaching and research can only qualify as academic if it is undertaken by peers, they failed to see that university academics without any experience of practice-based arts education or artistic research could not properly be considered as 'peers' of academies on their own terms. The universities, though unqualified as peers, were not about to disqualify themselves as the proper institutions to evaluate the academization of academies. Indeed, universities were very happy to be able to evaluate academies, and to play a decisive role in the procedural machine which in time would accredit programmes at academies as being academic. In some countries, universities also took it upon themselves to deliver the newly created doctoral degree in the arts.

While UK universities have been delivering practice-based PhDs in the arts for three decades, and while Finland has developed a practice-based arts PhD over two decades, it is only since the Berlin Declaration of 2003 that many continental European countries have, at varying speeds and within different institutional and legal frameworks, introduced the PhD or the doctorate in the arts. At the meeting of the Bologna Follow-Up Group in Berlin in 2003 the third cycle leading to the doctorate award became a priority of European higher-education policy and the idea of a doctorate award in the arts emerged.[4] If artistic study programmes had to conform to the structure of bachelor and masters cycles, it seemed logical to establish a third cycle of artistic study courses leading to a doctorate in the arts. The doctorate in the arts became the subject of heated discussions. Here, I will focus on one particular aspect, which is the debate about the format of the doctorate in the arts.

Academic curriculum developers and research administrators involved in the establishment of the rules of their respective institutions for the doctorate in the arts paid some attention to the demand that the new doctorate should respect the specificity of an artistic education. They accepted, for example, the idea that artists might present a port-folio of their work in the context of a doctorate. However, many of them fiercely defended – and still do defend – the idea that a doctorate in the arts is inconceivable without a written supplement. As a result, the format of the doctorate in the arts in many continental European countries mostly requires both an artistic portfolio and a written supplement. Though Nelson's approach as outlined in Part I of this book differs in that it allows for the possibility of the submission of practice alone for a PhD, typically it involves what Nelson calls 'complementary writings'. As a contribution to the dialogue between Parts I and II of the book, I propose here to revisit the role and status of writing in 'academic' study, making the case for a 'practice-alone' model.

The written supplement

The insistence on the obligation to produce a written supplement which currently dominates continental European universities appears to demonstrate a lack of confidence, either in the capacity of the arts to speak in a meaningful, complex, and critical way in a medium of their choosing, or in their own capacity to make sound judgements on the meaning, complexity and criticality of artistic output as such. In contrast, I hold that the presentation of the results of artistic research in general – of which the doctorate in the arts is only one particular

example – does not necessarily require an explanatory text as a supplement. For an evaluation by peers, the artwork itself (be it a theatrical, dance or musical performance, an installation, a film, a video, or a fashion show) which is the result of artistic research is sufficient in order to evaluate its originality and relevance.

Although there are notable exceptions, the demand of a written supplement is most insistently voiced not by peers, but by non-peers, that is by people who are not acquainted with the arts and understandably feel insecure about its evaluation. The different traditions of the academies and universities, broadly reflecting a separation between practice and theory, still obtains in continental Europe where, unlike in the UK, an appropriate accommodation between institutions and epistemologies has not yet been developed. Historically, academy peers have mostly been able to assess artistic research competently without the aid of supplementary writings. The audio-visual literacy of artists enables them to read the artistic research that is to be evaluated, even if in a certain sense there is nothing to read. Under the new requirement for a written supplement, 'peer' assessors seem now to be basing their assessments primarily on a reading of the written supplement, as if it were the doctorate itself, considering the artistic portfolio merely as a supplementary illustration to it. In a worst-case scenario, academically trained art historians with a hobby as amateur photographers might obtain a doctorate in the arts, merely because they are academically trained enough to produce an academically valid written supplement to a portfolio of doubtful photographic work, while a world-class musician might get in trouble concerning their doctorate in the arts because the written supplement to the dozens of CDs of their work as a performer and interpreter constituting their portfolio does not refer in an academically proper way to existing musicological literature.

In the interests of avoiding such apparent absurdity, I propose to make a case that the evaluation of a doctorate in the arts should focus on the capacity of the doctoral student to speak in the medium of his or her choice. If this medium is film, or video, or painting, or sculpture, or sound, or fashion, or even if the doctoral or master student wants to mix media, assessment will require from a peer jury ways of reading, interpretation and discussion other than those required by a written academic text. To impose an additional medium of words on the artist is to fail to recognize the artist as an artist. An artist who wants to obtain a doctorate in the arts should be given the academic freedom to choose his or her own medium. It may be that he or she chooses text (that is, as ordinarily understood to indicate material written in words) as the most

appropriate medium for his or her artistic purposes but it must be his or her choice, not an imposition from outside the domain.

Some of those who urge that a doctorate in the arts should consist not only of an artistic portfolio but also a textual supplement modified their position when it transpired that artists might be daunted by the requirement to write an academic text. A pluralist attitude towards mode of expression has been adopted towards supplements in some circles. As long as it looks like text, this supplement need not take an academic form but might be a literary text, a diary, maybe even a theatre play or a series of poems. However, in trying to sustain the requirement of the textual supplement by this means, its defenders are perhaps revealing that their requirement has always been nothing but a form of bureaucratic conformism. In the first instance the claim was that it would be impossible to judge an artistic portfolio, not because it is a portfolio, but because it is artistic, not academic. A textual supplement was needed because it would be more articulate and could thus be judged more easily. The idea now seems to be that artistic output can only be adequately judged if there is some form of written text, academic or not, that supplements it. The implication is that some form of text remains necessary in order to decipher the artistic work of the artist who wants to become a doctor in the arts. But if the supplement itself also becomes artistic, the question arises of how it might be easier to judge an artistic textual supplement than an artistic portfolio.

Defenders of the textual-supplement model may claim that they take a more intellectual or reflexive approach to the arts. However, this hierarchical claim has been challenged by some major intellectual reflections on the notion of 'text', notably those of Jacques Derrida. Interestingly, Derrida's philosophy of text was actually born out of a pragmatic reflection on how to write a doctoral thesis, and in the context of the debate about doctoral models it is worth revisiting some of his thinking.

The instance of Derrida

Derrida's struggle with this question began in Massachusetts. In 1956–57, the young French philosopher, who just had earned his *agrégation* at the Ecole Normale Supérieure in Paris, went for the first time in his life to the United States with a grant to study for a year at Harvard University as a 'special auditor'. As Geoffrey Bennington wrote in *Derridabase*, Derrida came to Cambridge, Massachusetts to check the microfilm archives of Husserl's unpublished manuscripts; at least that was his pretext.[5] Derrida

was interested in achieving a doctorate, but struggled tremendously with all the philosophical questions that came with the project of *writing* a doctoral dissertation. The most urgent question for him at that time was how to write a doctoral thesis in philosophy. Through his reading of James Joyce and his study of Edmund Husserl in Massachusetts, Derrida attempted to fix not just the theme, but also the form of the doctoral dissertation he planned to write once he was back home. For Derrida, it was inconceivable to write a philosophical thesis without ever asking the philosophical question 'What is writing?' The project of writing a doctoral thesis thus led Derrida to an immense intellectual struggle with the question of writing as he resisted traditional academic standards and expectations.[6] Indeed, only in 1980, at the age of fifty, did Derrida obtain a *doctorat d'état*, a special type of *doctorat* which until 1985 it was possible to obtain in France, not on the basis of a conventional doctoral thesis but on the basis of one's 'work'. Indeed, for his *doctorat d'état*, Derrida presented and defended – through a long oral examination by a jury – three books, which all deal in one way or another with the question of writing. In a sense, one can say that Derrida's doctorate merely consisted of a philosophical portfolio, without an academic supplement. Derrida simply couldn't accept that a traditional doctorate in philosophy was not supposed to reflect, in the way it was written, some fundamental thinking on the question of writing.

Derrida's philosophy of writing, as he developed it in the books that constituted the portfolio which he presented, is insightful in the debate about the format of the doctorate in the arts. The idea that an artistic portfolio should be supplemented with a written text in order to obtain a meaning which can be discussed intersubjectively misses the point that the artistic portfolio itself is always already text. This is a consequence of the famous Derridian dictum, '*Il n'y a pas de hors-texte*' (There is no outside of text). A firmly established, but quite ridiculous, misinterpretation of Derrida's philosophy which reads him as saying that there is nothing but text amounts to a supposed claim that there is no outside world. However, Derrida's idea that there is nothing but text means that the outside world is itself text too: not text is everything, but everything is text.

Angry at the way in which some American philosophers had been trying to ridicule his philosophy as an absurd form of scepticism, Derrida remarked:

> I wanted to recall that the concept of text I propose is limited neither to the graphic, nor to the book, nor even to discourse, and even less to the semantic, representational, symbolic, ideal, or ideological sphere.

What I call 'text' implies all the structures called 'real', 'economic', 'historical', 'socio-institutional', in short: all possible referents. Another way of recalling once again that 'there is nothing outside the text' . . . It does mean that every referent, all reality has the structure of a differential trace, and that one cannot refer to this 'real' except in an interpretive experience. The latter neither yields meaning nor assumes it except in a movement of differential referring.[7]

According to Derrida, then, a portfolio which is a selection of artworks is definitely always already text in itself. As a matter of fact a portfolio will most likely be a presentation and/or a documentation of artworks, rather than the works itself, which means that it is, in its presentation or documentation, already differentially mediating and reflecting the artworks and that text in the narrow sense of the word is even already part of it. The artistic portfolio as a documenting and representing form already speaks of the work, rather than being the work itself. At the same time it is also work done by the artist, an artistic work that represents and documents other artistic work by the artist. The portfolio itself has to be qualified as text, both in the expanded and in the narrow sense of the term.

Derrida's expanded concept of 'text' implies the need for an expanded notion of 'reading' as well as of an expanded notion of 'writing'. As Derrida wrote in *Of Grammatology*:

And thus we say 'writing' for all that gives rise to an inscription in general, whether it is literal or not and even if what it distributes in space is alien to the order of the voice: cinematography, choreography, of course, but also pictorial, musical, sculptural 'writing'.[8]

Here, Derrida's examples of writing are (still) all artistic. Later, Derrida would expand the concept of writing even more, but the first and self-evident move in his expansion of the concept of writing was to include all art forms. Film, dance, music, painting, sculpture, all of them are in themselves forms of writing. Art is writing and is therefore to be read. Reading however is not just about decoding the meaning of signs. Reading has to come to terms with the fact that it will never be possible to determine once and for all the meaning of artistic work.

Constructing 'artistic research'

The demand for a textual supplement to the artistic portfolio may be explained by a fear for the constitutive abyssal character of meaning. But it also reveals a presentist philosophy of text which, since Derrida,

has long proven unsatisfactory. To ask for a textual supplement is obviously not going to save us from the problem of interpretation. Instead of asking for an explanatory supplement, juries should confront themselves with their fear and have the courage to try to read what is already written. The argument that I posit against the textual supplement should not be understood as the idea that the artwork in itself is already full of meaning, but rather that there is no way to remedy the abyssal structure of meaning inherent in the artwork itself. The demand for the supplement suggests that there might be a way to fill the gap. What is at work in this demand is one particular logic of supplementarity, which one could define as the fiction that the open meaning of the artwork can and should be revealed by a supplementary explanation.

However, one should stress the difference between the supplement to the artwork as an academic requirement for having the right explanation on the one hand and a certain aesthetics of the supplement which is inherent in the work of many artists on the other, where the supplement is not seen as the explanation of the work, but rather as constitutive of the work itself. This artist's supplement is not what gives us the solution, the answer, the right interpretation, but rather what postpones the solution, the answer, the right interpretation even more. So 'supplementarity' can also be defined as an artistic strategy to escape the closure of interpretation, to leave all interpretations open, or to make interpretation even more the complex issue it always already is.

In the discussion on the format of the presentation of the results of artistic research in general and of the doctorate in the arts in particular, one may observe a tendency to appropriate thankfully the artist's supplement as if it were conforming to the spirit of the required academic supplement, while in fact its logic is quite the opposite. Of course, there are artworks that involve certain kinds of supplements and there are aspects of artworks that could be considered as supplements. One could argue, for instance, that the title of a painting is already a supplement to the painting. The question then becomes from what point exactly a supplement to an artwork, which may be considered by the artist as inherent to the artwork, becomes the kind of supplement that is considered a necessary requirement in order to present in an academic way the results of artistic research. The 'academic' requirement or a textual supplement to the artwork considered as a legitimate presentation of the results of artistic research would appear not to take seriously the artwork itself and all the writing that is involved in the production of the artwork. In other words, the academic requirement of a textual supplement to an artwork seriously lacks seriousness.

Artistic research can involve many different things: avidly reading about a specific subject matter, randomly visiting exhibitions and confronting oneself with other artistic positions, trying out the visual, acoustic, or haptic impressions of different materials, or even ritually going to the flea market in search of nothing in particular, as Eran Schaerf once beautifully and convincingly described one aspect of his practice of 'artistic research'.[9] What all these different practices have in common is the need of time, time to think, time to see, time to waste. As time is money, time is never given to anyone for free, and certainly not to the artist. In consequence, everybody is under extreme pressure to explain why he or she needs so much time for their projects. Accordingly one aspect of the discourse on artistic research is the rhetoric used to convince funding authorities that the artistic practice proposed is in fact also research.

Arts research opportunities

In a few European countries, a part of the research budget is now specifically allocated to artistic research. This is a great advance for the academy in these countries, because it allows it to become a major site of artistic research and to establish itself more self-consciously *within* the arts field, not in the margins. The academy is thus back as a credible partner in the arts world, as a site of artistic production, as a site of artistic research. As a theoretician, I am particularly delighted that the academy proves to be a space where artists and theoreticians might work on common artistic research projects. However, the nascent comeback of the academy remains in a precarious position. Great vigilance will be necessary in order to prevent the return of the academy from becoming a Pyrrhic victory. Wherever the academy gets funded for its artistic research, there is also talk about the need of a 'return on investment', of 'research output assessment', or 'matching funding'. An attempt is implicitly made to use the research mission of the academy as a means to discipline the academy capitalistically, with professors perhaps being expected to establish spin-off firms. The Bologna Process facilitated the recognition of artistic research as a fundamental task of arts academies, but European universities and academies (beyond the UK) have since struggled both with the concept of artistic research itself and with the question of how to assess its outputs.

But it is not in the arts alone that questions of the means of assessment are contested. Within the scientific community itself the 'double-blind peer review' norm has been under attack for many years and, motivated

by scientific studies, a number of high-profile scientific journals, such as the *British Medical Journal*, have made the decision to abandon it in favour of open review, where the name of the referee is known to the author of the article under review.[10] Today, it seems a scientifically proven fact that the quality of open review is as good as the quality of blind review.[11] Similarly, when it is proposed that citation analysis provides an objective criterion to measure research output, authorities are, deliberately or not, concealing the fact that citation analysis is considered by many in the scientific community as a very flawed procedure to measure research output.[12] In discussions between universities and academies, however, it has been suggested that academies should invent 'analogous' tools for measuring artistic research output. And thus it happens that some people are beginning to dream of an 'art citation index' while others are talking about the need to classify artistic venues in the same way as academic journals are classified according to their 'impact factor'. It might not take long before somebody invents the new science of 'artometrics'.

Tendencies like these in the institutional discussions on artistic research are at once dominant and off the mark, and the discussions themselves therefore are trying. But, while many aspects of research and its assessment are in question, the arts have an opportunity to establish their own methodologies and criteria for assessment. Whereas I am convinced that the discourse on artistic research allows people working in academies to reinvent the academy as an autonomous site of production, we should refuse a supplementary rhetoric that presents itself as an inevitable corollary to the discourse on artistic research.

9
Artistic Research in a Nordic Context

Annette Arlander

Finland was one of the first countries to engage in artistic research, as we prefer to call it.[1] Perhaps because of the historical respect for a pioneering spirit (take your spade and go out in the forest and create yourself a field), Finnish artists and educators tended to do first and to think later. This approach can have its drawbacks but it can also be seen as a practice-led inquiry on a meta-level. If we had waited for philosophers to agree upon a solid ontological and epistemological basis for artistic research, we might not, even now, have begun. However, theoretical debates as well as practical experiments in artistic research have been going on for more than twenty years.[2] I remember participating in a symposium in 1994,[3] which according to the proceedings *Knowledge is a Matter of Doing* (referring to Grotowski) was 'the first in Scandinavia in which both scholars from universities as well as artists and teachers from institutions who actually train practitioners were invited.'[4]

An important reason for the development of artistic research in Finland has been the independent university status of the major arts universities, alongside the general policy of encouraging doctoral studies in the country. Universities without art departments have not been much concerned about Practice as Research. There are still many proponents for a dualistic model, arguing that the parallel worlds of art and research should be kept apart, and the regulations governing universities in Finland still follow that model – a situation which has ironically been an important form of protection for the independence of the art universities. Artistic research has been an area of concern mainly for doctoral studies because funding is linked to the number of graduated students rather than the research output of the staff.

As more focus is placed on post-doctoral research in the art universities, the pressure on research funding to include artistic research will

increase. In 2009 the Academy of Finland[5] published an assessment of research in art and design in Finnish Universities.[6] The evaluation showed that artistic research is an existing field: 'The contribution that artistic research makes to the formation of knowledge is a challenge for all the parties involved and opens up new avenues for generating knowledge.'[7] Moreover, in an institutional research assessment of Aalto University the same year, one of the panels noted that many units had self-censored much of their own often excellent work, limiting themselves to a minority of staff and outputs that were considered to be 'scientific' (i.e. staff with doctorates, and outputs in the form of journal/book publications). This was seen severely to undermine the research value of the university and its societal impact.[8]

Only a few years ago I could reasonably write:

> Artistic research and practice-based research in the creative and performing arts are developing fields of study, and they can be understood as methodological approaches as well. The theory-practice divide and the valorization of the textual over embodied knowledge within academia have long been criticized[9] . . . But when artists start to carry out research on their own terms, complications can arise.[10]

Today we could claim that artistic research is an acknowledged field of research and knowledge production, rather than a specific methodology.[11] Artists undertaking research can use various methodologies.[12]

Brief overview of doctoral studies in higher art education in three Nordic countries[13]

In the Nordic countries debates around artistic research have mostly concerned doctoral studies in the arts and have at first been related to further education for artists.[14]

Sweden

Sweden has PhD programmes at the art schools of Gothenburg University (45 students, since 2000), and at Malmö Art Academy as part of Lund University (6 students, since 2008). A National research school in the arts, Konstnärliga forskarskolan, was founded in 2010 by 12 Swedish universities and university colleges engaged in artistic education and research. It is hosted by Lund University (24 students in 2011). The doctoral degree specific to this programme, Doctor of

Philosophy in theatre, visual arts and so on, can be awarded only by Gothenburg University and Lund University.[15] The programme aims to create a nationwide structure for postgraduate arts education in Sweden, a stimulating and productive environment for artistic research, characterized by a plurality of genres, disciplines and approaches.[16]

In Sweden the development has been complicated by the fact that unlike most art colleges, which are incorporated into local universities, like Lund, Gothenburg or Umeå, the major art colleges in Stockholm remain independent, but without university status and the right to award doctorates. They have thus engaged in artistic development work (*'konstnärligt utvecklingsarbete'*). This historical situation still creates tension and influences how the term 'artistic research' is understood. Musicologist Henrik Karlsson proposed a dual model in 2002 and suggested that a doctoral degree should be established in higher art education, but it should be distinguished from a research degree.[17] Professor and choreographer Efva Lilja has been an eager proponent of artistic research.[18] The Swedish higher-education system currently gives two doctorates in art; one is a conventional PhD as developed in the 1980s (in Gothenburg and Lund) and the other is a doctorate in fine, applied and performing arts.[19] University of Gothenburg prefers to develop both while the University of Lund has defined their exams as artistic.[20]

Norway

In Norway the funded Norwegian Artistic Research Fellowship Programme, founded in 2003, leads to a diploma at third-cycle study level – though explicitly *not* a doctorate. It is hosted by Bergen National Academy of the Arts, and includes 28 students from 8 higher art education institutes and departments. Funding within the programme is for three years.[21] The majority of research fellows are enrolled at Bergen National Academy of the Arts, Oslo National Academy of the Arts, and the National Academy of Music; others are at the Norwegian Film School, Trondheim Academy of Fine Art, and the music departments of Tromsø, Bergen and Trondheim University. All participating institutions have a representative in the steering committee.[22] The programme intends to secure high-level artistic research and leads to expertise as associate professor. A research fellow has to participate in an interdisciplinary professional community, beyond their artistic specialization.[23]

Finland

There are five higher art education institutions with university status in Finland. The majority of doctorates are awarded by Aalto University and

Sibelius Academy (approx. 10 Doctors of Art and 8 Doctors of Music per year). There are doctoral programmes at the Theatre Academy, Finnish Academy of Fine Arts and University of Lapland, Faculty of Art and Design.[24] The Aalto University School of Art, Design and Architecture (formerly University of Art and Design Helsinki) implemented doctoral studies in 1981; the first doctor of art graduated in 1991. In Sibelius Academy the doctoral programme was launched in 1982; the first doctor of music graduated in 1990. The Theatre Academy began doctoral studies in 1988, the first licentiate graduated in 1991 and the first Doctor of Arts (Theatre and Drama) in 1999. In the Finnish Academy of Fine Arts the first doctor of art graduated in 2001.[25] A four-year doctoral programme in artistic research commenced in 2012 as a joint project of the art universities. It is the first joint doctoral programme, which focuses solely on artistic research and explores artistic practices, thinking and observation, focusing on (1) the methodology and practices of artistic research; (2) art, aesthesis and society; and (3) a new notion of artistic agency.[26]

Sibelius Academy, Theatre Academy and Finnish Academy of Fine Arts are going to merge into the University of Arts Helsinki on 1 January 2013. How their different research cultures and approaches to research will be synchronized remains to be seen. In Sibelius Academy three types of doctorates in music can be undertaken – artistic, scientific, and so-called development projects.[27] In the Theatre Academy artistic research is an institutional umbrella term, which allows a spectrum of variations.[28] In the Academy of Fine Arts the main focus is on artistic practice, accompanied by a written theoretical part.[29] It will be interesting to see what will happen when shared regulations need to be created to cover all these approaches.

Artistic research: some Finnish voices

One philosopher preparing the way for artistic research in Finland, Professor of Art Education Juha Varto notes that every field produces knowledge via its own methodologies. 'If we for instance apply the methods of cultural studies to art education research, we get cultural studies as an outcome . . . There is no such thing as a neutral research method.'[30] The same could be expected of the field of artistic research.

In one of the most influential books discussing the methodology of artistic research in a Nordic context, Mika Hannula, Juha Suoranta and Tere Vadén (2005)[31] use two metaphors to describe their approach: democracy of experiences and methodological abundance.

They emphazise methodological pluralism, openness, criticality and ethical encounters, indicating that art should have the right to criticize science and science should be able to criticize art. They stress the need for open-mindedness, patience and dialogue; artistic research needs time to develop a research culture. Artistic research is often

> a tapestry-like weave of many factors – the read, the known, the observed, the created, the imagined and the deliberated – where the author does not so much strive to describe reality but to create a reality for her work with its own laws.[32]

They note that '[t]he starting point for artistic research is the open subjectivity of the researcher and her admission that she is the central research tool of the research'.[33] As a criterion for the validity of research, following models from qualitative research, they stress the convincingness of its rhetoric and point out as the main requirement that the research be intersubjective so that future readers can assess its validity. They name five points that are of prime importance for artistic research: (1) presenting the research context and delineating the problems, (2) credibility and explanations, (3) the internal coherence and persuasiveness of the research, (4) the usability, transferability and novelty value of the results and (5) the meaning and importance of the research results to the artistic and research communities.[34] How these five points are understood in practice depends on the artistic domain in question and to what extent ordinary artistic practice in that domain is research-based.

Tuomas Nevanlinna, a philosopher engaged in debates on artistic research in the Finnish Academy of Fine Arts from very early on,[35] writes:

> It is often said that in artistic research the artist researches his or her own works. There are at least two possibilities of interpreting this: either the artist investigates his works as if they were not his or her works at all, or then he or she subjectively reflects on their background and intentions. These are bad alternatives. Actually we should not speak of researching one's own work. The artist does not research his or her works but with (the help of) his or her works.[36]

According to Nevanlinna, artistic research cannot be an exact science, but it could nevertheless be experimental. In experimental research a question is investigated with the help of an experimental arrangement.

The initial questions and works in artistic research could be compared with this: we ask, we do and then we write out what the dialogue between questions and works produced. This kind of process produces experimental knowledge but not mathematical knowledge. Thus artistic research differs from empirical research, which tries to find general laws. Nevanlinnna suggests, in line with Sören Kjorup's argument, that[37]

> Perhaps only artistic research will realise the program of 'aesthetic research' proposed by the inventor of the term Alexander Baumgarten in the 18th century: it produces knowledge of the singular. This kind of knowledge concerns the singular and the unique and cannot be generalised into laws, but it is nevertheless knowledge.[38]

Esa Kirkkopelto, Professor of Artistic Research at Theatre Academy Helsinki, proposed in a recent talk that: (1) an artist changes her artistic medium into a medium of research and (2) as a process of artistic research carries out and displays a certain change, it articulates itself as a medium of invention.[39] He stressed the shared and institutional aspect of artistic research:

> The *inventiveness* of an invention is in itself a matter of evaluation (is it something really new and different in relation to previous devices and modes of practice; does it have an impact on these?). But mere originality, or even ingenuity, does not suffice to make an invention research in any institutional or *academic* sense, to distinguish it from art-making and experimental art . . . Artistic research done by an artist *outside* institutions is worthy of its name only if it has institutional consequences and if it can articulate itself in relation to institutions, was it only in order to resist them . . . As a consequence, the criteria for evaluation would consist of considering *to what extent an artist-researcher is able to present their invention as an institution.* If they manage to do that, their research has significance to everyone, it produces knowledge.[40]

These examples of voices from Finland are exactly that – examples.

Sensuous knowledge in Norway

In Norway the Sensuous Knowledge Conferences – an international working conference on fundamental problems of artistic research organized by the Bergen National Academy of the Arts – have been

instrumental in developing a discourse around artistic research on an interdisciplinary basis, with a strong focus on artistic excellence and questions of a specifically artistic knowledge production. The conferences, as well as the related publication series, have had resonance far beyond the Nordic countries. Themes include: Creating a Tradition (2004), Aesthetic Practice and Aesthetic Insight (2005), Developing a Discourse (2006), Context, Concept, Creativity (2007), Questioning Qualities (2008), and Reflection, Relevance, Responsibility (2009).[41] The discourse has represented what Henk Borgdorff has called the *sui generis* approach to artistic research, in contrast to both the central European understanding of artistic research as a critical intellectual practice and the British focus on academic criteria as in much Practice as Research.[42]

Nordic Summer University in Sweden – developments in performing arts

Outside the academies and universities, Nordic Summer University,[43] based in Sweden with a structure of funded self-organized study circles, has provided an open forum for people interested in research in performing arts. In the proposal for the first study circle, *Practice-Based Research in the Performing Arts*, in 2006, the coordinators, Annika Sillander and Sidsel Pape, write:

> The discipline is characterized by a continuous search for a current and convincing definition and investigation into feasible working methodologies. PBR is alternately also called Practice as Research, Practice-Led Research, Artistic Research or Art-Based Research . . . We advocate that PBR can be understood as a thoroughly integrated approach and set of strategies. This implies a constant, mutual, and reciprocal influence between the artistic practice and the research activities involved. It requires a different point of departure in terms of attitude and motivation for all involved – whether primarily as artists, researchers or as reflective-practitioners. In this context, both artistic practice and research are re-imagined from the outset – within a collaboratively determined set of objectives and processes.[44]

Since the first study circle, which produced a publication,[45] the focus has shifted slightly; the current study circle is called 'Artistic Research – Strategies for Embodiment'. The topics addressed in the six sessions from 2010 to 2012 are language and discourse, documentation and dissemination. Referring to a meeting at the Centre for Practise as

Research in Theatre in Tampere,[46] the coordinators, Luisa Greenfield and Disa Kamula, write:

> The last winter session made it clear that the discourse has moved and changed. This presents the need for making a new platform for investigating the implications of this redirection. Henk Borgdorff, a European authority within this context, has claimed that the most interesting turn in the field is presently happening in the Nordic countries (Borgdorff, 2009) . . . We need to investigate consequences and possibilities of Artistic Research. We have passed the stage of justifying the existence of the field itself. It actually exists. We are entering a new discourse, and we need to explore the outcomes of the ongoing research . . . We see an urgent need for investigating artistic research in a wider perspective than it is presently done at the Art Academies and Universities.[47]

These two subsequent study circles exemplify collaborative developments within performing arts regardless of university regulations.

Publications and colloquia for artistic research in performing arts

Practice in some form is being increasingly incorporated into traditional theatre research and dance research contexts. NOfOD, Nordic Forum for Dance Research,[48] and the Theatre Research Society in Finland,[49] have included Practice as Research in their symposia and publications.[50] In an issue of *Nordic Theatre Studies* devoted to the artist as researcher, Rikard Hoogland tentatively suggests that we might be at the beginning of a paradigm, albeit with a long way to go.[51] A Finnish journal of artistic research, *RUUKKU*, modelled on the international *JAR*, is in the making.[52] CARPA (Colloquium on Artistic Research in Performing Arts) in Helsinki is gathering artistic and practice-led researchers on a post-doctoral level. In the first call the purpose was explained:

> Artistic research, art-based research, practice-based research, practice-led research, performance as research – these are just some of the terms and approaches that have been developed to describe knowledge production originating from artistic concerns. This colloquium is the first in a series of biannual colloquia, organised by the Performing Arts Research Centre at the Theatre Academy of [sic] Helsinki, aimed at addressing the problems and possibilities

of artistic research, particularly those involving the performing arts. The term 'performing arts' is here understood in a broad sense that encompasses a variety of different creative practices. The purpose of these colloquia is to contribute to the development of research practices in the field of the performing arts and to foster their social, pedagogical and ecological connections.[53]

The first CARPA in 2009 asked: 'How does artistic research change us?' Artistic research does not only produce knowledge; it also changes us as individual and collective beings – artists, pedagogues, spectators, citizens, and consumers. Could the change itself serve as a criterion for the relevance of the research? The colloquium wanted to discuss and share experiences on the transformative dimensions of artistic research practice.[54]

The theme of the second CARPA in 2011 was 'Artistic Research in Action'. The colloquium was to take the form of a collective laboratory in which participants could share their research as it takes place and unfolds and aimed to explore the borderline between artistic research and action research. An artistic researcher transforms his/her artistic medium into a medium of research. 'Medium' is here understood as both the means and the object of reflection. Artistic research can claim validity only through taking place in action.[55]

The third CARPA, in 2013, will focus on 'The Impact of Performance as Research' and takes as its starting point the increasing demands of impact placed on all forms of research today. It wants to look at the performance of artistic research and the various forms of effects, affects and side-effects produced. Questions cover a broad range:

> How do expectations on efficacy relate to the so-called performative turn in social sciences? What is the relationship between artistic research and performance studies? What forms of shared authorship and collaboration does performance as research support? What are the results of our research projects?[56]

Proposals are invited related to: (1) performance studies and artistic research, (2) performance-as-research and (3) performativity of artistic research.[57]

The relationship between artistic research and performance studies is particularly interesting, since performance-as-research could be seen as situated in the intersection between them. Performance studies acknowledge performance practices extending outside the realm of art

into the everyday; artistic research extends the academic traditions of performance studies, 'doing' what performance studies have propagated but not always realised.[58] Impact refers also to the performativity of artistic research. Is performative research an extension of qualitative research or a distinct paradigm, research that produces what it names?[59] Is artistic research producing effects in the world, being successful or unsuccessful (happy or unhappy), rather than true or false?[60] How can we study the relevance of artistic research from inside the practice? What kind of impact do we expect to produce with our artistic research?[61]

In place of a conclusion

From my perspective, as a person who actively worked for the abolition of the dichotomy between doctorates with scientific emphasis and artistic emphasis at the Theatre Academy, artistic research as an umbrella concept that embraces various approaches to the relationship between practical and theoretical parts seems useful.[62] Experience has shown, however, that diversity is not easy to maintain, because many scholars and researchers find it hard to see as truly legitimate any other form of research than the one they have been trained in.

In Finland the university law maintains, as noted, a dichotomy between scientific versus artistic domain, and on a legal level any blurring between them is impossible. But, by granting equivalence to art, and a specific status to art universities, a new possibility has been opened up. Within the artistic realm we can demand what we want of a doctorate, even an equivalent of a traditional PhD. Thus the artistic domain leaves the door open to many types of research. If sciences (especially *humaniora*, perhaps) want to maintain and guard a 'normal science' paradigm, the arts can offer an intellectual arena for experimentation and debate. This is perhaps what some critics mean by describing artistic research as a fairground for free-floating intellectuals, whose only artistic practice is writing about art.

Another paradox is that many artists are uninterested in practice-as-research. They engage eagerly in their practice of course, but are also genuinely interested in writing theory or using theoretical studies to inspire them in art-making. They are not always happy to articulate their experiences of practice, although that would be valuable, as a basis for teaching, for instance. Some research projects by art pedagogues using qualitative methods are actually more practice-based (starting from data rather than theory) than research by artists who combine theoretical studies with public performances or artworks to

be examined as part of the research. A tendency among practitioners, who are working as designers or actors and dancers in collaborative and/or hierarchical structures, is to investigate and criticize those structures and conventions, whereas independent artists, directors, choreographers and performance artists are more concerned with the ethical and political implications of their work.

The place of the artwork or artistic practice in the research process can also be a problem. I have argued elsewhere that it could be useful to try to choose whether you use your artistic practice as data (as in qualitative research), as method (as in some types of practice-led research) or as a research outcome (as in most Practice as Research) or even as the mode of distributing research findings (as in so called art-based research).[63] However, in actual practice all these uses tend to (and perhaps have to) become mixed. Add to this the fact that what most people discuss as the research outcome and what remains to be quoted is often the written part.

Scholars engaged in qualitative research easily tend to incorporate artistic research as one approach or method among many like narrative research or action research. Scholars, curators, and administrators in higher art education prefer to see artistic research as a field, an area of knowledge and a discourse in the making. To some extent this is a question of priorities; many qualitative researchers seem more attached to methodological debates than to any specific field. The same might be true for practice-led research, since there are practices in each and every field.

If we accept that artistic research is a field rather than a method, then the question of defining the field becomes crucial. And we can ask whether artistic research is adequate in areas where the connection to contemporary art is weak. If artistic research is a field, are not all methods useful in contributing to that field, or in principle available to artist-researchers? Or should we rather try to develop specific methods based on artistic practices that produce knowledge specifically for this field? Moreover, if artistic research is a field, who defines its topography, the curators, producers and critics writing about it, the philosophers debating its legitimacy, the funding organisations calibrating their policies, the institutions of higher art education writing their regulations, or the artistic researchers themselves with their case studies stretching existing expectations? Hopefully these cases slowly but surely build up to a legacy that can be cultivated and challenged.

10
Practice as Research in South Africa
Veronica Baxter

In Chapter 1 of this volume, Robin Nelson quotes David Pears, relating Practice as Research to the act of riding a bicycle, in that we are striving to make conscious that which we know unconsciously. So the act of practice (riding the bicycle) is placed under scrutiny (the research) in order to find out which muscles are employed when, what the balancing entails, how propulsion forward is directly related to balance and probably also the important aspects of using the brakes and knowing how quickly you can get your feet to the ground. In the research, unconscious knowledge is brought to consciousness. In the process there is a serious risk that thinking about isolating muscle-memory and dissecting embodied knowledge may result in a fall, but the research cannot be conducted in any other way. In order to research riding a bicycle, we must actually ride.

In South Africa the Practice as Research (PaR) methodology is quite new, and is not officially recognized yet by the academy. The main focus of this chapter is a discussion of why PaR in theatre and performance is particularly rich in potential for South Africa, and the difficult processes of demanding recognition for PaR by the academy and the national Department of Higher Education South Africa.

South Africa is a society in transition, and is particularly rich with possibilities for the PaR methodology because of the national project of reconstituting South African identities, the extreme socio-political and economic difficulties, and the move to restore memory through performance. The first part of the chapter will recount some examples of where PaR has been the only suitable methodology across a range of applied theatre and performance contexts, and argue that a major factor in this process is what Walter Ong (1982) calls 'secondary orality' (see below). The urgency of acknowledging PaR will be contextualized

in this discussion, and the current project seeking recognition from the national Department of Higher Education (DHE) discussed.

It is not only crucial to take action to develop South African society, but also to find a way of carrying out research into that development. Part of the argument that will be developed below suggests that new methods of research need to emerge that encompass the breadth of work, and that close 'the knowledge gap that resulted from imperialism, colonization and the subjugation of indigenous knowledges', and support the 'reclamation of cultural and traditional heritage'.[1]

Secondary orality

South Africa is a society that is coming to terms with its identity, and part of the manifold experiments with cultural diversity is carried through performance Practice as Research. There is a sense in which Practice as Research serves the South African theatre-making fraternity better than other methodologies, because the society is geared towards lived and often communal experience as a way of knowing. To a great extent most of South Africa is based within 'secondary orality', that is, a society that is literate but which has strong connections to orality. A feature of secondary orality is the reclaiming of the pre-literate society's interconnectedness as community. While Ong intended to comment on the rapid rise of communications technology like television, his analysis of secondary orality takes on a powerful dimension when it is used to frame the theatre-making practices in South Africa.

Part of Ong's analysis involves the way in which knowledge is constructed through a collective process, where feedback is immediately provided though dialogue. This new knowledge is collectively owned, but also allows for individual interpretation, flexibility and contextualization; it transcends time and place, but also allows for situational and abstract or analytical thinking.

This new orality has striking resemblance to the old in its participatory mystique, its fostering of a communal sense, its concentration on the present moment, and even its use of formulas.[2]

In South Africa the post-1994 emphasis has been on trying to understand and rebuild a freed nation, develop new identities that arise from the past, work within reconciliation and reconstruction and develop an all-embracing tolerance and pride. Much of South Africa's fraught past was constructed as embodied, racialized 'difference'; the theatre has sought to reframe the debates about 'difference', articulate new ways of being, reclaiming and redeveloping understanding of ourselves,

through collective processes that mined the stories of the pre-literate past, and of the connections between past and present.

However, another way in which the theatre has sought to intervene in South Africa's present is through theatre as education or development, in conditions of poverty, disease and social inequity. The majority of these theatre projects have been directed to communities and groups of people who were systematically deprived and disempowered through apartheid. The circumstances of this work in communities were all the more complicated by fragmentation or disintegration of social order and norms through for example, migrant labour, exile, multiple deaths, corruption and infrastructural capacity.

Theatre and health education

In the early 1990s DramAidE (Drama Approach to AIDS Education), led by Lynn Dalrymple, formulated an approach to HIV preventive education, based on a three-phase intervention in schools in KwaZulu-Natal[3]. The first phase was the delivery of a catalyst play to school children in halls or in the open air, on the themes of HIV prevention. The second phase was smaller, group-process drama interventions in classrooms with pupils and teachers, developing knowledge around the virus, and discussing the social attitudes that gave rise to increased risk of infection. There was traditionally a break between the second and third phase, because the latter was a community open day, where the school would host a day of plays, music and dance performances and displays of posters – centred on the theme of HIV prevention learnt by the school in the preceding phases. There would be food and drinks, sometimes even a *'braai'* (barbecue), with a budget partly provided by DramAidE. Inevitably there were some who asked what a serious business like HIV education had to do with a party.

This third phase was, however, an inspired idea, a crucial opportunity for the community to come together around its school, and for the DramAidE team and its researchers to see how much of the information from their play and workshops had filtered through to the popular imagination of the community. It was through this encounter that there was a chance for the HIV information to be disseminated through the plays and posters, in communities that were rooted in 'secondary orality'. In respect of research to produce 'new knowledge', this raises the questions, 'Knowledge for whom?' and 'Knowledge to what purpose?' At the same time as DramAidE's work in the schools of KwaZulu-Natal took place, researchers struggled to find a way to measure the impact of

the work on local communities. Various methods were under constant discussion and testing, ranging from quantitative measures of condom supplies, reduced teenage pregnancies reported in local clinics, to qualitative evaluations of knowledge, attitude and behaviour change. All of the methods used for evaluating had their difficulties, not least because HIV/AIDS education must encounter the various taboos around sex and cultural practices in a culturally diverse society like South Africa.

During one of the many discussions with Lynn Dalrymple about research (while working with her at the University of Zululand) we were debating what constituted a research outcome. I suggested to her that the plays performed at Open Days were outcomes that indicated through the pupils' own practice what they understood about HIV (and theatre). It was knowledge that they could only manifest through performing their own plays – in a sense the medium was also the message. The pupils could perhaps only articulate through the medium of the play what they knew and understood, in part because this was a safer way to engage with a 'hot' topic, and the performance licensed them to be a bit 'rude'. But mostly the performance aspect of a play, with dancing and singing, was a familiar and communal way to interact with the information, and new knowledge was in the process of being embodied in the individuals concerned and in the community.

One of the outcomes of working through what Marie-Heleen Coetzee calls a 'performative inquiry' became evident in the accounts of sociocultural attitudes collected from workshops with senior school pupils.[4] For example, in one account of DramAidE's workshop 'A Man and Woman on the road to Life', drawing upon Boal's work, a tableau in a drama workshop may show a picture of a fierce, proud Zulu man holding a stick in his hand (Dalrymple, 1996). Behind him is a woman carrying a heavy load on her head and a baby on her back. Participants are asked to react to the picture, encouraged to change it, and provide reasons for the change.[5]

Another Zululand experience in 1995 persuaded me that theatre could be used as a means of research to uncover issues and attitudes that may otherwise be glossed over or missed by more established research methods. As part of a participatory rural appraisal (PRA) team in a rural village in Zululand, I introduced methods of mapping community structures through Image Theatre and dramatic scenes.[6] During one of the core appraisal exercises conducted with senior, male members of the community I was asked to work with women and youths. Initially I was annoyed that both these community groups were not part of the core activity by virtue of their age and gender, but in a short space of

time I realized that the insider knowledge that they held was valuable to the research. For the sake of brevity I shall discuss only a small group of women, who had been asked to describe their difficulties in the community through presenting a theatrical scene. The scene showed a woman receiving a handwritten letter from her migrant labourer husband, who was away working in a city. She was distressed because she wanted to hear the news from him, but was illiterate. She sought help from her neighbour who could read, but was the village gossip. The neighbour extracted payment for reading the letter by requesting the woman to clean her house. While she swept, her neighbour sat drinking tea, and reading the letter out loud to her, and anybody passing by. The letter was gradually revealed to be quite intimate, about how much the husband missed love-making with his wife, and speculated about what would happen on his return from work for the holidays. The neighbour shared these intimacies with passers-by with great embarrassment on the part of the woman.

The scene was shown back to the whole community among several others, but stood out for the perspective it gave on the plight of illiterate women,[7] where it was deemed to be information that would not have emerged if it were not for the dramatic scene. The scene itself was clearly a research outcome, equally valid as either the collectively made timeline of the area's history, or the counting of livestock and patterns of ownership. Once again it was embodied knowledge that described a social problem, relationships of power, labour exchange, and hinted at patterns of migrant labour in the community. Moreover, the accolades of the community and researchers for the scene clearly empowered the women in the moment.

In the examples above what became clear is that 'new knowledge' emerged through the 'performative inquiry', contextual knowledge that would not have surfaced by other means and knowledge that was particularly rich and textured. In the above examples, the research outcomes emerged at particular moments in an ongoing process of research, and the moments of understanding emerged through performance. One of the difficulties faced in this type of PaR is the hierarchy of venue that is in place. It is far more difficult to receive acknowledgement that community-based work is not necessarily an educational or development practice, but can be investigating people's lives and their performance practices. Other PaR that is studio-based, or part of development, therapy or education in community halls may not, however, have such opportunity for snapshot-like outcomes.

PaR in performance: theatre-making as research

Fast forward then, to my becoming a performer in a production of *BlueBeard*, devised by a cast of township and university-trained performers, under the direction of Tamantha Hammerschlag in 2005. I wished to conduct research into the physical and vocal 'vocabularies' of the performers (as part of a Theatre Anthropology/Interculturalism research project funded by the National Research Foundation in South Africa). Hammerschlag asked me to become a performer, to conduct my research as a fully immersed participant, as the narrator figure in her dark tale of *BlueBeard*. I was to be a survivor of Bluebeard's charms, who commented from her chaise longue, eventually the 'bourgeois bitch' who spied on him. I became as much an observer of Hammerschlag's processes as those of the rest of the cast. The most illuminating moments of practice were those associated with making the narrator's songs for the piece.

I was called upon to make songs from scratch. I would warm up at the start of each one-to-one session by singing a few songs from my childhood and moving about the rehearsal studio. Hammerschlag would ask me to choose songs that were simple, or just repeat a chorus or single thread. Some of my choices were 'London's Burning' (in Xhosa)[8] and 'Amazing Grace', and once I had settled into the song, I was to play with the sound of a particular section of the melody or rhythm, repeating and developing it into something completely different. When she sensed that the time was right, she would slip me a tiny piece of paper with one line on it, part of a whole. I would play with this one line, and slowly she would feed me more, out of which gradually a song would emerge. For example, 'London's Burning' became a song with a verse, 'This place is littered with the souls of the dead, everywhere I look they're around me, everywhere I go I can smell them.' At some point in the rehearsal process, the cast physically manipulated me from side to side, pushing and catching me, influencing the rhythm of the song and my breathing – deliberately destabilizing my balance and breath and therefore the song, a state of voice which I needed to reproduce in performance.

In devising theatre or in studio work, this is the type of outcome that only emerges through embodied practice. I could only know that I knew how to make songs, through doing. I could only investigate the vocal impulses, combinations of sound and words, breath control and release, tension in the throat and body that gave rise to performance, through singing in the studio, rehearsing changes, development and performing the final piece.

At the same time, I was asking in critical reflection how I came to be drawn to certain types of melodies, certain ways of phrasing in singing, rhythms that are derived from my musical heritages. An audience member memorably asked me how I could 'sing beautifully about terrible things', and another commented on the Celtic lyricism of the songs. In addition to the physical processes of making the songs, I also questioned my musical 'vocabulary' – if there was a default mode of music that I gravitated towards. I questioned how my mixed Western and African heritage shaped my song-making, an aspect of PaR that is increasingly part of performance-making.

Mandla Mbothwe is a theatre maker and writer in South Africa who has consciously created theatre that investigates the connections between past and present, the spiritual and secular, the theatre worlds of Westerners and Africans. In an account of his production, *Isivuno Sama Phupha*, Mbothwe[9] describes a ritual performance that seeks to break with Western theatre traditions, explore the notions of Victor Turner's 'communitas', and theatrically describe the social processes of 'Breach', 'Crisis', and 'Redress' through either restoration of peace or recognition of irremediable schism.[10] The theatre production leads the audiences through embodied and visceral experiences culminating in a potential celebration of 'communitas', or in South African terms, '*ubuntu*' (interconnectedness).The key aspect of this process for Mbothwe is Victor Turner's stages of social drama, which seek

> to create a liminal state in which performers and audience participate in physicalizing and visualizing dreams, a theatre where people are given a chance not to wait passively for change, but rather to be part of generating and becoming that change. By so doing a spirit of optimism and possibility is felt and experienced in a way that can be taken forward in the daily lives of *all* participants.[11]

The production was crafted by Mbothwe with a group of actors from Khayelitsha township in Cape Town and students from the University of Cape Town Drama Department, through a PaR method. He explains that he consciously sought to create liminal ritual experiences that investigated what he refers to as his 'African Dream Play', citing the influences of August Strindberg, South African theatre-maker Brett Bailey, and Nigerian writer Ben Okri.[12] He and the actors created a 'dream dictionary' in order to 'foster a clear understanding of structure and dream aesthetics' which then became embodied performance. The final production was made in a participatory and collective

process, and its performances were an embodied research report to its audiences.

Marie-Heleen Coetzee similarly suggests that making a performance with students at the University of Pretoria was concerned with the contemporary South African identity.[13] For her a 'performative inquiry' in part 'foregrounds the body as the site/site of becoming, of storying and of hegemonic signification with regards to identity'. The result of the work, *Shiftings 2007*, allowed students to reach new understandings of their own changing identities as South Africans, and also allowed them ownership of and increased insight into their curriculum on contemporary performance, 'by encouraging them to re-position, re-iterate and re-imagine themselves in/and their wor(l)ds[14]'.

In a different context, theatre dramaturg Mark Fleishman and various creative arts practitioners are seeking to rework the stories of the /Xam[15] in a region around Clanwilliam, in the Western Cape. The stories were written down in translation by William Bleek and Lucy Lloyd (1870–84), and now form part of a University of Cape Town archive. As Bleek predicted, the San were doomed to lose their languages and culture, and therefore he and Lloyd wrote down the words of men serving prison sentences in Cape Town. The key informant, //Kabbo, stayed on after his prison sentence was over, seemingly lured by the idea of a legacy of words that could survive past his death.

Each year the University of Cape Town's creative arts departments take one of the stories from the Bleek and Lloyd collection to Clanwilliam, the landscape where the /Xam people were based. Through a week-long process of workshops in performing and visual arts, the story is reworked by the local communities, 'not as the /Xam would have told it, but recast for our time',[16] culminating in a set of performance events and a lantern parade. Fleishman argues that this is

> [a] remembering that must be worked at, brought into being, creatively imagined, re-invented, collectively sustained, argued over each and every time. A remembering that is never complete, never stable, never fixed once and for all.[17]

Echoing Coetzee (2009), Fleishman is suggesting that performance is a way of knowing, and one which allows the South African to build the 'capacity to aspire'.[18] Fleishman summarizes the strengths of the PaR methods for South Africa (and his own position):

> [P]erformance involves acts of storying, sounding, moving, feeling and relating that are all embodied and constitute alternative

ways of knowing that are non-representational, experimental, and potentially political, both in the sense of transforming knowledge in the academy but also as a means of creating voice in marginalised communities.[19]

Practice as Research recognition in South Africa: the academy

Given that performance has this potential for South African research, how do the academy and HE sector respond? PaR is sufficiently onerous that perhaps anyone without the stomach for it should be recommended to another type of research. Certainly PaR is currently one of the least rewarding ways to earn research kudos in academia in South Africa.

The difficulty faced by theatre and performance academics in South African Higher Education (HE) is that the majority are deemed to be both researchers and practitioners, unlike their European counterparts where traditionally there has been a split. HE institutions in South Africa usually offer a liberal arts degree with drama as a major subject, or more specialized training through a performer's diploma or a programmed drama/theatre/performance degree. The academic members of the twelve drama/theatre departments in HE institutions in South Africa are all required to conduct research, as well as fulfil their teaching, administrative and social responsibilities.

The performing and visual arts disciplines across the country have long been victim to rather cavalier attitudes to their research practices by the public and government. However, there have been a few changes in the recent past that give reason to hope that in the longer term there may be a satisfying change in attitude and policy. In the first instance, the White Paper on Higher Education 1997[20] allowed that performing and visual arts were to be accorded a higher level of subsidy from the government in the calculation of funding, because of the need for laboratory space and practical processes – similar in earning FTEs[21] to the formula for physics or chemistry.

This new provision meant a lot to endangered arts departments, departing from the usually held opinion that they did not belong in the academy because they were applied disciplines, and that they were too expensive for too few results and throughput. This placed the arts disciplines on a more secure footing within the academy, in how their teaching was costed. The thorny question remains of how to evaluate and reward the research outputs of creative arts practices, since articles in accredited journals, chapters in academic books and

certain conference proceedings are subsidy earning in South African HE institutions.

Efforts to gain recognition for practitioner researchers in the performing and visual arts in the HE sector have been underway since 2005, with some progress. For the sake of brevity only the project between twelve drama/theatre/performance departments at HE institutions in South Africa will be discussed in any detail.[22]

In 2005, representation of the drama departments of the twelve universities convened to begin a project to establish and test criteria for the evaluation of Practice as Research. Led by Mark Fleishman, the project tested a set of criteria, a peer review process and a self-evaluative mechanism as a potential procedure for evaluating submissions of PaR. In the first instance, the researcher would provide the reviewers with a framing document about the research. The research output would be reviewed in conjunction with the framing document, against the criteria that had been decided upon as follows:

- How does the product/process viewed relate to the framing?
- Does it contribute to current practice and the advancement of knowledge in the discipline? How and to what extent?
- Does it reflect theatrical and/or dramatic accomplishment and a creative signature, relative to the particular nature of the project and its context?
- To what extent does the product and process impact upon the context, the discipline or the viewer (scope/complexity/effect/affect).[23]

Each submission was to be reviewed by three peers, including at least one reviewer seeing a performance live. In addition to the framing document, and after the performance or project had been completed, the researcher would have to provide:

- a self-reflection on the project;
- a report on the reception of the work in the public domain.[24]

Six submissions from a geographic spread in South Africa were used to test the criteria and the peer review process. Significantly, five of these submissions were for discrete performance productions, and only one for process-oriented research practice, where what was evaluated was a 'snapshot'. There was a great deal of debate around the necessity of experiencing the production or process 'live', especially given the distances in South Africa and the costs of travel. Peer review of

'live' performance projects has budget implications, especially when performer 'presence' is part of the evaluation. Questions were raised about 'live' peer review when sensitive work was being conducted in closed applied theatre processes (e.g. therapy) where an outsider attending could have a negative impact. Despite the constraints, the project brought many important ideas to the surface.

The project (2006–08) raised consciousness of PaR for practitioner-researchers in drama departments across the country, even if one of the recommendations was that further research training and development within the academy was necessary. The criteria were deemed mostly successful, the first two specified as most important, and the notion of 'an evidence box' of additional information (e.g. video clips, reviews) very useful for reviewers. Further recommendations were about the management of peer review by a national body, how to 'publish' the PaR projects, and advocacy of PaR to individual institutions' research managers and national government.

Another project, convened by Sandra Klopper (then of Stellenbosch University), incorporated all of the arts disciplines, and together these projects provided critical mass to pressurize the Department of Higher Education and Training to establish a working group. The university sector Working Groups for the Creative and Performing Arts submitted proposals to the national Department of Higher Education (DHET) in late 2011, arguing for the recognition of PaR as subsidy-earning, and suggested assessment criteria.

These proposals (for the recognition and reward of outputs from the creative and performing arts) are still under consideration by the DHET, but, at the time of writing, no changes have been made to the current system in which only published journal articles, chapters in academic books and certain conference proceedings are counted for accreditation and related subsidy-earning for the academic institution.

The proposals to the DHET are numerous, in the disciplines of Design, Architecture, Music, Fine Arts, Literary Arts, Film, Media and Television, and Theatre and Dance. For the sake of brevity, only Theatre and Dance will be discussed here, where six types of output are under consideration: Directing, Theatre-Making/Dramaturgy/Choreography, Performance, Scenography/Design/Performance Technology, Performance Processes, and Interventions.

What is evident from the criteria presented in the proposals is that the criteria present a hierarchy of venue, with higher points awarded if the theatre product or process is presented on a significant local, national or international 'platform'. While the criteria clearly intend

the hierarchy of venue to be a way of validating the work as research through sharing products or snapshots of process, they nevertheless create certain biases. Since studio-based or community hall PaR (as in some of the examples mentioned earlier) is not a 'platform' where the work can be reviewed, some other means of sharing the research would need to be found, which reverts researchers back to writing, or perhaps digital archives such as Russell Kaschula is creating of oral performances in Xhosa and Zulu.

Another bias in the criteria is towards the urban experience, where theatres and public spaces are easily reached by researchers. However in South Africa this is a little like conducting research into rural poverty by looking at informal vendors along national highways. Arguably, the outcomes of research in performance will remain linked to education, psychology, sociology or anthropology rather than artistic, aesthetic practice, because these performance practices happen in community halls, dusty fields, and poor schools. The criteria beg the question of whether indigenous and rural performance forms will always be viewed and researched as social anthropology or 'traditional'.

In South Africa, the questions surrounding PaR are complex, and speak as always about the nation in the process of becoming. As is evident, despite slow and sure progress, we still have some way to go in South Africa before the value of PaR and the distinctive kinds of knowing it produces are fully recognized to be of benefit to all – within the academy and in broader culture where its potential, as indicated, is so great.

11
Why Performance as Research? A US Perspective

Shannon Rose Riley

Resistance is futile – or, why resist?

Practice as Research (PaR) doctoral programmes are not well established in the US, and are established least of all in theatre and performance. The conventional 'terminal degree' in arts practice in the US continues to be the Master of Fine Arts (MFA).[1] Moreover, the bulk of conversation (or fierce debate) about PhDs for artists (PaR or otherwise) has been in the area of the visual arts, to which performance art lays substantial historical claim.[2] Several fairly new practice-based doctoral programmes in visual arts currently exist in the US – and, as Nelson notes in Chapter 1, James Elkins forecasts their increase as inevitable.[3] Yet there are only one or two established PhD programmes in theatre or performance framed up as practice-based programmes or as having a substantial and required practice component: the Practice as Research strand in the PhD in Performance Studies in the Department of Theatre and Dance at the University of California, Davis and to a lesser degree, the PhD in Theatre Performance in the Department of Theatre and Dance at the University at Buffalo.[4] I suggest this disparity is partly because the visual arts in higher education in the US have been thoroughly saturated with theory for the last few decades, primarily in the independent art schools such as the School of the Art Institute of Chicago, the School of the Museum of Fine Arts at Boston, Maine College of Art, and so on. For some time, nary an undergraduate art student at such schools has been able to avoid taking required courses in critical theory – much less graduate students pursuing the MFA in studio art.[5] Contrary to this, theatre departments in US universities have embraced the theoretical turn rather recently and remain more divided between theory and practice than the visual arts, despite the aims of performance studies

to challenge such distinctions.[6] Moreover, the integration of theory seems to have occurred predominantly at the graduate level and even then, most MFA acting programmes eschew critical theory and most PhD programmes limit or curtail performance practice.[7] An incredibly tenacious theory–practice divide continues to exist in terms of most undergraduate teaching in theatre in the US.[8] The lack of integration of theory at the undergraduate level may be part of the reason why theatre lags behind the visual arts (in this context, I group performance art with the latter) in terms of conceiving arts practice and theory as fruitfully imbricated within one another – but it is not the whole story.[9]

Why does the US academy seem reluctant when it comes to practice-based research in the arts and with regard to performance as research in particular? Why resist 'the PaR initiative', as Robin Nelson succinctly puts it? Is resistance futile, as Elkins seems to suggest? Are more PaR doctorates in performance – or of any kind – likely in the current climate of US higher education, particularly in the arts and humanities? Is PaR likely to take hold given devastating financial cutbacks and the gutting of the arts in higher education (indeed, across all levels of education in the US), given that humanities and theatre programmes are at risk of termination even in well-funded universities?[10]

It is not only, or even primarily, that the US academy rejects *qua* knowledge the modes of knowing that PaR work engages and produces. Nor is it simply that US programmes are going broke and cannot spend resources on new doctoral initiatives. Indeed, one well-known US scholar suggests that Performance as Research (as it is most frequently referred to in the US) may be a way out of the current predicament in theatre higher education (a bit more on this below).[11]

Some of the resistance against the PaR PhD has to do with turf since many institutions and individuals want to protect (1) the value of the MFA as a terminal degree and (2) the sacrosanct divide between theory and practice on which many scholarly identities are based. This last seems strange in performance studies, given its scope and aims. Yet at the same time it is not uncommon to find scholars using some additional component of performance in a conference presentation, for example. However, even this kind of work may not be helpful when it is weak precisely because it lacks a trained professional practice. Shannon Jackson has written, for example, about the problem of thinking one can simply borrow across disciplines without substantial research and practice.[12] In the current situation, these same scholars might continue to be suspicious about what artists can bring to academic discourse. Bringing elements of practice into scholarship seems to be a new way for scholars

to become more 'creative' and still maintain a power hierarchy in terms of the production of knowledge. I would suggest that this generates an unfair exchange in that scholars seem to think they can dip into the arts, but are very nervous when artists move into scholarship.

In addition to these issues, a substantial part of the problem of translating PaR to the US is structural. PaR initiatives have developed primarily in the UK and other countries with national research audits like the RAE, and there is no comparable process in the US.[13] The National Research Council did conduct something like the RAE in 2006 but it took five years to publish the data, was incredibly expensive, and most participants nixed the idea of attempting the process again.[14] There are just too many universities in the US – as compared with the UK or even compared with larger geographic areas with smaller populations such as Australia. There are too many individual states, financial stakeholders, and governing bodies involved.

Most of all, the US does not use government-led research audits to determine university, department, or programme access to funding and resources, at least not on a nationwide scale. And this gets to the primary structural difference as I see it: funding. As has been noted elsewhere, funding issues were at the root of the formal emergence of PaR in the UK and elsewhere.[15] In the early years of UK national research audit (RAE 1992, 1996), the relatively traditional research of the few long-established theatre departments featured more strongly than emergent PaR, since acceptable research models for the latter remained in development. Accordingly, theatre departments missed an opportunity to achieve funding in the research-driven national higher education model. In response, theatre programmes set up a working group on practice and research in order to develop criteria that the RAE might accept for assessment of theatre practice as a mode of research and therefore open the door for funding opportunities. Articulating the work as research kept the programmes funded and the work alive, and since then PaR in performance has undoubtedly produced innovative work that motivates scholars and practitioners to see the model spread in higher education. Interest in PAR in the US arises from slightly different motives than those just described. Some interest in PaR may in fact be economic (about programme preservation), but the basic structures are so substantially different that rather than increasing access to funding, PAR and PaR work in the US is very difficult to fund or excluded from funding entirely.

In terms of grants and funding for scholars engaging in interdisciplinary PaR work, a kind of professional siloing appears that reproduces

a divide between practice and theory despite decades of conversation on interdisciplinarity.[16] In other words, one can be interdisciplinary across academic disciplines or across arts practices, but if one produces interdisciplinary work across the arts and scholarship (if one does PaR work), funding sources will be practically non-existent. In the US, funding sources separate practice in the arts and academic research in the humanities absolutely (e.g. the National Endowment for the Arts *versus* the National Endowment for the Humanities). Private sector funding agencies tend to follow suit. For this reason, scholar-artists producing innovative work that crosses the theory–practice divide currently have to vet themselves and their projects according to the funding source, presenting either as an artist or as an academic researcher. US funding bodies (both public and private) would need to change dramatically in order to support the professional activities of scholar-artists, if we were to seriously implement PaR initiatives in US higher education.[17] Indeed, the problem here is because funding bodies have not articulated truly interdisciplinary assessment strategies to keep up with the call for interdisciplinary work in the academy over the last decade or so, as much as it is because of a conscious rejection of certain kinds of work *as* knowledge. Add to this a kind of anti-art stance on the part of the US nation and you have a very difficult funding situation for the implementation of PaR. For example, the National Endowment for the Arts primarily stopped funding the experimental work of individual artists decades ago. It does not seem coincidental to me that the countries where PaR initiatives flourish, such as the UK, Canada, and Australia, have governmental funding structures available to support individual artists' grants and for supporting PaR work.

Other aspects of resistance to PaR may have to do with what I see as a general faculty mistrust of administration-driven assessment agendas in US higher education. Indeed, there is a powerful phenomenon in the corporatization of higher education in the US. Much of its current toolkit consists of 'deliverology' approaches, deepening budget cuts that keep programmes reeling and unable to reorganize, and undermining pedagogical and curricular freedom and decision-making, often through the rhetorics of assessment. Indeed, deliverology is also an import from UK higher education – and one that has not gained much sympathy among faculty in the arts and humanities for many reasons, including, at least in California, its STEM-obsession (Science-Technology-Engineering-Math).[18] Given what I see as an anti-assessment and anti-systems climate in the trenches of higher education in the humanities and arts, some of the language of PaR may indeed be off-putting to some faculty (research

outcomes and so on) but outcome-obsessed administrators may like it quite a bit.[19] It should be noted, too, that deliverology is just one example of admin- and finance-driven research audit culture and that such culture, broadly, is not unique to the UK – hence the ability of 'deliverology' models to translate so neatly to US higher education. As Jon McKenzie notes, performance management culture is a phenomenon that emerges alongside the service/information economy.[20]

Elkins rightly cautions against an uncritical translation of the UK scenario into US academia – at least at the level of language.[21] Specifically, he warns against letting 'UK administrative terminology' determine the theoretical and practical shapes of similar (or dissimilar) PaR programmes in another context.[22] That makes good sense to me and I do not see it as an outright rejection of the PaR model, just a critical reflection on context and need. Both Elkins and Charles Harrison, rightly or wrongly, view PaR initiatives as a top-down administrative agenda, and in that regard are somewhat suspicious of the ultimate aims.[23] Yet the history provided in Part I suggests that UK PaR, at least in performance, emerged more 'from below' than through administrative design (albeit under duress and from within the regime of research and assessment laid out in do-or-die fashion by the RAE). If we keep this history of PaR in mind, perhaps we can draw some useful parallels with the situation in theatre higher education in the US.

What would US arts programmes gain by developing doctoral tracks under the rhetoric of research and new knowledge? To develop a potential market in a new doctoral area is surely one possibility. But is it sustainable given funding and associated issues? What would US arts programmes gain by integrating the rhetoric of research and new knowledge into the arts at other levels of higher education? And how do we distinguish between creative process that is a form of research from that which is not? I have seen a lot of work that I would not call research. I also believe there is something vital at stake in making that gesture as an artist – and by saying all art is research, I worry we may lose that critical ability. I also am concerned that saying all creative practice is a form of research or produces new knowledge is like saying that all writing is research and produces new knowledge. We write for many reasons and in many ways – we use various expressive systems for many reasons and in many ways. Sometimes it is research and sometimes it is not. And if practice and scholarship are to be more porous, then how are we to account for or prevent weak performance work being done by some scholars and weak scholarship being done by some artists? It is clear what was at stake in the UK when

it came to calling arts practice a form of research, but it is not entirely clear what the stakes are in the US.

If the motive is to bring the artist from the margin and into the centre of higher education and scholarly debates and discourse, then George Smith, founder of the Institute for Doctoral Studies in the Visual Arts, suggests that PaR is not the only possible answer. Rather, he describes a need for a wide range of possibilities, even as his provocative essay cautions that in the US context,

> No matter how eloquent and compelling the argument that studio practice comprises academic research, no matter how much theory is included in the curriculum, odds are the studio PhD still will be pegged as a practical degree in the American academic hierarchy. As such, in all likelihood it still will be relegated to the university fringe – at least for the foreseeable future.[24]

Why embrace PaR? Some fruitful possibilities

Despite these and other important critiques and concerns, it seems there are tremendous possibilities for PaR approaches in US higher education. It should be noted, first of all, that UK models for Practice as Research in performance were used to develop both of the PaR doctoral programmes mentioned in my introductory paragraph: the evaluative mechanisms used in the Davis programme are based partly on guidelines published by Robin Nelson and Stuart Andrews and the Buffalo programme credits PARIP models for the structure of its studio coursework.[25]

PaR work is, in fact, being done in the US and there is tremendous interest, but it frequently happens outside the few official programmes, and often in forms that combine theorization with what Nelson distinguishes as applied or creative practices. Many communications studies and performance studies departments in the US have courses and/or graduate programmes with strong oral history or ethnographic components, for example. These methodologies have been articulated within performance as research approaches in the US and take place not only at the graduate level but also in undergraduate courses such as Lara Nielsen's Oral History Project.[26] In most of these graduate programmes, however, traditional dissertations remain predominant although they frequently contain appendices of oral history interviews, ethnographic notes, or related performance work, and so on, in written or other media.

There is some very interesting work going on unofficially in non-PaR programmes. Indeed, the fringe or margin provides a productive

place of inquiry. One of my former students produced the first PaR thesis in a theatre MA programme that did not acknowledge PaR work in any formal way or have criteria for assessing it. Her project combined an excellent written thesis on the topic of pregnant Latina migration with solo performance art/video installation work that was a kind of creative/critical reflection on the thesis itself (as opposed to the other way around).[27] The source material for both the written document and the performance was also produced collaboratively by the student and several women (who had migrated from Mexico or Central America to the US while pregnant) using oral history methodology. Faculty in the department were quite supportive, and in the end she produced an important project that was nominated for an Outstanding Graduate Thesis award. To be frank, the award committee members seemed both excited and horrified by the PAR component, but the work was one of only four nominated finalists from the entire university, and this alone indicates the tremendous opportunities that exist for integrating PaR into public higher education in the US. The student had a bit of a battle and even had to defend her use of 'I' in the chapter on her PaR work with the graduate programmes office that ultimately approves all theses. They approved the work – and then some – but enquired as to its scholarly veracity simply over the use of the personal pronoun. Her thesis committee had already made sure that she articulated clearly within the thesis why a PaR approach would be beneficial in the production of 'new knowledge'. This was partly to prevent a challenge against the work on the grounds of its PaR chapter, but it also provided an opportunity to expose more people on campus to the idea that PaR work is a serious form of scholarship. To be sure, it may have been partly the research terminology merged with creative process that intrigued the various award committee members who supported the work to the level of university-wide competition.

While PaR terminology and graduate programme structures may be new within the US academy, the concept of performance as theory or performed research is not entirely new. Nor is the attempt for artists to position themselves strategically within the research–practice divides in the US academy. In the past twenty years or so, the completion of both an MFA and a traditional PhD (two terminal degrees) has been one way to acquire the training needed to produce what might be described as practice-based or practice-informed research – or performing theory or performing research or any number of other things – and to teach studio as well as theory and history courses in US higher education.[28]

I recognized something in PaR language when Lynette Hunter introduced me to it not quite ten years ago precisely because I had been a performance artist doing theory and performing theory for quite some time. For example, from 1996 through 2001, I gave a series of lectures as Professor Peter Winston Mulciber III – a volcanologist turned art historian who specializes in aspects of idem and ipse identity in the work of performance artist Shannon Rose Riley. These occurred in a range of contexts, from performances at the Institute of Contemporary Art in Portland, Maine and the School of the Art Institute of Chicago to a panel on postmodernism and identity at the International Association of Philosophy and Literature (IAPL) annual conference in 2000.[29] 'I' would begin the paper, in drag, as Peter, discussing Riley's performance work and showing slides of Riley in performance. Part way through the presentation, an image of Mulciber would appear on the projection screen and he realizes he is one of Riley's personae. At that moment, 'I' would undress, redress, put on some lipstick, and continue to use contemporary theories of performativity to refute most of what the scientist and scholar had just said about the artist's work. At times the audience was 'in' on the fact that Mulciber was always already Riley, but in non-art contexts such as IAPL, the audience did not know until the change occurred in performance (the panel organizer had been 'in on it', however).

For me, performance art was the hinge on which the connection to PaR was made – and this seems a generative point of correspondence for other US artists and scholars. Because of that connection, I found that I had very little resistance to the idea of PaR, in fact I thought to myself 'Aha! There's a name for it!' Indeed, many performance art/visual art/PaR synergies can be found in the current US context and may prove quite fruitful in the establishment of further PaR initiatives. For example, a former chair and ongoing faculty member of a BFA- and MFA-granting art department in a top research university is currently pursuing a PaR PhD in performance (not in visual arts). This will no doubt impact upon her work as an internationallyknown performance artist as well as the way she teaches in a visual arts context. Who knows what will come of this or what kinds of formations might result. I also serve as a reader and dissertation adviser at two institutions: the PaR programme at Davis and the non-PaR (but not quite anti-PaR) Institute for Doctoral Studies in the Visual Arts, established by Smith. Despite his important analysis of the limitations of PaR in the US context, Smith's embrace of multiple approaches is well documented and IDSVA seminars are sites of inquiry across the binary of PaR/non-PaR

approaches. For example, the inaugural seminar at IDSVA in the summer of 2007 began with a presentation on PAR given by Lynette Hunter and myself and we each continue to serve as affiliated faculty. With this broader spectrum of practice in mind, I suggest that PaR work is most visible in the US when seen as more of a constellation or conjunction of points of synergy that exists predominantly outside formal structures.

With Smith's IDSVA we are full circle, and, interestingly for me, back at one of my early PaR experiences, although, as noted, I would not have used that name at the time. I ultimately completed my BFA in studio art and a minor in art history under the tutelage of George Smith. I wrote a historical thesis on the relations between art and healing that included a chapter on a public art project of mine called the Healing Hearts Project.[30] In that chapter, I theorized my own creative production and situated it within a larger historical legacy. Sounds like what I might call PaR today, but then I just understood it as doing art and doing theory. Both were done and were done together and I was not all that unique in the art school context among students pursuing work in both studio and art history. Moreover, this kind of approach to studio practice continues today, although it is not necessarily framed up as PaR; perhaps it should be.

There is, indeed, increasing room and need to make arguments for PaR programmes in US higher education. As noted, there may be untapped potential for PaR strategies to help theatre programmes avoid being cut in the current economic crisis in the US. As Nelson notes in Chapter 1, Marvin Carlson recently suggested that the 'movement' of performance as research might be a useful direction for a flailing and at-risk field of theatre in US higher education.[31] One of many options could be the articulation of a discipline-specific PaR approach in theatre departments. Another could be the articulation of interdisciplinary PaR approaches both in arts departments and especially across the arts and letters.

Many US administrators – increasingly seduced by corporate deliverology models and STEM initiatives – seem afraid, or suspicious, of the arts in general and it is more than likely they have never heard of PaR. They love assessment lingo, however, and may respond very favourably to such programmes once they are clear on the payoffs. This may sound very cynical, but, in my opinion, represents accurately the situation in public higher education in the US. There is a potential risk involved here, but the payoff could be well worth it. The risk, of course, is that the arts would become constrained under additional assessment that

would drain creative process and perhaps limit forms of assessment such as critique altogether because they may be unquantifiable. The payoff might be a revised and much revived higher education curriculum across the arts and humanities and not only at the graduate level. Indeed, initial interest in PaR is emerging in advance of administrative agendas – as it had done in the UK. Perhaps, as in the case of the UK, the funding crisis and general crisis within higher education today provide the crucible in which to forge formal PaR programmes and informal PaR strategies, not in order to come on board with troubling administrative agendas, but primarily to shape-shift into resistant new forms – even at the undergraduate level – that might permit ongoing education in the arts in the US academy.

Outliers: PaR and a small undergraduate programme in the humanities

Like Elkins, I believe that PaR provides an opportunity to rethink 'not only the place of creative arts, but the coherence of the university as a whole'.[32] Interestingly, the particular context within which I currently teach and work is very similar to the context in which Robin Nelson initially developed his approach to PaR.[33] I am the coordinator and primary faculty member of a small, interdisciplinary practices-and-research-based BA Programme in Creative Arts at San José State University in California. The programme was established in 1956 and is the only one of its kind in the entire California state university system and its numerous campuses. We do not claim to train artists – we do not offer a BFA. Yet we require that all students take at least two studio courses and at least seven courses in history and theory in at least two arts areas before they engage in a core curriculum with classes like Seminar in Creative Process, The Arts in US Society, Thinking About Contemporary World Arts, Creativity and Creative Leadership, and so on. Creative Arts is an outlier – it does not live in the art department, theatre department, or music department. Instead it lives, quite gratefully, in the Department of Humanities – that is to say within the letters. This gives us a unique position but at times has also marginalized us within both arts and letters contexts. At times we have been looked down upon as 'the easy major' or a major for those that do not fit elsewhere and aren't 'real' artists or 'real' scholars.

We have just completed a five-year review of the department (an administratively driven assessment process that measures student

learning outcomes and counts full-time-equivalent students, retention in the major, and the rate at which students progress toward degrees, etc.). As part of this process, the Creative Arts Programme has revised its mission as of the fall of 2012, such that demonstrating skill in PaR becomes an official requirement. This commitment to PaR has various political aims on campus (to further articulate what we do that no other arts programme on campus claims to do, and to challenge some of the ways the programme is marginalized). The primary objective, however, is educational reform in the humanities and of course it remains to be seen whether this strategy will prove successful.

A *New York Times* article from 2011, 'Education Needs a Digital-Age Upgrade', makes an interesting argument about student writing and summarizes the findings of the MacArthur Foundation Digital Media and Learning Competitions. Citing the competition's co-director, Cathy N. Davidson, the author notes that 65 per cent of today's grade-school children in the US may end up doing work that has not yet been invented. The findings indicate the need for a reform of higher education – yet do not support the gutting of humanities and arts pro-grammes that we find so prevalent in 'deliverology' discourse.[34]

Instead, Heffernan argues, the suggestions Davidson articulates in her book, *Now You See It*, look 'more like a classical education' (albeit one that embraces various technologies) than the STEM-centred vision that US academia seems to be embracing.[35] One of the most interest-ing points Davidson makes, and one we are bringing to the fore in the Creative Arts Programme, is to question the conventional forms through which students demonstrate knowledge and critical thinking. Davidson suggests that videos and other digital formats may become increasingly important forms for assignments in non-arts classes. This is not news for Creative Arts, which already does much of this kind of work in its core courses; but the university has resisted integrating these approaches more fully into general education courses, which have constraints regarding written formats and word count requirements. Davidson also challenges us to think about new *kinds* of writing forms in addition to the traditional research paper and to develop reading/writing interac-tions that challenge the model of the solo writer and single reader. Part of my hope is that PaR terminology may be useful in developing and defending such strategies and reforms against an administration that often devalues other forms of knowing beyond the verbal-linguistic or logical-mathematical.

Conclusions (or should I say Outcomes?)

It seems that PaR work being produced in the US rarely culminates only in performance but we hope to see more experimentation in this area. Lynette Hunter and I have argued elsewhere that, partly owing to the influences of performance studies as it developed in the US and its overlap with the fields of communications, visual arts, and sociology, this is incredibly productive terrain.[36] The reader will note that most literature in the field is in the form of edited collections. I gather this is because in places where PaR in performance is established, the primary format for sharing research outcomes is in fact performance or some media documentation of performance. To my knowledge, Graeme Sullivan has produced the only current monograph on practice-based research in the arts and his subject is the visual arts.[37] Moreover, most of the literature on PaR in performance makes PaR its subject matter rather than its method per se. I suggest there is a need to explore what it might look like to incorporate PaR methodologies into other kinds of projects and to produce a body of literature in the field that takes PaR as its method in other research projects while expanding the subject matter to other interdisciplinary areas. For example, I am currently working on a monograph that, in part, documents the use of PaR methodologies in the investigation of another topic, namely, cultural transmissions between Cuba and Haiti. It is an interdisciplinary project that draws on comparative literature, critical race theory, performance studies, and my performance art practice; the project has a performance art/research component and one chapter based on that work, but the scope of the book is much more broad. I propose this is very generative terrain for future PaR work in the US and will indeed be necessary to prove the robustness of PaR methodologies within a largely sceptical system of higher education.

Despite such possibilities, not enough time has passed to know whether graduates from Davis and Buffalo will find places in the centre of academia and its debates and also succeed in changing the ways we understand practice and research. For now, I suggest we might let go of terminology a little bit and instead look for synergies in practice and build on them. Individual programmes and departments (and scholar-artists) can determine whether there is a benefit in using PaR terminology and just what the benefits or risks might be. I do think it could be a game-changer, although I am not sure in what direction it will shift. There is not enough data to know the potential pitfalls of implementing PaR as a structured system in US higher education.

Would such programmes be sustainable? Would students enrol? And who can ultimately teach such classes? Assess them? And in the end, if funding structures do not change, the scholar-artist could be more marginalized than ever. Perhaps the proposals of a book such as this will suggest opportunities for further extensions of 'the PaR initiative' and for possible solutions to some of these issues.

Notes

1 Introduction: The What, Where, When and Why of 'Practice as Research'

1. Bella Merlin points out, however, that, since a doctorate is now an essential requirement for most university posts, PhDs are often 'primarily undertaken for pragmatic reasons' (2004: 40).
2. As some of the narratives in this book testify, institutionalized binary divisions between theory and practice still obtain.
3. The various artforms have different histories. Sullivan (2005) recounts the interplay of visual arts in the Enlightenment project.
4. Sullivan notes that 'parallels between the artworld of contemporary culture and the academic artworld of institutional culture are seen in particular with the introduction of studio art into debates about doctoral degrees in higher education' (2005: 27, n. 1).
5. The *Accademia degli Intronati*, formed to promote theatrical presentations in Siena in the 1550s, is an early exception and the conservatoire tradition in dance and theatre as well as music is a later, indeed mainly twentieth-century, exception, though typically UK conservatoires prepare people for the professions rather than engaging in academic research.
6. 2001: 18.
7. See, for example, Bartos (1990); Denzin (2003); Rodaway (1994).
8. The RAE is the acronym of the Research Assessment Exercise as conducted in the UK in 1986, 1989, 1992, 1996, 2001 and 2008. The REF stands for the revised version of the national research audit scheduled for 2014 in the UK, the Research Excellence Framework. Other countries have undertaken similar national audits with similar titles. RQF (Research Quality Framework) is a similar process in Australia.
9. The AHRC-funded initiatives were PARIP and AVPhD.
10. Some esteemed theatre/performance scholars are known to decry PaR; some film studies departments eschew the idea of film-making; some visual arts theorists and historians hold that arguments cannot be made – indeed that research cannot be undertaken – through practice. However, despite my actively seeking counter-arguments against PaR as a methodology in the preparation of this book, none has been forthcoming.
11. Kershaw in Allegue *et al.* (2009: 02).
12. In Allegue *et al.* (2009: 15).
13. A notable exception is Borgdorff, whose writings and presentations have recently been collected and updated in the aptly titled *The Conflict of the Faculties* (2012). Alison Richards's detailed account of the painful and protracted process of establishing PaR in Australia is also an exception (in Allegue *et al.*, 2009: 164–78).
14. Following Heidegger, I use this term as do others (see for example, Carter, 2004; Bolt, in In Barrett and Bolt (2010 [2007]) to indicate a mode of knowing

which arises through doing-thinking (practice) prior to any articulation in propositional discourse (theory).

15. Simon Jones in Allegue *et al.* (2009: 31).
16. In Allegue *et al.* (2009: 25).
17. See Allegue *et al.* (2009: 35–49).
18. In Allegue *et al.* (2009: 06).
19. In Allegue *et al.* (2009: 46).
20. 2006. My model resonates with and, in significant ways extends, Haseman and Mafe's 'six conditions of practice-led research' with an emphasis on 'emergence' and 'reflexivity' as key aspects of a PaR process as set out in Smith and Dean (2009: 211–28).
21. In Allegue *et al.* (2009: 29).
22. For a discussion of recent developments in practice-based degrees in music in the Netherlands and in Queensland, Australia, see, respectively, Schippers (2007) and Draper and Harrison (2011). Pakes (2003) makes the case for new dance.
23. 2007: 02.
24. Pears (1971: 26–7).
25. Following Bergson, and drawing specifically upon Deleuze's notion of 'difference and repetition', Cutler and MacKenzie (2011) similarly consider what is involved in learning to swim. They challenge the conventional distinction between the 'physical' bodies of swimmer and water understood as qualitatively different from the 'ideational' body of knowing how to swim.
26. For example, 'artistic research' (in the Nordic countries); 'research-creation' (in Canada) 'studio art' and Performance As Research (in the US). The last is expounded in Riley and Hunter (2009).
27. It is also currently preferred by the AHRC as in the research grants practice-led and applied route (RGPLA); http://www.ahrc.ac.uk/FundingOpportunities/Documents/RGPLA%20Pamphlet.pdf.
28. Barrett and Bolt (2010 [2007]: 147).
29. Haseman and I agree on the primacy of practice in PaR. He writes: 'The "practice" in "practice-led research" is primary – it is not an optional extra; it is the necessary pre-condition of engagement in performative research' (2006: 103). It is just a matter of the most appropriate verbal formulation to articulate the idea.
30. For an illustration, see Borgdorff (2012: 108–10).
31. For additional information on John Irving's project, see http://music.sas.ac.uk/news.html and www.johnirving.org.uk.
32. As, for example, in John Irving's book *Understanding Mozart's Piano Sonatas*; http://www.ashgate.com/isbn/9780754667698.
33. In a seminal contribution, Frayling (1993) distinguishes 'research *for* art, research *into* art and research *through* art'.
34. Freeman uses the terms differently in respect of performance as research: 'We would probably agree that when practical performance, in its most inclusive sense, forms the core of the contribution to knowledge then that research can most logically be described as practice-based [or PaR]. Conversely, when the research undertaken is likely to lead primarily to new and/or advanced understandings about practice, we can say that this is practice-led' (2010: 62–3).

35. It is the thread which in classical mythology led Theseus out of the Cretan labyrinth (designed by Daedalus for King Minos) after he has slain the Minotaur.
36. In Barrett and Bolt (2010 [2007]: 33).
37. Throughout the book I place key terms in italics to highlight their significance.
38. With Petra Kuppers, I convened the first formal symposium on PaR in the UK at Manchester Metropolitan University in 1993, though it was emergent well before then.
39. For accounts of the emergence of PaR in Australia, France and Canada see, respectively, Alison Richards, Ludivine Allegue and Henry Daniel in Allegue *et al.* (2009).
40. There are strong pockets of 'artistic research' in the arts academies (Hogeschoole voor de Kunsten, for example) in continental Europe but equally strong pockets of opposition in the university sector, particularly in theatre and performance studies where *Theaterwissenchaft* dominates. See Borgdorff (2012) for a nuanced account.
41. In Elkins (2009: 100).
42. A thorough account of 'Researching Research in Art and Design' to which I am indebted is given by Judith Mottram in Elkins (2009: 03–30). Freeman (2010: 37–8) offers a succinct history of the emergence of the PhD and of theatre studies in this context. See also Gislén's diagram in Kershaw (2009b: 105–06).
43. See, for example, Blain (forthcoming, 2013).
44. vii.
45. See Elkins (2009: viii).
46. i.
47. ix.
48. 2009: xi.
49. 2009: 130.
50. Jones notes that the College Art Association of America determined that the MFA should be the terminal degree award in 1977 (in Elkins, 2009: 37).
51. In Elkins (2009: 32).
52. See also Borgdorff (2012: 57–73) for an account of the 'uneasy relationship' between artistic research and academia.
53. The Deleuzian rhizome (see Deleuze and Guattari, 1987: 21) has been invoked by others in developing models for Practice as Research (see Smith and Dean, 2009: 21). In broad terms, emphasis is placed upon interconnectedness and the dynamics of process, a state of 'always becoming' or 'in-between-ness' rather than arrival or closure.
54. In Elkins (2009: 81).
55. In Elkins (2009: 81).
56. In Elkins (2009: 84).
57. Jones also notes that, both in the UK and the US, art schools emerged in a crafts and design tradition and offered 'a vocational education' (in Elkins, 2009: 37).
58. CNAA is the abbreviation for the Council for National Academic Awards founded in the 1960s in the UK to be the awarding body for higher degrees offered in the non-university, polytechnic and college of HE sector until its status was upgraded into what is known as 'post-1992' university sector.

59. In Elkins (2009: 10).
60. See Bougourd *et al.* (1988 appx: 4).
61. See UNESCO (1979: 27).
62. OECD (2002: 67). For a full discussion of the history of such exclusions to which I am indebted, see Borgdorff (2012: 76–101).
63. In Elkins (2009: 12).
64. This transformation process, announced by the Sorbonne Joint Declaration of the Ministers of Higher Education of France, Italy, Germany and the UK in Paris on 25 May 1998, and launched by the Joint Declaration of European Ministers of Higher Education in Bologna on 19 June 1999, has been dubbed 'The Bologna Process'.
65. http://www.ond.vlaanderen.be/hogeronderwijs/bologna/pcao/index.htm.
66. On the impact of Bologna, see also Borgdorff (2012: 25ff.).
67. Elkins's emphasis (2009: 145).
68. The development of 'professional doctorates' seems to me to have clouded the issues. Although deemed to be the equivalent of a PhD, formulations somehow imply they are not quite as good. See for example, UK Council for Graduate Education (1997: 16).
69. ix.
70. Carlson (2011).
71. 2011: 119.
72. 2011: 119–20.
73. 2011: 123.
74. 2011: 123.
75. In the UK, the drama schools – the conservatoire sector – are accredited by the National Council for Drama Training. The council's website explains that, 'this essentially means that the students applying for it can be reassured that this particular course is recognised by the drama profession as being relevant to the purpose of their employment, and that the profession has confidence that the people they employ who have completed these courses have the skills and attributes required for the continuing health of the industry'; http://ncdt.co.uk/guidetotraining/courses/coursesfaqs/. The NCDT has recently been subsumed under Drama UK (see http://www.dramauk.co.uk/).
76. Students came with a background in two of the named subjects but all engaged in an interdisciplinary core (various called integrated arts or live arts) which involved practical interdisciplinary workshops and a challenging lecture–seminar programme which embraced contemporary ideas as well as a historical context in modernism and postmodernism.
77. This issue is more fully explored in Fred McVittie's PhD thesis (2009).
78. Smith and Dean (2009: 02).
79. Nelson (2009: 130).
80. The forthcoming research audit in the UK requires HEIs to demonstrate not only how their research has 'impacted' upon the broader community but what actions they have positively taken to achieve that impact. In other countries (Australia, for example), the 'impact agenda' has also been set in the research context.
81. Haseman (2007; no page numbers given).
82. For a sketch account of this history, see Nelson (2006).
83. In Barrett and Bolt (2010 [2007]: 150.

2 From Practitioner to Practitioner-Researcher

1. 1983 [1976]: 14.
2. These are the seven 'liberal arts' identified by Martianus Capella in *De nuptiis* in the fifth century AD. See also Borgdorff (2012) for an account of the more recent historical 'conflict of the faculties'.
3. In the RAE and REF research audit exercise in the UK, PaR submissions typically include a recording on CD DVD for the benefit of the assessor who may well not have experienced the event.
4. Beethoven innovatively entrusted key material to woodwind, using double pairs of flutes, oboes, clarinets and bassoons.
5. 1983: 67.
6. What I have in mind differs from the traditional 'artist's statement' accompanying a visual art exhibition, though it may include a note on influences, as such statements typically do. The key addition needed is an articulation of the research inquiry.
7. 1983: 69.
8. 2012: 12.
9. Though he acknowledges that 'self-reflexivity is a central purpose of graduate study (2009: 152), Elkins challenges '[t]his idea that self-awareness is a desideratum for PhD-level instruction', arguing that it 'needs to be treated as a problematic assumption, not as a guiding principle' (2009: 153).
10. In Barrett and Bolt (2010 [2007]: 29).
11. This kind of approach is formally taken by many university research degrees committees in registering prospective students (see Chapter 5).
12. Professionals may operate a 100:1 raw footage/edited film ratio, but the time practitioner-researchers have for this function is typically more limited.
13. 1983: 54ff.14. http://www.sfmelrose.org.uk/justintuitve/: 03 of 12, accessed 19 May 2011.
15. http://www.sfmelrose.org.uk/justintuitve/: 10 of 12, accessed 19 May 2011.
16. *New Scientist* (2000); http://www.rbiproduction.co.uk, accessed 30 April 2012.
17. Elkins remarks: 'When I was advising Duggan, I wasn't sure whether to be thorough, and ask Duggan to acknowledge and read every source on a given subject, as I would have asked a history of art student to do . . . But *what discipline was supporting me* when I made those decisions?' (2009: 162, Elkins's emphasis).
18. 2009: 163.
19. In Elkins (2009, 16).
20. 2006: 09.
21. This point was forcefully made by Michael Biggs at the PARIP conference in Bristol, 29 June–3 July 2005.
22. 1998: 113.
23. My notion of dialogism is drawn from Vygotsky (1986) and Bakhtin (1981).
24. Propositional knowledge is verbally expressed in declarative or indicative propositions as distinct from procedural knowledge demonstrated in performance. Propositional knowledge corresponds to 'know-that' while procedural knowledge corresponds to 'know-how'.
25. 1983: 26.
26. 1983: 06. Formerly a scientist, Polanyi turned philosopher late in his career, spurred by Stalin's dismissal of the independence of science. His reflections

on how we know things stems from a science-informed analysis of gestalt in psychology.
27. In Elkins (2009: 52).
28. In Elkins (2009: 105).
29. 1983: 69.
30. In the play between the proximal and the distal in Polanyi's two-stage model of the tacit powers of knowing he proposes that: 'In the exercise of a skill, we are aware of its several muscular moves in terms of the performance to which our attention is directed. We may say, in general, that we are aware of the proximal term of an act of tacit knowing in the appearance of its distal term; we are aware of that *from* which we are attending *to* another thing, in the *appearance* of that thing. We may call this the *phenomenal structure* of tacit knowing' (1983: 11).
31. In Barrett and Bolt (2010 [2007]: 15–16).
32. 1981: 226–7.
33. See, for example, Roger Dean's account of his use of computational techniques in musical composition in Smith and Dean (2009: 13–15).
34. 2010: 21.
35. According to Gibson (1977), the coiner of the term *'affordance theory'* states that the world is perceived not only in terms of object shapes and spatial relationships but also in terms of object possibilities for action (*affordances*). Donald Norman (1988) appropriated the term in the context of human–machine interaction to refer to just those action possibilities that are readily perceivable by an actor.
36. See Ryle (1949).
37. See Lakoff and Johnson (1981).
38. 1983: 54.
39. 1983: 15.
40. 1993: 172–73.
41. 2004: 03.
42. Ibid.: 11.
43. In Elkins (2009: 40).
44. 1983: 61.
45. In Smith and Dean (2009: 219).
46. See Lakoff and Johnson (1999).
47. 2006: 30.
48. See Smith and Dean (2009: 19–25).
49. Smith and Dean (2009: 23).
50. 1983: 61.
51. 1983: 13–14.
52. 1983: 55. In Polanyi's model, emergence applies to both specific innovations of the human bodymind towards the intellectual and more broadly to the process of evolution itself.
53. In Smith and Dean (2009: 220).

3 Conceptual Frameworks for PaR and Related Pedagogy: From 'Hard Facts' to 'Liquid Knowing'

1. *The Guardian*, 11 March 1995: 53.
2. A thick description of an instance of human behaviour or text is one that explains not just the external behaviour or internal workings of a text,

but also sets it in a context promoting broader understanding (see Geertz, 1973: 3–30).

3. Leavy 2009: 07. Goffman's *The Presentation of Self in Everyday Life* has been highly influential in theatre and performance studies.

4. See Nelson in Allegue *et al.* (2009: 112–32).

5. Both deduction and induction involve inferences; but, in deductive syllogisms, the conclusion is true as long as the premisses are true while induction draws conclusions beyond the premises based on generalizations drawn from broad experience. Famously, the European induction that 'all swans are white' proved false when black swans were discovered in Australia where the Aborigines had, of course, always known of them.

6. Karl Popper, the distinguished philosopher of science, popularized his method of falsifiability in *Conjectures and Refutations* (1963).

7. 1988: 71.

8. 2009: 06.

9. Sixth International Congress of Qualitative Inquiry, Urbana–Champaign, IL, 26–29 May 2010.

10. 1990: 28.

11. The remark was made by the late Edgar Wilson, lecturer in philosophy at Manchester Metropolitan University and one-time chair of the UK Republican Party.

12. In Allsopp and Delahunta, 1996: 18.

13. See, for example, Nagel, 1986.

14. See Haraway, 1988.

15. 2009: 08.

16. Notably, the tradition of Continental thought from the neo-Kantians, Dilthey, Husserl and the phenomenologists, up to the poststructuralists.

17. Sinner *et al.* (2003: 1252).

18. The hermeneutic spiral model was devised by Kurt Lewin in 1948 but has since been significantly refined.

19. For a discussion and an example of the application of hermeneutics to arts research, see Trimingham (2002).

20. Though the first 'linguistic turn' in philosophy might be traced back to Frege and Russell, I am marking here the later, 1970s, 'linguistic turn' in the humanities (Saussure, Butler, Kristeva, Foucault, Derrida).

21. Derrida, and his concept of *difference/différance* is a key reference point here.

22. Significant reservations about the relative tendencies of poststructuralism have been made, notably by Jürgen Habermas and his concept of 'communicative rationality'; see Habermas (1976).

23. See Butler (2006 [1990]).

24. Austin (1975 [1962]).

25. 2006: 104.

26. See 1987.

27. See 1984.

28. For postdramatic theatre, see Lehmann (2006).

29. 2004: 27.

30. I recognize that Karl Otto Apel might see this quasi-universal claim as one of the performative contradictions inhabiting postmodernism; see Apel (1996).

31. 2009: 163.

32. 1983: 33; 'analytic proposition, in logic, a statement or judgment that is necessarily true on purely logical grounds and serves only to elucidate meanings already implicit in the subject; its truth is thus guaranteed by the principle of contradiction. Such propositions are distinguished from **synthetic** the meanings of which include information imported from nonlogical (usually empirical) sources and which are therefore contingent' (*Encyclopaedia Britannica* online); http://www.britannica.com/EBchecked/topic/22595/analytic-proposition, accessed 12 July 2012

33. See Hopkins (1995).

34. For the 'performance turn', see also Hopkins (1995), Denzin (2003) and Denzin *et al.* (2003).

35. 2001: 25.

36. In Barrett and Bolt (2010 [2007]: 150).

37. Though haptic perception is traditionally concerned simply with recognizing objects through touch, the notion has been expanded by Gibson (1966) to include the sensibility of the individual to the world adjacent to his body by use of his body. Deleuze and Guattari (1987) also widen the definition of haptic space, implying a porosity between the senses and the ability to communicate or evoke touch by other means. The geographer Paul Rodaway proposes that 'each space and place discerned, or mapped, haptically is in this sense our space and because of the reciprocal nature of touch we come to belong to that space' (1994: 55).

38. For an illustrated discussion of knowledges 'about', 'in' and 'for' in this context, see Zarrilli (2002).

39. See Nelson (2006).

40. See (1999 [1958]).

41. 2004: 17.

42. 2004: 01.

43. 2004: 181; my emphasis.

44. 2004: 199. In *What Is Called Thinking*, Heidegger famously remarked that. '*thinking* may be 'something like building a *cabinet*'. At any rate, it is a handiwork [*Handwerk*]' (1976: 16), and Wittgenstein (1984), albeit in a different context, affirmed this notion.

45. Nöe (2004: 189).

46. Cited in Nöe (2004: 121).

47. In Macleod and Holdridge (2006: 26).

48. See 1989.

49. In Macleod and Holdridge (2006: 24).

50. In Macleod and Holdridge (2006: 31).

51. 1986: 4.

52. 1983: 06.

53. 1983: 50.

54. 1949: 34.

55. 1949: 28.

56. Ryle mobilizes two major critiques of the presumed two-stage process in which propositional thinking in the mind precedes putting into practice what these propositions enjoin. The first is that the presumption involves an infinite regress and the second is that it involves a 'category mistake'.

57. 1949: 29.

58. 1949: 31.
59. 1949: 42.
60. 1949: 46.
61. 1949: 57.
62. 1986: xxxi.
63. 1986: xxxii.
64. 1986: xlv.
65. 1986: xxxiv.
66. 1949: 58.
67. 1949: 41.
68. 1949: 55.
69. 1949: 44.
70. 1983: 187.
71. I am thinking particularly of the reconstruction by Stan's Cafe in 1999 of Impact Theatre Co-operative's seminal piece *The Carrier Frequency*, but much dance is, of course, reconstructed from documentary traces. The Bristol-based Performing Documents project held a Remake Symposium on 15 September 2012, a day of experimentation with creative ways of engaging with documents and recordings authored by other artists; http://Bristol.ac.uk/performing-docs
72. 'Intuition' may, of course, carry different accents; see Zarrilli (2002) and Melrose (2005).
73. 1949: 53. Ryle notes, however, that 'the ability to appreciate the perform-ance does not involve the same degree of competence as the ability to execute it' (1949: 55).
74. 1949: 50.
75. 2006: 21.
76. 1983: 69.
77. 1983: 62.
78. 1983: 68.
79. This may explain why so many of the publications to date on PaR deal in case studies rather than general theories.
80. 2003: xi.
81. 1990: 9.
82. 2007: 57.
83. 2007: 50–1.
84. It should not be forgotten that much science is rooted in the practice of laboratory experimentation, its research findings being written up after the event.
85. In Barrett and Bolt (2007: 148).
86. RAE (2001: 1.12).

4 Supervision, Documentation and Other Aspects of Praxis

1. See Reason (2006: 24).
2. 2006: 23. I am indebted in this chapter to Reason's book, which affords a measured summary of the differing positions in the seminal debate between Phelan and Auslander and of the related discursive constructions supporting the case for and against documentation.

3. See, for example, McAuley (1986: 5).
4. 2006: 27.
5. See Elkins (2009: xii).
6. See, for example, Whalley and Miller (2005); Kershaw in Smith and Dean (2009: 108–13); Freeman (2010: 218–31); For those readers who have not come across accounts of *Partly Cloudy, Chance of Rain*, Bob Whalley and Lee Miller's PhD investigation culminated in a performance event at the Sandbach M6 motorway services UK, at the heart of which a service of renewal of their marriage vows (being a husband and wife team) was conducted by MMU's Anglican chaplain. Ten pairs of 'brides and grooms' in Victorian wedding attire assisted, and a choir sang across the motorway bridge. A commemorative bench was dedicated by the services manager and (mis)guided tours of the motorway site were led by Lee and Bob. The project interrogated various notions of the inscription of space through performed narrative, non-places (Augé) and performativity.
7. The full-time bursaries were awarded by Manchester Metropolitan University as part of its development of practice-based research in Drama/Dance/ Theatre/Performance.
8. See Freeman (2010).
9. There is just one 'black book' bearing both their names: 'PhD Thesis Joanne Whalley & Lee Miller, 2003'.
10. In Smith and Dean (2009: 110).
11. In Smith and Dean (2009: 113).
12. See, for example, Bannerman and McLaughlin, 'Collaborative Ethics', in Allegue *et al.* (2009: 65–80).
13. Whalley and Miller (2005: 140).
14. See Freeman (2010: 227).
15. In Smith and Dean (2009: 109).
16. Quotations from REF (2012: 86).
17. I coined this term, in place of 'spectator' or 'audience', in working with Anna Fenemore when she was a PaR PhD student, and formalized it in Bay-Cheng *et al.* (2010: 45).
18. The writings of the Frankfurt School – in particular Adorno and Marcuse – are seminal in this context.
19. In Allegue *et al.* (2009: 30).
20. In Elkins (2009: 74–5).
21. See, for example, the 2012 British Museum exhibition 'The Tomb of the Unknown Craftsman', in which a critical commentary was literally inscribed not only in specific exhibits but more generally into the entire curatorial practice.
22. In Elkins (2009: 76–7).
23. See Derrida and Stiegler (2000: 141–43).
24. 1993: 3 and 146 respectively.
25. 2003: 115.
26. 2006: 74.
27. 1999: 40
28. For a clear view on the difference between the live and the recorded image, see Rye (2003).
29. 2006: 20.

30. 2003: 115.
31. See 1994.
32. 2003: 116.
33. 2006: 78 and 82.
34. 2003: 117.
35. 2003: 118–19.
36. In Allegue *et al.* (2009: 44).
37. 2006: 37.
38. This exhibition at the National Gallery, London (9 November 2011 to 5 February 2012) brought together under rare circumstances almost all the paintings of Leonardo and his pupils from 1482 to 1519, his time as court painter in Milan. Though it was most interesting to see these works juxtaposed, the insights afforded by the numerous drawings were most striking.
39. 'Extra-daily' indicates behaviours in organized performance situations different from those used in daily life (see, for example, Barba, 1991: 187–8).
40. 2006: 01ff.; http://www.eis.mdx.ac.uk/staffpages/satinder/Melroseseminar 6 April.pdf, accessed 15 July 2012.
41. This seminal essay of Diderot (1713–84) was first published in English in 1883.
42. On DVD, see for example those of Caroline Rye (Stirling University) and ML White (University of Middlesex) and, in respect of blogs, see McVittie (2009).
43. Ellis unpublished notes (shared with the author) for a presentation at Kingston University, London, July 2011.
44. 2006: 40.
45. See http://www .bristol.ac.uk/performing documents.
46. See: http://www.bris.ac.uk/parip/ and http://www.westminster.ac.uk/research/ a-z/cream/avphd.
47. http://www.presence.stanford.edu: 3455/Collaboratory/496, cited in Allegue *et al.* (2009: 46).
48. See http://www .livearchives.org.
49. An AHRC-funded project located at Coventry University ; http://wwwm. coventry.ac.uk/researchnet/grandchallenges/digitalmedia/DDA/Pages/ DigitalMedia.aspx.
50. http://www.ahds.ac.uk/creating/guides/new-media-tools/kozel.htm.
51. http://curatingknowledge.com/.
52. http://www.ausstage.edu.au.
53. In Allegue *et al.* (2009: 47).

5　PaR PhDs: A Guideline/*Clew* to a Successful Outcome for All (Candidates, Examiners, Administrators, Regulators)

1. In Macleod and Holdridge (2006: xiv).
2. This project, funded by PALATINE, was assisted by Stuart Andrews and its findings remain available on the PARIP website, PALATINE having recently been disbanded.
3. For example, Manchester Metropolitan University has an MA Creative Arts which directly addresses PaR. Central School of Speech and Drama, University of London has an MA Performance Practices as Research and the University of Kent has a Performance Practice MA.

4. Whereas students are funded by an external agent such as the AHRC, there is a threshold for completions, falling under which universities may be barred from application for future studentships. If the funding is internal, by way of a bursary, it is usually for a fixed period after which the source of funding is lost. Thus, failure to complete on time may leave a student unable to complete at all.
5. UKCGE (2001: 16). Though I do not fully share this view, the report overall makes helpful recommendations about arts research training.
6. Professor Tom Wilson, University of Sheffield, 'Structure in Research Methods'; http://informationr.net/tdw/publ/ppt/ResMethods/tsld002.htm, accessed 19 March 2012.
7. This slightly weaker sense of 'method' is taken from *Collins English Dictionary: Millennium Edition*.
8. http://www.ahrc.ac.uk/FundingOpportunities/Documents/CDAScheme Guidance.pdf.
9. 'Audience Immersion: Environment, Interactivity, Narrative in the work of Punchdrunk', led by Dr Jane Milling.
10. 2010: 157.
11. In Bolt and Barrett (2010: 29).
12. In Bolt and Barrett (2010: 33).
13. In Smith and Dean (2009: 226).
14. Where PhD candidates are part of a team working in a science laboratory, short tutorials might be much more frequent – weekly even – because the supervisors themselves are working alongside students.
15. I am indebted to Alison Richards for this and other suggestions.
16. 'Performances being becomes itself through disappearance' (Phelan, 1993: 146).

6 Aotearoa/New Zealand and Practice as Research

1. 2009: 1–15.
2. 2008: 19.
3. Ibid.
4. CPA panel-specific guidelines: (Tertiary Education Commission/Te Amorangu Mātauranga Matua (2011) 'Performance-Based Research Fund), 2011: 5; http://www.tec.govt.nz/Site-information/Search/?q=CPA
5. Ibid.: 5.
6. Ibid.: 4.
7. Ibid.: 5.
8. 2006: 112.
9. Ibid.
10. Little (2011: 21); Pakes (2004: 5).
11. University of Auckland, National Institute of Creative Arts and Industries, PG Prospectus, 3.
12. In an email to the author, December 2011.
13. Ibid.
14. Ibid.
15. In an email to the author, 1 December, 2011.

16. Ibid.
17. Halba is a founding member of Kilimogo Productions, a bicultural Dunedin-based company that creates work in partnership with *tāngatā whenua* (indigenous peoples)
18. Halba (2009, 2010).
19. Halba (2010: 23).
20. Ibid: 24.
21. Pihama *et al.* (2002: 33).
22. Halba (2010: 26).
23. Ibid.
24. Ibid.: 27.
25. Ibid.: 28.
26. Ibid.: 29.
27. Falkenberg (2007: 297).
28. Ibid.: 297–8.
29. The Big Idea, 2011.
30. The production was the result of collaboration between Falkenberg, Richard Gough (Centre for Performance Research), Richard Till, the Free Theatre and A Different Light Theatre Company.
31. Niemetz *et al.* (2011: 6).
32. Ibid.: 1.
33. Ibid.
34. Ibid.: 1.
35. 2012: 17–18.
36. De Freitas (2007, 2002, respectively).

7 Artists in Australian Academies: Performance in the Labyrinth of Practice-Led Research

1. See Baker and Buckley (2009: 19–25) for the chronology of inaugural institutional enrolments.
2. Richards (1995).
3. Haseman (2006: 98).
4. Albinger (2010: 25).
5. Ibid.
6. Maxwell (2003: 286).
7. Kroll (2008: 12).
8. Baker and Buckley (2009: 68).
9. Phillips *et al.* (2009); http://www.dancingbetweendiversity.com/code/discussion.html#Definition.
10. See Melrose (2003); http://www.sfmelrose.u-net.com/curiosityofwriting/, accessed 12 February 2007.
11. Barrett and Bolt (2010 [2007]: 1).
12. See Chapter 1 in this volume.
13. 'Performance as Research Colloquium Report', internal document compiled by Felix Nobis, ADSA Conference, Melbourne, 2 July 2011.
14. Haseman (2007: 12–36).
15. Hutchison (2011).

16. The other weightings were 1 per cent books, 7 per cent book chapters, 6 per cent conference papers and 12 per cent journal articles; http://www.arc.gov.au/pdf/ERA_report.pdf, p. 184.
17. Jaaniste and Haseman (2009: 1).
18. See Camilla Nelson (2009).
19. Robson (2012: 149).
20 [Baker and Buckley] 2009: 28 (my emphasis).
21. Ibid.
22. Murdoch University, *Guidelines for PhD, MPhil or RMT with a Creative Production Component*, April 2009, p. 3.
23. See Robson *et al.* (2010).
24. Stock (2011: 9).
25. DCA, Wollongong University.
26. PhD, Murdoch University.
27. Angela Campbell was a doctoral candidate at Murdoch University, Western Australia.
28. PhD in progress, La Trobe University.
29. Donna Jackson is currently a doctoral candidate at La Trobe University, Victoria.
30. See Mercer and Robson (2012).
31. Haseman (2006: 3).
32. Haseman and Mafe (2011: 221–2).
33. Biggs (2004).
34. McWilliam *et al.* (2005).
35. Green (2007: 3).
36. Holbrook *et al.* (2006).
37. Kroll (2008: 8).
38. 2007: 2.
39. 2012 Stipend Rates as stated by the Australian Research Council; http://www.arc.gov.au/pdf/2012_salaries_stipends.pdf, accessed March 2012.
40. PhD, Cowan University.
41. PhD, Queensland UT.
42. PhD in progress, Curtin University.
43. Izzard is a currently a doctoral student at Curtin University.
44. Downing is a currently a doctoral student at Edith Cowan University.
45. See Haseman and Jaaniste 2008; Jaaniste and Haseman 2009.
46. Beginning with *Creative Nation: Commonwealth Cultural Policy* (1994); many other reports have followed, such as *Research in The Creative Arts* (or the *Strand Report*) (1998), the *Creative Industries Cluster Study* (2003), the *Imagine Australia* report to the Prime Minister's Science, Innovation and Engineering Council (2005), the *Creative innovation strategy* of the Australia Council for the Arts (2006), *Educating for a Creative Workforce* (2007), *Towards a Creative Australia* (2008), *Venturous Australia* (2008), and *Powering Ideas* (2009).
47. Stock (2011).
48. While not officially termed practice-led, Michael Balfour's ARC projects have applied drama processes at the heart of their creativity and social justice concerns. Their conceptualization and instrumentalist tendencies, however, differentiate them from an entirely practice-led approach.
49. Funding results for 'Performing Arts and Creative Writing'; http://www.arc.gov.au/ncgp/dp/dp_outcomes.htm.

50. See, for example, the work of Roger T. Dean, Andrew Brown or Cat Hope.
51. Buckley and Conomos (2009: 88).
52. www.ausstage.edu.au.
53. See Bollen (2009).
54. Hugo (2008). For statistics on maturation profile of arts academics see pp. 25–6.
55. Forgasz (2010).

8 PaR in Continental Europe: A Site of Many Contests

1. This essay is a reworking of some ideas I have already presented in other publications, such as Lesage (2009a, 2009b, 2011).
2. See Münch (2009, 2011).
3. Whereas I consider a few aspects of the Bologna Process as strategically interesting, Lorenz (2012) is much more severe.
4. In order to be accepted as a participating country in the Bologna Process, a nation state does not have to be a member state of the European Union. According to the Berlin Communiqué of 19 September 2003, all European countries that signed the European Cultural Convention accept the basic premises of the Bologna Declaration, and strive to implement the Process at the national level, can become participating countries in the Bologna Process. The current number of countries participating in the Bologna Process is 46. San Marino and Monaco, two more countries that signed the European Cultural Convention, are not participating in the Bologna Process for lack of higher-education institutions.
5. See Bennington and Derrida (1991).
6. Derrida beautifully described this struggle in the presentation of his doctorate: Derrida (1991).
7. In an interview at the end of a book in which he discusses among others J.L. Austin's and John Searle's philosophy of language, Derrida (1988: 148).
8. Derrida (1976: 09).
9. Eran Schaerf (2007: 108–12).
10. For a motivation of this change in editorial policy of the *British Medical Journal*, see Smith (1999).
11. Goldbeck-Wood (1999). On this issue, see also van Rooyen *et al.* (1999).
12. Ever since Eugene Garfield published the first *Science Citation Index* in 1964, it has been a very controversial instrument, the eventual misuses of it being recognized from the very beginning by leading scientists, such as Nobel prize winner Joshua Lederberg. Lederberg, while promoting it as a tool for research, fiercely rejected it as a tool for measuring research output. Not only are all known citation indexes far from complete, they are also terribly biased in favour of articles and against books. To that one might add that the *Science Citation Index* and the other citation indexes are products sold by Thomson, a media corporation which also owns a lot of academic journals.

9 Artistic Research in a Nordic Context

1. The terms *Practice as Research, Practice Based Research, Practice-Led Research* are clumsy to translate into Finnish. The term '*tekijälähtöinen*' is often used,

which literally means author-based or maker-based, instead of 'käytäntöön perustuva', based on practice, which in Finnish sounds like a truism. The adjective 'artistic' ('taiteellinen') seemed equally artificial in Finnish as in English, but people quickly grew accustomed to it, and welcomed its core meaning, a focus on art. Today the term artistic research is used more and more as an umbrella concept for research undertaken in art universities.

2. In a proposal for a Nordic study circle in 2006, Annika Sillander and Sidsel Pape observe: 'Practice-Based Research (PBR) is an academic discipline that is fairly new in a Nordic context. Of the Scandinavian countries Finland is clearly ahead, as PBR was established there in the 80s and 90s. Sweden is currently most active in implementing PBR within its institutions of higher education. Norway and Denmark, where PBR was introduced in 2000 and 2002, are following hesitantly'; http://www.nsuweb.net/wb/pages/att-delta-i-nsu/fF6rslag-till-nya-studiekretsar/2006/d.-practice-based-research-in-the-performing-arts.php.

3. 'Theatre and Dance Artist Doing Research in Practice' at Theatre Academy, Helsinki, 13–15 October 1994.

4. Paavolainen and Ala-Korpela (1995: 5).

5. The Academy of Finland is the major funding institution for research. For a presentation see www.aka.fi/eng.

6. The evaluation focused on research and doctoral education at all four Finnish art universities and the University of Lapland's Faculty of Art and Design in 2003–07, with a focus on the quality of research, doctoral education, research environments, national and international cooperation and the societal impact of research in the field. The chair of the panel was Professor Richard Buchanan); see Buchanan et al. (2009).

7. Buchanan et al. (2009: 6).

8. Aalto University Research Assessment Exercise 2009 Panel Reports (2009).

9. For one eloquent plea for balance, see Conquergood (2004).

10. Arlander (2008: 30).

11. Professor Esa Kirkkopelto began with this assertion in his presentation (Kirkkopelto 2012).

12. Smith and Dean (2009: 5) add conceptual research to quantitative and qualitative methodologies.

13. The situation regarding doctoral studies in art in Finland, Sweden and Norway is partly drawn from an overview provided by SHARE, an international networking project comprising 39 partners from across Europe working together on enhancing the third cycle of arts research and education in Europe; http://www.sharenetwork.eu/home.

14. See for example Further and Continuing Education of Performing Artists in the Nordic Countries: A Nordic Task (2000).

15. Presentation of Sweden; http://www.sharenetwork.eu/artistic-research-overview/sweden.

16. Konstnärliga Forskarskolan; http://www.konstnarligaforskarskolan.se/wordpress/.

17. Karlsson (2002: 20–1).

18. See Efva Lilja's home pages; http://www.efvalilja.se/page.php?id=start& lang=eng.

19. With regard to the title Sweden has recently taken a step 'ahead' of Finland, since 'konstnärlig doktor' (literally artistic doctor) is translated as PhD rather

than Doctor of Art, as in Finland, mainly to assure the equivalence internationally, since Doctor of Art is a separate lower degree in some English-speaking countries.

20. Hedberg(2012).
21. Presentation of Norway; http://www.sharenetwork.eu/artistic-research-overview/norway.
22. Presentation of Norway; http://www.sharenetwork.eu/artistic-research-overview/norway/national-fellowship-programme.
23. Norwegian Artistic Research Programme http://artistic-research.no/.
24. Besides these Tampere University has a Department of Communication, Media and Theatre with education in acting.
25. Buchanan *et al.* (2009); see also Karlsson (2002: 187–92).
26. TAHTO doctoral programme in artistic research; http://www.teak.fi/Doctoral_programme_in_artistic_research.
27. The first are evaluated for artistic excellence, only a modest written study is required. The second include musicology, and historical or pedagogical research. The third seems to resemble the research and development type of applied research. See Sibelius Academy Doctoral Academy; http://www.siba.fi/en/how-to-apply/doctoral-degrees/doctoral-academy/about-us.
28. Until 2007 there was a dichotomy between doctoral works with a scientific emphasis and those with an artistic emphasis. Today all research, whether educational research using qualitative methods or work emphasizing theoretical reflection, is called artistic research and is required to include some practical (although not necessary artistic) parts. See Research and Post-Graduate Studies at Theatre Academy, Helsinki; http://www.teak.fi/Research
29. The problem with using a terminology separating the production component and the theoretical component has been discussed, though. See *Finnish Academy of Fine Arts Curricula Guide 2010–2015*, pp. 102–5; http://www.kuva.fi/en/.
30. Varto (2009: 159).
31. A new book on the topic by the same authors is forthcoming, presumably with some new articulations related to qualitative research. It is worth noting that none of the authors is an artist, though – Mika Hannula is an experienced curator, Juha Suoranta is an expert on educational research and Tere Vadén is a philosopher.
32. Hannula *et al.* (2005: 160).
33. Ibid.
34. Ibid.
35. Nevanlinna in Kiljunen and Hannula (2002).
36. Nevanlinna (2008); '*Usein sanotaan, että taiteellisessa tutkimuksessa taiteilija tutkii omia teoksiaan. On ainakin kaksi vaihtoehtoa tulkita, mitä tämä tarkoittaa: joko taiteilija tutkii teoksiaan ikään kuin ne eivät hänen tekosiaan olisikaan tai sitten pohtii täysin subjektiivisesti niiden taustoja ja tavoitteita. Nämä ovat huonoja vaihtoehtoja. Omien teosten tutkimisesta ei pitäisi ensinkään puhua. Taiteilija ei tutki omia teoksiaan, vaan omilla teoksillaan*' (English translation by A.A.). The grammatical form used in Finnish is normally added to the end of a word in order to indicate that something is used as a tool or aid in a process. So this could mean, freely translated, that the artist is researching something and using her work as a tool or aid in that process.

37. Kjorup (2006).
38. 2008; *'Ehkä vasta taiteellinen tutkimus lunastaa sen "esteettisen tutkimuksen" ohjelman, jonka estetiikka-termin "keksijä" Alexander Baumgarten hahmotti 1700-luvun puolivälissä: se luo tietoa yksittäisestä.* Se koskee yksittäistä ja ainutlaatuista eikä sitä voida yleistää laeiksi, mutta yhtäkaikki se on tietoa' (English translation by A.A.).
39. Kirkkopelto (2012).
40. Ibid.
41. Sensuous Knowledge Conferences; http://sensuousknowledge.org/.
42. See Borgdorff (2012).
43. The Nordic Summer University (NSU) is a long-established institution within the Nordic intellectual arena. During more than 50 years of existence it has provided a lively forum for academic and intellectual debate, and involved many leading academics, politicians, and intellectuals from all the Nordic countries. The NSU has always been at the forefront of intellectual thinking, juxtaposing views from the international and Nordic academic arenas, and introducing new thinking and influences into the Nordic countries ... These thematic study circles form the backbone of our organization, creating interdisciplinary networks that function within the Nordic countries for three-year periods. Study circles largely focus on issues related to the social and human sciences, and most participants are PhD students or post-doctoral scholars in these fields.' See the presentation at the website http://www.nsuweb.net/wb/pages/information/briefly-in-english.php.
44. NSU-proposals http://www.nsuweb.net/wb/pages/att-delta-i-nsu/fF6rslag-till-nya-studiekretsar/2006/d.-practice-based-research-in-the-performing-arts.php.
45. Barton *et al.* (2010).
46. The host – Centre for Practise as Research in Theatre, founded in 2007 – is a centre of expertise and research at the School of Communication, Media and Theatre at the University of Tampere, Finland concentrating on collaborative practical research projects rather than education. 'Projects carried out within the Centre for Practise as Research in Theatre have a direct connection to working life. Project teams involve individual artistic and connecting technical and productive research components. Results and practical innovations produce benefits to theatre professionals, producers and audiences.' http://t7.uta.fi/en/center/index.html.
47. Artistic research – strategies for embodiment, project description; http://www.nsuweb.net/wb/studiekretsar/?q=dz15JmFtcDtlPWYmYW1wO2FjdGlvbj1mdWxsbmV3cyZhbXA7bm1sZHM3dlduMW9wSHMDFT19lclY2VyZXRlTlZhsdfAX0qRXdvRTlkMmF1IDEFRXXXXX... NOfOD
48. NOfOD http://www.nofod.org/.
49. Theatre Research Society; http://www.teats.fi/english.html.
50. See for instance the bilingual web publication Ikonen *et al.* (2012). The slightly misleading rubric 'artist's statements' encompasses a huge spectrum of approaches.
51. Hoogland (2008).

52. *JAR*: *Journal of Artistic Research*; http://www.jar-online.net/.
53. CARPA description: http://www.teak.fi/menu_description.asp?menu_ id=1198.
54. Call for CARPA (2010); http://www.teak.fi/alltypes.asp?menu_id=1203. For the proceedings, *How Does Artistic Research Change Us?*, see Arlander (2010).
55. Presentations could take the form of installation, experiment, workshop, performance, rehearsal, exercise, discussion, or test. Proposals were expected to include a purpose statement, research topic or research questions, a description of the arrangement of the presentation and practical require-ments; see Call for CARPA 2 (2011). For the proceedings, *Artistic Research in Action*, see Arlander (ed.) (2011).
56. Call for CARPA 3 (2013); http://www.teak.fi/Tutkimus/carpa/call_for_ presentations.
57. Ibid.
58. Mckenzie *et al.* (2010).
59. Haseman (2006).
60. Bolt (2008).
61. Call for CARPA 3 2013).
62. For a brief historical description of the development at the Theatre Academy Helsinki, see Arlander (2008 or 2009).
63. Arlander in Biggs and Karlsson (2011).

10 Practice as Research in South Africa

1. Chilisa (2012: 100).
2. Ong (1982: 133).
3. For information on DramAidE and critical analysis of their work see, inter alia, Dalrymple (1996 2006); Singhal (2004).
4. 2009: 99.
5. Singhal *et al.* (2004: 391).
6. See Boal (1979, 1992).
7. A 2001 study by John Aitchison found that 28 per cent of South Africans were functionally illiterate, most of them women.
8. Xhosa is part of the Nguni set of African languages, one of 11 official languages in South Africa.
9. 2010: 241.
10. 2010: 250.
11. Mbothwe (2010: 251).
12. Ibid.: 245.
13. Ibid.: 96.
14. Ibid.: 113.
15. See Fleishman (2009, 2011). /Xam people are one language group of the San, the hunter-gatherers who were the first peoples of South Africa.
16. Fleishman (2011: 241).
17. Ibid.: 243.
18. Appadurai cited in Fleishman (2009: 125).
19. Ibid.: 126.

20. The White Paper became the Higher Education Act 1997 promulgated in 2003; the measurement of research units makes no mention of creative outputs; http://www.gibs.co.za/SiteResources/documents/Policy_and_procedures_for_measurement_of_research_output_of_higher_education_institutions.pdf.
21. FTE is a measurement of subsidy according to 'full-time equivalent' student numbers.
22. Fleishman *et al.* (2009).
23. Ibid.: 10.
24. Ibid.: 11.

11 Why Performance as Research? A US Perspective

1. In the US, the terminal degree is the degree required to teach at the university level in a particular discipline. In theatre, creative writing, visual arts, media, film, etc., it is the MFA; doctorates in music and design are exceptions in the arts and have been around for some time already; see Elkins (2009).
2. For a collected summary of the debates on the value of PhDs for visual artists in the US, see ibid.
3. As Nelson notes in Chapter 1, Elkins (2009) counted around a dozen doctoral programmes in the visual arts in existence or in development in the US and forecast that there would be well over a hundred such programmes by 2012. His projections have not come to pass, perhaps owing to budget cutbacks in all areas of higher education – or perhaps because they simply have not taken off as anticipated.
4. There are graduate programmes in theatre and/or performance studies in the US that encourage or permit doctoral students in theatre history or criticism to acquire basic experience in directing or dramaturgy; there are others that market themselves as combining 'theory and practice' without establishing a formal programme of study and/or without modification regarding possible forms for the dissertation (writing and performance, for example). I exclude such programmes from this analysis. I should also make clear that I did not identify these programmes through a research study or programme survey, but via a series of Google searches for practice-based doctoral programmes in theatre and/or performance in the US. This should work well, theoretically, given schools intend for some students to find programmes through online searches.
5. I taught the required theory class, Critical Issues, at Maine College of Art from 1998 to 2002. The course became a requirement in 1993.
6. This has been my experience as both student and educator: I have taught undergraduate history, theory, and practice courses in performance and visual arts in independent art schools, two university theatre departments, a combined communications/performance studies department, and a department of humanities. I have also advised on PaR and non-PaR dissertations produced by artists in performance and visual studies. My disciplinary training is in the visual arts and performance art as well as in art history, critical theory, and performance studies. I have a BFA and MFA in Studio Art – in sculpture, performance art, and video installation – and a non-PaR PhD in

Performance Studies and Critical Theory. As such, I have disciplinary train-
ing in both visual arts and theatre, and each in practice and theory. Indeed,
I was first introduced to theory as a young art student at the School of the Art
Institute of Chicago in the late 1970s and was among the theory-hungry art
students described by George Smith in his introductory paragraphs (Smith
in Elkins 2009). When I made the move to a department of theatre in 2002,
after many years in art schools and art departments, I was absolutely stunned
at the reticence to embrace theory in practical courses at the undergraduate
level – something that had been *de rigueur* in art school for decades.

7. In some more traditional theatre PhD programmes, it is acceptable to con-
tinue some limited work as a dramaturge or director, but not in performance.
This reproduces the divide between those who do (perform) and those who
know (contextualize, conceptualize, research, and so on). There is tremen-
dous possibility to reconceive of both directing and dramaturgy as forms of
PaR; see Rossini (2009).

8. Courses are grouped as practice courses or history/theory courses, for
example.

9. To perform a thorough analysis of the situation, one might examine, for
example, the effects of US pragmatism on the ways that the arts are per-
ceived in higher education. Such an analysis is outside the scope of this short
essay. It bears on theatre education in the US because acting degrees – at any
level – are seen as practical degrees for a market (film, theatre) that is more
commercially driven than the art world, per se.

10. The State University of New York recently announced that it was going to
suspend five programmes in humanities on the Albany campus: French,
Italian, Russian, Classics and Theatre; see Adler (2010). For a description
of the dire situation in theatre at Cornell University, see Film and Dance
Faculty in the Department of Theatre (2010).

11. Carlson (2011).

12. Jackson (2009).

13. See Riley and Hunter (2009).

14. National Research Council of the National Academies (2011).

15. James Elkins, 'On Beyond Research and New Knowledge', and Charles
Harrison, 'When Management Speaks...', both in Elkins (2009), point out
the economic factor in the development of PaR PhD programmes in the UK.
Temple Hauptfleisch (2005) has written similarly on the national research
audit as it emerged in South Africa.

16. The popular rhetoric of interdisciplinarity is widespread in higher education
in the US – not only is it useful in research, but it has become a kind of
buzzword that attracts grants and has saturated all levels of administration.
Claims to interdisciplinarity hold substantial currency in departmental and
programme assessments right now – at least in the two state-run systems
of higher education in the State of California – the University of California
system, which is research-based and the California State University system.
Unfortunately its rhetoric also provides a too-easy solution to funding
problems on university campuses by justifying the merging of various arts
programmes.

17. 'Scholar-artist' is George Smith's preferred formulation.

18. Barber (2011); for a counter to Barber, see Seddon (2008).

19. Moreover, I am not sure that all learning at the college level can or should be assessed, but such a discussion is outside the scope of this chapter; see also Elkins (2001).
20. See Mckenzie (2001).
21. Elkins, in Elkins (2009: 112).
22. Ibid.
23. Harrison, in Elkins (2009).
24. See Smith, in Elkins (2009: 90). The Institute for Doctoral Studies in the Visual Arts, established in the USA, is an international academic PhD programme (complete with coursework and traditional dissertation) for practising artists who already hold a 'terminal degree' (MFA). It is not a PaR programme, although some students write dissertations that reflect on their own creative practice in some way.
25. Lynette Hunter established the PaR track at UCD and was also involved in early assessment exercises in the UK. She is a point of linkage between the US and UK PaR legacies and I am indebted to her (for many years now) for her thinking on this subject. See also Nelson and Andrews (2003). See further http://www.theatredance.buffalo.edu/academics/graduate/phd_requirements/
26. On performance as research in oral history and ethnography, see Della Pollock, 'Oral History'; Lara D. Nielsen, 'The Oral History Project: Practice-Based Research in Theatre and Performance'; John T. Warren, 'Performative and Pedagogical Interventions: Embodying Whiteness as Cultural Critique'; and Shannon Rose Riley, 'Miss Translation USA Goes to Cuba'; all in Riley and Hunter (2009).
27. Brittany Coleman-Chávez (2011) 'Remembering Latina Maternal Migration to the Silicon Valley: Performance and Poetics', MA Thesis, Department of Theatre, San José State University. The performance installation related to the thesis is titled *Embodied Borderlands*. She will soon be starting a non-PaR PhD programme in Communications Studies that is well-established in oral history and ethnographic methodologies – and her future faculty are excited about the kind of work she is doing. Who knows how her dissertation might ultimately incorporate PaR work?
28. Otherwise, those with MFA degrees are predominantly limited to teaching studio courses and those with PhDs teach primarily courses in history, criticism, and/or theory.
29. Shannon Rose Riley, 'Who Is Speaking?', delivered/performed at Organized Session 'Crossing the Boundaries of the Self', International Association of Philosophy and Literature Conference, SUNY Stonybrook, 2000.
30. Riley (1995). The project and thesis received one of five national Howard R. Swearer Student Humanitarian Awards by Campus Compact and Brown University. I presented a version of the thesis at Bates College in Lewiston Maine and the American Association of Higher Education conference in Washington DC, both in 1995.
31. Carlson (2011).
32. Elkins, in Elkins (2009: 111).
33. In an interdisciplinary, practices-based BA Creative Arts programme in Manchester.
34. The same can be said of the findings of a 2010 IBM poll and Daniel Pink's (2006) book, which both suggest that creativity is one of the most

important skills in business and thus negate 'deliverology' and STEM-focused approaches. See Heffernan (2011), http://opinionator.blogs.nytimes.com/2011/08/07/education-needs-a-digital-age-upgrade/, accessed 1 June 2012; IBM Press Room (2010); Pink (2006).

35. See Davidson (2011). Cathy Davidson served as the first Vice Provost for Interdisciplinary Studies at Duke University from 1998 to 2006.

36. See Riley and Hunter (2009).

37. See Sullivan (2005).

References

Aalto University Research Assessment Exercise 2009 Panel Reports (2009) The Panel on Architecture, Design, Media and Art Research, 2009, 226; http://www.aalto. fi/fi/research/rae/aalto_rae_2009 panel_reports.pdf.

Academy of Finland, presentation; http://www.aka.fi/en-GB/A/.

Academy, 2010, 1–2. http://www.teak.fi/tutkimus/carpa/proceedings

Adams, J. (2008) *Strategic Review of the Performance-Based Research Fund: The Assessment Process*. Leeds: Evidence Ltd.

Albinger, D. (2010) 'Resisting Romantic Love: Transforming the Wound of Amputation into a Caress', in Milne, G. (ed.) *Australasian Drama Studies*, 56, 25–37.

Allegue, L., Kershaw, B., Jones, S. and Piccini, A. (eds) (2009) *Practice-as-Research in Performances and Screen*. Basingstoke: Palgrave Macmillan.

Allsopp, R. and Delahunta, S. (1996) *Connected Body: an Interdisciplinary Approach to the Body and Performance*. London: Art Data.

Apel, Karl Otto (1996) *Ethics and the Theory of Rationality: Selected Essays*, vol. 2. Atlantic Highlands, NJ: Humanities Press.

Arendt, Hannah (1999 [1958]) *The Human Condition*. University of Chicago Press.

Arlander, Annette (2008) 'Finding Your Way Through the Woods – Experiences in Artistic Research', *Nordic Theatre Studies*, 20, 28–41.

Arlander, Annette (2009) 'Artistic Research – from Apartness to Umbrella Concept at the Theatre Academy, Finland', in S.R. Riley and L. Hunter (eds), *Mapping Landscapes for Performance as Research - Scholarly Acts and Creative Cartographies*. Basingstoke: Palgrave.

Arlander, Annette (2011) 'Characteristics of Visual and Performing Arts', in Michael Biggs and Henrik Karlsson (eds), *The Routledge Companion to Research in the Arts*. London and New York: Routledge, 315–32.

Arlander, Annette (ed.) (2010) 'How Does Artistic Research Change Us?', *Proceedings of CARPA 1: 1st Colloquium on Artistic Research in Performing Arts, Theatre Academy, Helsinki, 19–21 November, 2009*. Theatre Academy.

Arlander, Annette (ed.) (2011) *Artistic Research in Action – Proceedings of CARPA 2: Colloquium on Artistic Research in Performing Arts*. Publication Series, Theatre Academy Helsinki, **42**; http://www.teak.fi/tutkimus/carpa/proceedings.

Arts; http://www.teak.fi/Tutkimus/carpa.

Auslander, Philip (1999) *Liveness*. London and New York: Routledge.

Austin, J.L. (1975 [1962]) *How To Do Things with Words*. Cambridge, MA: Harvard University Press.

Australia Council for the Arts (2010) *Artist Careers*; http://www.australiacouncil. gov.au/__data/assets/pdf_file/0007/79072/Artist_career_research_summary.pdf

Baker, S. and Buckley, B. (2009) 'Future-Proofing the Creative Arts in Higher Education: Scoping for Quality in Creative Arts Doctoral Programs'; www. creativeartsphd.com.

Bakhtin, Mikhail (1981 ([1930s]) *The Dialogic Imagination: Four Essays*, ed. Michael Holquist, tr. Caryl Emerson and Michael Holquist. Austin and London: University of Texas Press.

Barba, Eugenio (1991) *A Dictionary of Theatre Anthropology: The Secret Art of the Performer*. London and New York: Routledge.

Barber, Michael (2011) *Deliverology 101: A Field Guide for Educational Leaders*. Thousand Oaks, CA and London: Corwin.

Barrett, Estelle and Bolt, Barbara (eds) (2010 [2007]) *Practice as Research: Approaches to Creative Arts Enquiry*. London and New York: Tauris.

Barton, Bruce, Friberg, Carsten and Parekh-Gaihede, Rose (eds) (2010) *At the Intersection Between Art and Research: Practice Based Research in the Performing Arts*. Malmö: NSU Press.

Bartos, Michael (1990) 'Performance and Performativity in Education', *Journal of Sociology*, **26** (3), 351–67.

Bay-Cheng, S., Kattenbelt, C., Lavender, A. and Nelson, R. (eds) (2010) *Mapping Intermediality in Performance*. Amsterdam University Press.

Bennington, Geoffrey and Derrida, Jacques (1991) *Jacques Derrida*. Paris: Seuil.

Biggs, Michael (2004) 'Learning from Experience: Approaches to the Experiential Component of Practice-Based Research', in *Forskning, Reflektion, Utveckling*. Stockholm: Vetenskapsrådet, 6–21.

Blain, Martin (2013) 'Composition-as-Research: *Connecting Flights II* for Clarinet Quartet: a Research Dissemination Methodology for Composers', *Music Performance Research*, **6** (forthcoming).

Bohm, David (1988) *On Creativity*. London and New York: Routledge.

Bollen, J. (2009) 'AusStage: E-Research in Milne (ed.), *The Performing Arts*', Australasian Drama Studies, 54, 178–94, April.

Bolt, Barbara (2008) 'A Performative Paradigm for the Creative Arts?' Working Papers in Art and Design, 6; http://sitem.herts.ac.uk/artdes_research/papers/wpades/vol5/bbfull.html.

Borgdorff, Henk (2009) 'Artistic Research Within the Fields of Science', Sensuous Knowledge Publications 6/2009. Bergen Academy of Arts; http://sensuous knowledge.org/publications/62009-artistic-research-within-the-fields-of-science/.

Borgdorff, Henk (2012) *The Conflict of the Faculties: Perspectives on Artistic Research and Academia*. Leiden University Press.

Bougourd, J., Evans, S. and Gronberg, T. (eds) (1988) *The Matrix of Research in Art and Design Education: Conference on Research in Art and Design Organised by the London Institute and the CNAA*. London: Central Saint Martins College of Art and Design and the London Institute.

Bourdieu, Pierre (1990) *The Logic of Practice*. Cambridge: Polity Press.

Buchanan, Richard *et al.* (eds) (2009) *Research in Art and Design in Finnish Universities*, Academy of Finland Publication 4/09; http://www.aka.fi/Tiedostot/Tiedostot/Julkaisut/04_09%20Research%20in%20Art%20and%20Design.pdf.

Buckley, B. and Conomos, J. (2009) 'The Australian Research Council Funding Model Condemns Art Schools to a Bleak Future', in Buckley, B. and Conomos, J. (eds) (2009) *Rethinking the Contemporary Art School: The Artist, the PhD, and the Academy*. Halifax: The Press of the Nova Scotia College of Art and Design, 87–9.

Butler, Judith (1993) *Bodies That Matter: On the Discursive Limits of Sex*. London and New York: Routledge Classics.

Butler, Judith (2004) *Undoing Gender*. London and New York: Routledge.

Butler, Judith (2006 [1990]) *Gender Trouble: Feminism and the Subversion of Identity*. London and New York: Routledge Classics.

Call for CARPA 1; http://www.teak.fi/menu_description.asp?menu_id=1198.

Call for CARPA 2 (2011); http://www.teak.fi/carpa2011.

Call for CARPA 3; http://www.teak.fi/Tutkimus/carpa/call_for_presentations.

Capella Martianus (ca.AD410) *De nuptiis Philologiae et Mercurii*. (See *Encyclopedia Brittanica*.)

Carlson, Marvin (2011) 'Inheriting the Wind: A Personal View of the Current Crisis in Theatre Higher Education in New York', *Theatre Survey*, 52 (1), May.

Carter, Paul (2004) *Material Thinking: The Theory and Practice of Creative Research*. Carlton, Victoria: Melbourne University Press.

Centre for Practise as Research in Theatre, University of Tampere. http://t7.uta.fi/en/center/index.html.

Chilisa, B. (2012) *Indigenous Research Methodologies*. London: Sage.

Coetzee, M.-H. (2009) '(Re)Storying the Self: Exploring Identity Through Performative Inquiry', *South African Theatre Journal*, 23, 94–15.

Collins English Dictionary (1998: Millennium Edition). Aylesbury: HarperCollins.

Conquergood, Dwight (2004) 'Performance Studies, Interventions and Radical Research', in H. Bial (ed.) (2004) *The Performance Studies Reader*. London and New York: Routledge, 311–20.

Creative and Performing Arts Panel-Specific Guidelines (2011) Quality Evaluation'; http://www.tec.govt.nz/Site-information/Search/?q=pbrf.

Cutler, A. and MacKenzie, I. (2011) 'Critique as a Practice of Learning: Beyond Indifference with Meillassoux, Towards Deleuze', *Warwick Journal of Philosophy*, 22: Contingency (55), 88–109.

Davey, Nicholas (2006) 'Art and *Theoria*', in K. Macleod and L. Holdridge (eds) (2006) *Thinking Through Art*. London and New York: Routledge, 20–9.

Davidson, Cathy N. (2011) *Now You See It: How the Brain Science of Attention Will Transform the Way We Live, Work, and Learn*. New York: Viking.

de Freitas, N. (2002) 'Towards a Definition of Studio Documentation: Working Tool and Transparent Record', Working Papers in Art and Design, 2; 1–10;http://sitem.herts.ac.uk/artdes_research/papers/wpades/vol2/freitasfull.html.

de Freitas, N. (2007) 'Activating a Research Context in Art and Design Practice', *International Journal for the Scholarship of Teaching and Learning*, 1 (2), 1–12; http://www.georgiasouthern.edu/ijsotl.

de Freitas N. (2011) *Welcome to Studies in Material Thinking*; http://www.material thinking.org/.

Deleuze, G. and Guattari, F. (1987) *A Thousand Plateaus: Capitalism and Schizophrenia*. Minneapolis and London: University of Minnesota Press.

Denzin, N.K. and Lincoln, Y.S. (2003)*The Landscape of Qualitative Research*. London: Sage.

Denzin, Norman (2003) *Performance Ethnography: Critical Pedagogy and the Politics of Culture*. Thousand Oaks, CA: Sage.

Derrida, Jacques (1976) *Of Grammatology*, tr. Gayatri Chakravorty Spivak. Baltimore and London: Johns Hopkins University Press.

Derrida, Jacques (1988) *Limited Inc.*, Evanston, IL: Northwestern University Press.

Derrida, Jacques (1991) 'Ponctuations: le temps de la thèse', in *Du droit à la philosophie*. Paris: Galilée, 439–59.

Derrida, J. and Stiegler, B. (2000) *Echographies of Television*. Cambridge: Polity Press.

Draper, P. and Harrison S. (2011) 'Through the Eye of a Needle: The Emergence of a Practice-Led Doctorate in Music', *British Journal of Music Education*, **28** (1), 87–101.

Elkins, James (2001) *Why Art Cannot Be Taught: a Handbook for Art Students*. Urbana and Chicago: University of Illinois Press.

Elkins, James (ed.) (2009) *Artists with PhDs: On the new Doctoral Degree in Studio Art*. Washington, DC: New Academia Publishing.

Etherington, Kim (2004) *Becoming a Reflexive Researcher* London and Philadelphia: Jessica Kingsley.

Falkenberg, P. (2007) 'Theatre of Unease', in Maufort, M. and O'Donnell, D. (eds) *Performing Aotearoa: New Zealand Theatre and Drama in an Age of Transition*. Brussels: Peter Lang, 293–306.

Fenemore, Anna, ed (2012) *The Rehearsal: Pigeon Theatre's Trilogy of Performance Works on Playing Dead*, Bristol, UK, and Chicago, USA: Intellect.

Finnish Academy of Fine Arts Doctoral Studies; http://www.kuva.fi/en/research/doctoral-studies/.

Finnish Academy of Fine Arts Curricula guide 2010–2015; http://www.kuva.fi/en/.

Fleishman, M., Hauptfleisch, T., Baxter, V. and Sutherland, A. (2009). 'Testing Criteria for Recognising Practice as Research in the Performing Arts in South Africa, With Particular Reference to the Case of Drama and Theatre', unpublished report.

Fleishman, Mark (2009) 'Knowing Performance: Performance as Knowledge Paradigm for Africa', *South African Theatre Journal*, **23**, 116–36.

Fleishman, Mark (2011) '"For a Little Road It Is Not. For It Is a Great Road; It Is Long": Performing Heritage for Development in the Cape", in A. Jackson and J. Kidd (eds) *Performing Heritage: Research, Practice and Innovation in Museum Theatre and Live Interpretation*. Manchester University Press.

Forgasz, R. (2010) 'What in the World Do They Think We're Doing? Practitioners' Views on the Work of the Theatre Studies Academy', *Australasian Drama Studies*, **57**, 214–27.

Frayling, Christopher (1993) 'Research in Art and Design', Royal College of Art Research Papers Series 1(1). London: Royal College of Arts.

Freeman, John (2010) *Blood, Sweat and Theory: Research Through Practice in Performance*. Farringdon: Libri Publishing.

Further and Continuing Education of Performing Artists in the Nordic Countries: A Nordic Task, proceedings of the conference in Oslo, 12–14 November 1999, TemaNord 2000, 621; http://openlibrary.org/books/OL3772202M/Further_and_continuing_education_of_performing_artists_in_the_Nordic_countries.

Gadamer, Hans-Georg (1989 [1960]) *Truth and Method*, tr. J. Weinsheimer and D.G. Marshall. London: Sheed & Ward.

Geertz, Clifford (1973) *The Interpretation of Cultures*. New York: Basic Books.

Gibson, J.J. (1966) *The Senses Considered as Perceptual Systems*. Boston, MA: Houghton Mifflin.

Gibson, William J. (1977) 'The Theory of Affordances' , in Robert Shaw and John Bransford (eds), *Perceiving, Acting, and Knowing: Toward an Ecological Psychology*. Hillsdale, NJ: Erlbaum.

Goffman, Ervine (1959) *The Presentation of Self in Everyday Life*. New York: Anchor.

Goldbeck-Wood, Sandra (1999) 'Evidence on Peer Review: Scientific Quality Control or Smokescreen?', *British Medical Journal*, **318**, 44–5.

Gray, Carole (1996) 'Inquiry Through Practice: Developing Appropriate Research Strategies'; http://carolegray.net/Papers%20PDFs/ngnm.pdf.

Green, Lelia (2007), 'Recognising Practice-Led Research . . . at Last!', unpublished conference paper, Hatched 07 Arts Research Symposium, Perth Institute of Contemporary Arts, Perth, 20 April; http://www.pica.org.au/downloads/141/L_Green.pdf.

Habermas, Jürgen (1976 [1973]) *Legitimation Crisis*, tr. T. McCarthy from *Legitimationsprobleme im Spätkapitalismus*. London: Heinemann Educational.

Halba, H. (2009) 'Creating Images and Telling Stories: Decolonising Performing Arts and Image-Based Research in Aotearoa/New Zealand', *About Performance*, 9, 193–211.

Halba, H. (2010) 'Performing Identity: Teaching Bicultural Theatre in Aotearoa', *Australasian Drama Studies*, 57, 22–37.

Hannula, Mika, Suoranta, Juha and Vadén, Tere (2005) *Artistic Research: Theories, Methods and Practices*. Academy of Fine Arts Helsinki and University of Gothenburg.

Haraway, Donna (1988) 'Situated Knowledges: the Science Question in Feminism and the Privilege of Partial Perspective', *Feminist Studies*, 14, 575–99.

Harrison, Charles (2009) 'When Management Speaks . . . ', in James Elkins (ed.), *Artists with PhDs: On the New Doctoral Degree in Studio Art*. Washington, DC: New Academia Publishing.

Harvey, M. (2011) 'Performance Test Labour', unpublished PhD thesis, Auckland University of Technology.

Haseman, B. C. (2006) 'A Manifesto for Performative Research', *Media International Australia Incorporating Culture and Policy: Quarterly Journal of Media Research and Resources*, 118, 98–106.

Haseman, Brad (2007) 'Tightrope Writing: Creative Writing Programs in the RQF Environment', *TEXT*, 11 (1), 1–15; http://www.textjournal.com.au/april07/haseman.htm.

Haseman, Brad and Jaaniste, Luke (2008) 'The Arts and Australia's National Innovation System, 1994–2008: ARGUMENTS, Recommendations, Challenges', Council for the Humanities, Arts and Social Sciences Occasional Paper no. 7, Canberra.

Haseman, Brad and Mafe, Daniel (2009) 'Acquiring Know-How: Research Training for Practice-Led Researchers', in H. Smith and R. Dean (eds), *Practice-Led Research, Research-Led Practice in the Creative Arts (Research Methods for the Arts and Humanities)*. Edinburgh University Press, 211–28.

Haseman, Brad (2007b) 'Rupture and Recognition: Identifying the Performative Research Paradigm', in Estelle Barrett and Barbara Bolt (eds), *Practice as Research: Approaches to Creative Arts Enquiry*. London and New York: Tauris, 147–58.

Hauptfleisch, Temple (2005) 'Artistic Outputs, Arts Research and the Rating of the Theatre Practitioner as Researcher: Some Responses to the NRF Rating System after the First Three Years,' *South African Theatre Journal*, 19, 9–34.

Hedberg, Hans (2012) Hand-out distributed at SHARE conference hosted by CCW Graduate School, Gothenburg University. University of the Arts London, May 2012.

Heffernan, Virginia (2011) 'Education Needs a Digital-Age Upgrade', *New York Times*, 7 August.

Heidegger, Martin (1976 [1954]) *What Is Called Thinking?*, tr. J.G. Gray and F.D. Wieck. London: HarperCollins.

Helsinki, Research and Post-Graduate Studies; http://www.teak.fi/Research.

Holbrook, A. *et al.* (2006). 'Assessment practice in fine art higher degrees', *Media International Australia incorporating Culture and Policy*, no. 118, February, 86–97.

Hoogland, Rikhard (ed.) (2008) 'The Artist as Researcher', *Nordic Theatre Studies*, vol. 20. Föreningen Nordiska Teaterforskare; http://blogs.helsinki.fi/nordictheatrestudies/2009/12/01/nts-vol-20-2008-the-artist-as-researcher/.

Hopkins Mary (1995) 'The Forum: the Performance Turn—and Toss', *Quarterly Journal of Speech*, **81** (2), 228–36.

Hugo, Graeme (2008) 'The Demographic Outlook for Australian Universities' Academic Staff', Council for the Humanities and Social Sciences, Canberra, Occasional Paper no. 6.

Hutchison, Heidi (2011) *Humanities and Creative Arts: Recognising Esteem Factors and Non-Traditional Publications in Excellence in Research for Australia (ERA) Initiative*, Advocacy Report, Council for the Humanities and Social Sciences, Canberra, 25 October; http://www.chass.org.au/papers/pdf/PAP20111025HH.pdf.

IBM Press Room (2010) 'IBM 2010 Global CEO Study: Creativity Selected as Most Crucial Factor for Global Success'. Armonk, NY, May.

Ikonen, Liisa, Järvinen, Hanna and Loukola, Maiju (eds) *Näyttämöltä tutkimukseksi – esittävien taiteiden metodologiset haasteet* [From Stage to Research – Methodological Challenges of Performing Arts], Näyttämö ja tutkimus 4, Teatterintutkimuksen seura Helsinki 2012; http://www.teats.fi/TeaTS4.pdf.

Jaaniste, L.O. and Haseman, B.C. (2009) 'Practice-Led Research and The Innovation Agenda: Beyond the Postgraduate Research Degree in the Arts, Design and Media', ACUADS 2009 Conference: *Interventions in the Public Domain*, 30 September – 2 October 2009, Queensland College of Art, Griffith University, Brisbane.

Jackson, Shannon (2009) 'When Is Art Research?', in S.R. Riley and L. Hunter (eds), *Mapping Landscapes for Performance as Research: Scholarly Acts and Creative Cartographies*. Basingstoke: Palgrave Macmillan, 157–63.

JAR Journal of Artistic Research; http://www.jar-online.net/.

Karlsson, Henrik (2002) '*Handslag, famntag, klapp eller kyss?*' – Konstnärlig forskarut-bildning I Sverige, SISTER Skriftserie 4, Stockholm.

Kaschula, Russell H. (2011) 'Technauriture: Multimedia Research and Documentation of African Oral Performance', in M. Chapman and M. Lenta (eds), *SA LIT: Beyond 2000*. Scottsville: UKZN Press.

Kershaw, Baz (2009a) 'Practice-as-Research: an Introduction', in L. Allegue *et al.* (eds) *Practice as Research in Performances and Screen*. Basingstoke: Palgrave Macmillan.

Kershaw, Baz (2009b). 'Practice as Research through Performance', in H. Smith and R. Dean (eds) *Practice-Led Research, Research-led Practice in the Creative Arts (Research Methods for the Arts and Humanities)*. Edinburgh University Press, 63–75.

Kiljunen, Satu and Mika Hannula (eds) (2002) *Artistic Research*. Helsinki: Finnish Academy of Fine Arts.

Kiljunen, Satu and Mika Hannula (eds) (2012) 'Inventions and Institutions: Artistic Research as a Medium of Change', presentation at the seminar of the Finnish Society for Aesthetics, 1 March 2012 (manuscript).

Kirby, Michael (ed.) (1974) *The New Theater: Performance Documentation.* New York University Press.

Kirkkopelto, Esa (2012) 'Inventions and Institutions: Artistic Research as a Medium of Change', presentation at the seminar of the Finnish Society for Aesthetics, 1 March 2012 (manuscript).

Kjorup, Soren (2006) *Another Way of Knowing: Baumgarten, Aesthetics, and the Concept of Sensuous Cognition.* Sensuous Knowledge Publications 1/2006, Bergen Academy of Arts; http://sensuousknowledge.org/publications/another-way-of-knowing/.

Konstnärliga Forskarskolan, Sweden,The Doctoral Programme in Artistic Research, rligaforskarskolan.se/wordpress; http://www.konstnarligaforskarskolan.se/wordpress/.

Kozel, Susan (2007) *Closer: Performance, Technologies, Phenomenology.* Cambridge, MA and London: MIT Press.

Kroll, Jerry (2008) 'Creative Practice And/As/Is/Or Research: An Overview', in *Creativity and Uncertainty: The Refereed Proceedings of the 13th Conference of the Australian Association of Writing Programs*; http://www.aawp.org.au/files/Kroll.pdf.

Lakoff, G. and Johnson, M. (1981) *Metaphors We Live By.* Chicago University Press.

Lakoff, G. and Johnson, M. (1999) *Philosophy in the Flesh: the Embodied Mind and Its Challenge to Western Thought.* New York: Basic Books.

Leavy, Patricia (2009) *Method Meets Art.* New York: Guilford Press.

Lehmann, Hans-Thies (2009 [1999]) *Postdramatic Theatre*, tr. K. Jürs-Munby. London and New York: Routledge.

Leonard, D. and Sensiper, S. (1998) 'The Role of Tacit Knowledge in Group Innovation', *California Management Review*, 40, 112–32.

Lesage, Dieter (2009a) 'Who's Afraid of Artistic Research? On Measuring Artistic Research Output', *Art & Research – A Journal of Ideas, Contexts and Methods*, 2 (2); http://www.artandresearch.org.uk/v2n2/lesage.html.

Lesage, Dieter (2009b) 'The Academy Is Back: On Education, the Bologna Process, and the Doctorate in the Arts', *e-flux journal*, no. 4, March; http://www.e-flux.com/journal/view/45.

Lesage, Dieter (2011) 'On Supplementality', in J. Cools and H. Slager (eds), *Agonistic Academies.* Brussels: Sint-Lukas Books, 75–86.

Lewin, Kurt (1948) *Resolving Social Conflicts.* London: Harper & Row.

Lilja, Efva, home page; http://www.efvalilja.se/page.php?id=start&lang=eng.

Little, S. (2010) 'Creating the Reflective Student Practitioner', *Australasian Drama Studies Journal*, theme issue 'Teaching and Pedagogy in Theatre Studies', (53), 38–53.

Lorenz, Chris (2012) 'If You're So Smart, Why Are You Under Surveillance?' – Universities, Neoliberalism, and New Public Management', *Critical Inquiry*, 38 (Spring), 599–629.

Lyotard, Jean-Francois (1984 [1979]) *The Postmodern Condition.* Manchester University Press.

Macleod, K. and Holdridge, L. (eds) (2006) *Thinking Through Art.* London and New York: Routledge.

Marsh, H., Smith, B., King, M. and Evans, T.D. (2012) 'A New Era for Research Education in Australia?', *Australian Universities Review*, 54 (1), 83–93.

Maxwell, Tom (2003) 'From First to Second Generation Professional Doctorate', in *Studies in Higher Education*, **28** (3).

Mbothwe, Mandla (2010) 'Dissecting the Aesthetics of Identity in *Isivuno Sama Phupha* (A Harvest of Dreams)', *South African Theatre Journal*, 24, 241–58.

McAuley, Gay (ed) (1986) *The Documentation and Notation of Theatrical Performance*. Sydney Association for Studies in Society and Culture.

McAuley, Gay (1994) 'The Video Documentation of Theatrical Performance', *New Theatre Quarterly*, **10** (38), 183–94.

McKenzie, J., Roms, H. and Wee, C.J.W.-L. (eds) (2010) *Contesting Performance: Global Sites of Research*. Basingstoke: Palgrave Macmillan.

McKenzie, J., Wee, C.J.W.-L. and Roms, H. (2010) 'Introduction: Contesting Performance in an Age of Globalization', in J. McKenzie *et al.* (eds), *Contesting Performance: Global Sites of Research*. Basingstoke: Palgrave Macmillan, 1–22.

McKenzie, Jon (2001) *Perform or Else: From Discipline to Performance*. New York and London: Routledge.

McVittie, Fred (2009) 'The Role of Conceptual Metaphor Within Knowledge Paradigms', unpublished PhD thesis, Manchester Metropolitan University.

McWilliam, E., Lawson, A., Evans, T. and Taylor, P.G. (2005) '"Silly, Soft and Otherwise Suspect": Doctoral Education as Risky', *Australian Journal of Education*, **49** (2), 214–27.

Melrose, Susan (2003) 'the curiosity of writing (or, who cares about performance mastery?)'; http://www.sfmelrose.u-net.com/curiosityofwriting/.

Melrose, Susan (2005) ' . . . just intuitive . . . '; http://sfmelrose.org.uk/justintuitive.

Melrose, Susan (2006) '"The Body" in Question: Expert Performance-Making in the University and the Problem of Spectatorship'; http://www.eis.mdx.ac.uk/staffpages/satinder/Melroseseminar6April.pdf.

Mercer, L. and Robson, J. (2012), 'The Backbone of Live Research: a Synthesis of Method in Performance Based Enquiry', in L. Mercer, J. Robson and D. Fenton (eds), *Live Research: Methods of Practice-Led Research in Performance*. Brisbane: Queensland University of Technology.

Mercer, L., Robson, J. and Fenton, D. (eds) (2011) *Live Research: Methods of Practice-Led Research in Performance*. Brisbane: Queensland University of Technology.

Merlin, Bella (2004) 'Practice as Research in Performance: A Personal Response', *New Theatre Quarterly*, **20** (1), 36–44.

Miller, L., Whalley, J. and Stronach, I. (1990) 'From Structuralism to Poststructuralism', in B. Somekh and C. Lewin (eds), *Research Methods in the Social Sciences*. London: Sage, 310–17.

Moustakas, Clark (1990) *Heuristic Research: Design, Methodology and Applications*. Newbury Park, CA, London and New Delhi: Sage.

Münch, Richard (2009) *Globale Eliten, Lokale Autoritäten. Bildung und Wissenschaft unter dem Regime von PISA, McKinsey & Co*. Frankfurt am Main: Suhrkamp.

Münch, Richard (2011) *Akademischer Kapitalismus. Über die politische Ökonomie der Hochschulreform*. Berlin: Suhrkamp, 328–80.

Nagel, Thomas (1986) *The View from Nowhere*. New York: Oxford University Press.

National Qualifications Authority of Ireland (2006) *Review of Professional Doctorates*. Available at: http://www.eua.be/eua/isp/en/upload/Review%20of%20Professional%20Doctorates_Ireland2006.1164040107604.pdf.

National Research Council of the National Academies (2011) 'A Data-Based Assessment of Research-Doctorate Programs in the United States'; http://www.nap.edu/rdp/.

Nelson, Camilla (2009) 'Best Practice? The Problem of Peer Reviewed Creative Practice Research', *TEXT*, **13** (1).

Nelson, Robin (2006) 'Practice as Research and the Problem of Knowledge', *Performance Research*, **11** (4), 105–16.

Nelson, Robin (2009) 'Modes of Practice-As-Research Knowledge and Their Place in the Academy', in L. Allegue, B. Kershaw, S. Jones and A. Piccini (eds), *Practice as Research in Performances and Screen*. Basingstoke: Palgrave Macmillan, 112–30.

Nelson, Robin and Andrews, Stuart (2003) 'Practice as Research: Regulations, Protocols and Guidelines'; http://78.158.56.101/archive/palatine/development-awards/337/index.html.

Nevanlinna, Tuomas (2002) 'Is "Artistic Research" a Meaningful Concept?', in Satu Kiljunen and Mika Hannula (eds), *Artistic Research*. Academy of Fine Arts Helsinki, 61–78.

Nevanlinna, Tuomas (2008) 'Mitä taiteellinen tutkimus voisi olla? [What artistic research could be?]', *mustekala* (octopus), 5/2008 (26 September); http://www.mustekala.info/node/835.

Niemetz, A., Brown, C. and Gander, P. (2011) 'Performing Sleep/Wake Cycles: An Arts–Science Dialogue through Embodied Technologies', *Body Space and Technology* Online Journal, **10** (1), 1–10; http://people.brunel.ac.uk/bst/vol1001/home.html.

Noë, Alva (2004) *Action in Perception*. Cambridge, MA: MIT Press.

NOfOD Nordic Forum for Dance research; http://www.nofod.org/.

Nordic Summer University (NSU) (2009)NSU – Study Circle 7, 2009: Artistic Research – Strategies for Embodiment, Introduction; http://www.nsuweb.net/wb/studiekretsar/.

Nordic Summer University (NSU)NSU – (2006) Proposal for Study Circle, 2006: Practice-Based Research in the Performing Arts; http://www.nsuweb.net/wb/pages/att-delta-i-nsu/fF6rslag-till-nya-studiekretsar/2006/d.-practice-based-research-in-the-performing-arts.php.

Norman, Donald (1988) *The Design of Everyday Things*. New York: Basic Books.

Norwegian Artistic Research Program; http://artistic-research.no/.

NSU Nordic Summer University (NSU), Presentation; http://www.nsuweb.net/wb/pages/information/briefly-in-english.php.

OECD (2002) *Frascati Manual: The Proposed Standard Practice for Surveys of Research and Experimental Development*, 6th edn; http://www.oecd.org/document/6/0,3746,en_2649_201185_33828550_1_1_1_1,00.html.

Ong, Walter (1982) *Orality and Literacy: The Technologizing of the Word*. London: Routledge.

Paavolainen, Pentti . and Ala-Korpela, Anu (eds) (1995) *Knowledge Is a Matter of Doing, Acta Scenica*, 1. Helsinki: Theatre Academy.

Pakes, Anna (2003) 'Original Embodied Knowledge: The Epistemology of the New in Dance Practice as Research', *Research in Dance Education*, **4** (2), 127–49.

Pakes, Anna (2004) 'Art as Action or Art as Object? The Embodiment of Knowledge in Practice as Research', *Working Papers in Art and Design*, 3 (5), 1–9; http://sitem.herts.ac.uk/artdes_research/papers/wpades/ vol3/apfull.html.

Pears, David (1971) *What Is Knowledge?* London: Allen & Unwin.

Phelan, Peggy (1993) *Unmarked: The Politics of Performance.* London and New York: Routledge.

Phillips, M., Stock, C. and Vincs, K. (2009). *Dancing Between Diversity and Consistency: Improving Assessment in Post Graduate Degrees in Dance;* http://www.dancingbetweendiversity.com/code/discussion.html#Definition.

Pihama, L., Cram, F. and Walker, S. (2002) 'Creating Methodological Space: a Literature Review of Kaupapa Maori Research', *Canadian Journal of Native Education,* **26** (1), 30–43.

Pink, Daniel (2006) *A Whole New Mind: Why Right-Brainers Will Rule the Future.* New York: Penguin.

Polanyi, Michael (1983) *The Tacit Dimension.* Gloucester, MA: Peter Smith.

Popper, Karl (1963) *Conjectures and Refutations.* London: Routledge.

Poststructuralism', in B. Somekh and C. Lewin (eds), *Research Methods in the Social Sciences.* London: Sage, 310–17.

RAE (2001) *Guidance on Submissions.* Bristol: Higher Education Funding Council for England.

Reason, Matthew (2006) *Documentation, Disappearance and the Representation of Live Performance.* Basingstoke: Palgrave Macmillan.

REF (2012) 'Panel Criteria and Working Methods'. Bristol: Higher Education Funding Council for England.

Research in Art and Design Education, documentation from the conference on research in art and design organised by the London Institute and the Council for National Academic Awards. London: Central Saint Martins College of Art and Design and the London Institute.

Research', *Media International Australia incorporating Culture and Policy,* theme issue 'Practice-Led Research', no. 118, 98–06; http://eprints.qut.edu.au/3999/1/3999_1.pdf.

Richards, Alison (1995) 'Performance as Research/Research By Means of Performance'. Discussion paper presented to the Australasian Drama Studies Association Annual Conference, Armidale, NSW, July 1995; http://www.adsa.edu.au/research/performance-as-research.

Riley, S.R. and Hunter, L. (eds) (2009) *Mapping Landscapes for Performance as Research.* Basingstoke: Palgrave Macmillan.

Riley, Shannon Rose (1995) 'The Reconstruction of Monological Perspectives: Postmodernism and the Expanding Discourses of Art and Medical Science,' unpublished BFA thesis.

Robson, J. (2012) 'Mercury and Method: the Alchemy of Documentation in Performance-Led Research', in L. Mercer, J. Robson and D. Fenton (eds), *Live Research: Methods of Practice-Led Research in Performance.* Brisbane: Queensland University of Technology, 149–62.

Robson, J., Brady, D. and Hopkins, L. (2010) 'From Practice to the Page: Multidisciplinary Understandings of the Written Component of Practice-Led Studies', *Australasian Drama Studies,* **56** (1), 88–189.

Rodaway, Paul (1994) *Sensuous Geographies: Body, Sense and Place.* London. Routledge.

Rossini, Jon D. (2009), 'Dramaturgy: Conceptual Understanding and the Fickleness of Process', in S.R. Rileyand L. Hunter (eds), *Mapping Landscapes*

for *Performance as Research*. Basingstoke and New York: Palgrave Macmillan, 237–43.

Rye, Caroline (2003) 'Incorporating Practice: a Multi-Viewpoint Approach to Performance Documentation', *Journal of Media Practice*, 3 (2), 115–23.

Ryle, Gilbert (1949) 'Knowing How and Knowing That', in *Concept of Mind*. Harmondsworth: Penguin, 26–60.

Schaerf, Eran (2007) 'Unsubstantiated Investigation', in D. Lesage and K. Busch (eds), *A Portrait of the Artist as a Researcher: The Academy and the Bologna Process (AS#179)*. Antwerp: MuHKA.

Schatzki, T.R., Knorr Cetina, K. and Savigny, E. von (2001) *The Practice Turn in Contemporary Theory*. London and New York: Routledge.

Schippers, H. (2007) 'The Marriage of Art and Academia: Challenges and Opportunities for Music Research in Practice-Based Environments', *Dutch Journal of Music Theory*, 12, 34–40.

Schön, Donald (1983) *The Reflective Practitioner*. New York. Basic Books/Perseus.

Scrivener, S. (2002) 'The Art Object Does Not Embody a Form of Knowledge', *Working Papers in Art and Design*, 2; http://www.herts.ac.uk/artdes/research/papers/wpades/vol2/scrivenerfull.html.

Scrivener, S. (2004) 'The Practical Implications of Applying a Theory of Practice Based Research: A Case Study', *Working Papers in Art and Design*, 3; http://sitem.herts.ac.uk/artdes_research/papers/wpades/vol3/ssfull.html, accessed 16 December 2011.

Seddon, John (2008) *Systems Thinking in the Public Sector: The Failure of the Reform Regime . . . And a Manifesto for a Better Way*. Axminster: Triarchy Press. Sensuous Knowledge Conferences; http://sensuousknowledge.org/.

SHARE (Step-Change for Higher Arts Research and Education) Network; http://www.sharenetwork.eu/home.

Sibelius Academy Doctoral Academy; http://www.siba.fi/en/how-to-apply/doctoral-degrees/doctoral-academy/about-us.

Singhal, A. (2004) 'Entertainment-Education Through Participatory Theater: Freirean Strategies for Empowering the Oppressed', in A. Singhal, M.J. Cody, E.M. Rogers and M. Sabido (eds) *Entertainment-Education and Social Change: History, Research, and Practice*. Mahwah, NJ: Erlbaum.

Sinner, A. *et al.* (2003) 'Arts-Based Education Research Dissertations; Reviewing the Practices of New Scholars', *Canadian Journal of Education*, 29 (4), 1223–70.

Smith, George (2009) 'The Non-Studio PhD for Visual Artists', in J. Elkins (ed.), *Artists with PhDs: On the New Doctoral Degree in Studio Art*. Washington, DC: New Academia Publishing, 87–95.

Smith, H. and Dean, R. (eds) (2009) *Practice-Led Research, Research-Led Practice in the Creative Arts (Research Methods for the Arts and Humanities)*. Edinburgh University Press.

Smith, Richard (1999) 'Opening Up BMJ Peer Review: a Beginning That Should Lead to Complete Transparency', *British Medical Journal*, 318, 4–5.

Stock, Cheryl F. (2011) 'Approaches to Acquiring "Doctorateness" in the Creative Industries: An Australian Perspective', in L. Justice and K. Friedman (eds), *Pre-Conference Proceedings: Doctoral Education in Design: Practice, Knowlege, Vision*, Hong Kong Polytechnic University.

Sullivan, Graeme (2006) 'Research Acts in Research Practice', *Studies in Art Education*, **48** (1), 19–35.

Sullivan, Graeme (2010 [2005]) *Art Practice as Research: Inquiry in the Visual Arts*. Thousand Oaks and London: Sage.

TAHTO Doctoral Programme in Artistic Research; http://www.teak.fi/Doctoral_programme_in_artistic_research.

The Big Idea/te aria nui (2011) 'Free Theatre Presents The Earthquake in Chile'; http://www.thebigidea.co.nz/connect/media-releases/2011/sep/92540-free-theatre-presents-the-earthquake-in-chile.

Theatre Academy, Helsinki Research and Post-graduate Studies, http://www.teak.fi/Research.

Theatre Research Society; http://www.teats.fi/english.html.

Trimingham, M. (2002) 'A Methodology for Practice as Research', *Studies in Theatre and Performance*, **22** (1), 54–60.

UK Council for Graduate Education (1997) *Practice-Based Doctorates in the Creative and Performing Arts and Design*. Coventry: Dialhouse Printers.

UNESCO (1979) *Resolutions of the 1979 UNESCO Conference*, Annex 1; http://unes-doc.unesco.org/images/0011/001140/114032e.pdf.

United Kingdom Council for Graduate Education (UKCGE) (2001) *Research Training in the Creative and Performing Arts and Design*. Dudley.

University of Auckland (2011) '2012 National Institute of Creative Arts and Industries Postgraduate Prospectus'; http://www.creative.auckland.ac.nz/uoa/home/about/programmes-and-courses/download-a-prospectus.

University of Auckland (2011) 'PhD with Creative Practice'; http://www.auckland.ac.nz/uoa/cs-pg-doc-creative-practice.

van Rooyen, Susan *et al.* (1999) 'Effect of Open Peer Review on Quality of Reviews and on Reviewers' Recommendations: a Randomised Trial', *British Medical Journal*, **318**, 23–7.

Varela, F., Thompson, E. and Rosch, E. (1993) *The Embodied Mind: Cognitive Science and Human Experience*. Cambridge, MA and London: MIT Press.

Varto, Juha (2009) *Basics of Artistic Research: Ontological, Epistemological and Historical Justifications*, University of Art and Design Helsinki Publication B94. Helsinki: Gummerus.

Vygotsky, Lev (1986 [1934]) *Thought and Language*, tr. and ed. Alex Kozulin. Cambridge, MA: MIT Press.

Whalley, J. and Miller, L. (2005) 'A Dwelling in the Screen, at Least for a Little Time', *Performance Research*, **10** (4), 138–47.

Williams, Michael (2001) *Problems of Knowledge*. Oxford University Press.

Williams, Raymond (1981) 'Communications Technologies and Social Institutions', in Raymond Williams (ed.), *Contact: Human Communication and its History*. London: Thames and Hudson, 225–38.

Williams, Raymond (1983 [1976]) *Keywords: A Vocabulary of Culture and Society*. London. Fontana Paperback, Flamingo edition.

Wittgenstein, Ludwig (1994) *Philosophical Investigations*, tr. G.E.M. Anscombe. Oxford: Blackwell.

Worthen, Bill (2010) *Drama: Between Poetry and Performance*. Oxford: Wiley-Blackwell.

Zarrilli, Philip (2001) 'Negotiating Performance Epistemologies: Knowledges "About", "In" and "For"', *Studies in Theatre and Performance*, **21** (1), 31–46.

Bibliography: Practice as Research

Allegue, L. and Miereanu, C. (2009) 'Practice-as-Research in France, 2008', in L. Allegue, B. Kershaw, S. Jones and A. Piccini (eds) *Practice-as-Research in Performance and Screen*. Basingstoke: Palgrave Macmillan, pp. 143–7.

Allegue, L., Kershaw, B., Jones, S. and Piccini, A. (eds) (2009) *Practice-as-Research in Performance and Screen*. Basingstoke: Palgrave Macmillan.

Arlander, A. (2008) 'Finding Your Way Through the Woods – Experiences of Artistic Research', *Nordic Theatre Journal*, 20, 29–42.

Bannerman, C., Sofaer, J. and Watt, J. (eds) (2006) *Navigating the Unknown: The Creative Process in Contemporary Performing Arts*. London: I.B. Tauris.

Barrett, E. and Bolt, B. (eds) (2007) *Practice as Research: Approaches to Creative Arts Enquiry*. London: I.B. Tauris.

Biggs, I. (2009) *Art as Research: Creative Practice and Academic Authority*. Saarbrucken: VDM Verlag.

Biggs, M. (2000) 'The Foundations of Practice-based Research' (Editorial), *Art and Design*, 1; http://sitem.hert.ac.uk/artdes_research/papers/wpades/vol1/vol1intro.html.

Biggs, M. and Karlsson, H. (eds) (2011) *The Routledge Companion to Research in Art and Design*. London and New York: Routledge.

Birdsall, C., Boletsi, M., Sapir, I. and Verstraete, P. (eds) (2009) *Inside Knowledge: (Un)Doing Ways of Knowing in the Humanities*. Newcastle upon Tyne: Cambridge Scholars Publishing.

Borgdorff, Henk (2012) *The Conflict of the Faculties: Perspectives on Artistic Research and Academia*. Leiden University Press.

Brien, D.L. (2006) 'Creative Practice as Research: A Creative Writing Case Study', *Media International Australia*, (118), 53–9.

Bruneau, M. and Burns, S. (2007) 'Des Enjeux épistemologiques à une méthodologie hybride de la recherché en art', in M. Bruneau and A. Villeneuve (eds) *Traiter de recherche création en art: entre la quête d'un territoire et la singularité des parcours*. Presses de l'Université du Québec, pp. 79–152.

Bruneau, M. and Villeneuve, A. (eds) (2007) *Traiter de recherche création en art: entre la quête d'un territoire et la singularité des parcours*. Presses de l'Université du Québec.

Cahnmann-Taylor, M. and Siegesmund, R. (eds) (2007) *Arts-Based Research in Education: Foundations for Practice*. London: Routledge.

Daichendt, G. James (2012) *Artist Scholar Reflections on Writing and Research*. London and New York: Routledge.

Draper, P. and Harrison S. (2011) 'Through the Eye of a Needle: The Emergence of a Practice-Led Doctorate in Music', *British Journal of Music Education*, 28 (1), pp. 87–101.

Fenton, D., Mercer, L. and Robson, J. (eds) (2012) *Live Research: Models of Practice-Led Research in Performance*. Brisbane: Queensland University of Technology.

Fleishman, Mark. (2009) 'Knowing Performance: Performance as Knowledge Paradigm for Africa', *South African Theatre Journal*, 23, 116–36.

Fleishman, Mark. (2011) '"For a Little Road It Is Not. For It Is a Great Road; It Is Long": Performing Heritage for Development in the Cape', in A. Jackson and J. Kidd (eds) *Performing Heritage: Research, Practice and Innovation in Museum Theatre and Live Interpretation*. Manchester University Press.

Frayling, C. (1997) *Practice-Based Doctorates in the Creative and Performing Arts and Design*. Lichfield: UK Council for Graduate Education.

Freeman, John (2010) *Blood, Sweat and Theory: Research Through Practice in Performance*. Farringdon: Libri Publishing.

Hannula, M., Suoranta, J. and Vadén, T. (2005) *Artistic Research: Theories, Methods, Practices*. London: Sage.

Haseman, B.C. (2006) 'A Manifesto for Performative Research', *Media International Australia Incorporating Culture and Policy: Quarterly Journal of Media Research and Resources*, **118**, pp. 98–106.

Haseman, B. and Mafe, D. (2009) 'Acquiring Know-How: Research Training for Practice-Led Researchers', in H. Smith and R. Dean (eds) *Practice-Led Research, Research-Led Practice in the Creative Arts (Research Methods for the Arts and Humanities)*. Edinburgh University Press, pp. 211–28.

Kershaw, B. (2002) 'Performance, Memory, Heritage, History, Spectacle – The Iron Ship', *Studies in Theatre and Performance*, **21** (3), 132–49.

Kershaw, B. (2009) 'Practice as Research Through Performance', in H. Smith and R. Dean (eds) *Practice-Led Research, Research-Led Practice in the Creative Arts (Research Methods for the Arts and Humanities)*. Edinburgh University Press, pp. 63–75.

Kershaw, B. *et al.* (2011) 'Practice as Research: Transdisciplinary Innovation in Action', in B. Kershaw and H. Nicholson (eds) *Research Methods in Theatre and Performance: Research Methods for the Arts and Humanities*. Edinburgh University Press, pp. 63–85.

Knudsen, E. (2003) 'Creation and I, Me and My Work', *Journal of Media Practice*, **3** (2), pp. 107–14.

Kroll, J. (2008) 'Creative Practice And/As/Is/Or Research: An Overview', in L. Neve, and D.L. Brien (eds) *The Creativity and Uncertainty Papers: The Refereed Proceedings of the 13th Conference of the Australian Association of Writing Programs*, pp. 1–14; http://aawp.org.au/creativity–and–uncertainty–papers.

Leavy, P. (2009) *Method Meets Art*. New York: Guilford Press.

Little, S. (2010) 'Creating the Reflective Student Practitioner', *Australasian Drama Studies Journal*, theme issue 'Teaching and Pedagogy in Theatre Studies', (53), 38–53.

Little, S. (2011) 'Practice and Performance as Research in the Arts', in D. Bendrups and G. Downes (eds) *Dunedin Soundings: Performing Place in/Aotearoa/ New Zealand Music*. Dunedin: Otago University Press, pp. 17–26.

Lycouris, S. (2011) 'Practice-Led Doctorates in the Arts, Design and Architecture', in T. Fell, K. Flint and I. Haines (eds) *Professional Doctorates in the UK (2011)*. Lichfield: UK Council for Graduate Education, pp. 62–70.

McNiff, S. (2008) *Art-Based Research*. London: Jessica Kingsley.

Melzer, A. (1995) '"Best Betrayal": The Documentation of Performance on Video and Film', *New Theatre Quarterly*, **42**, pp. 147–50.

Mercer, L. and Robson, J. (2012) 'The Backbone of Live Research: A Synthesis of Method in Performance-Based Inquiry', in D. Fenton, L. Mercer and J. Robson (eds) *Live Research: Models of Practice-Led Research in Performance*. Brisbane: Queeensland University of Technology.

Mock, R. (ed). (2000) *Performing Processes: Creating Live Performance*. Bristol: Intellect.

Mock, R. *et al.* (2004) 'Reflections on Practice as Research Following the PARIP Conference, 2003', *Studies in Theatre and Performance*, **24** (2), 129–41.

Nelson, Camilla. (2009). 'Best Practice? The Problem of Peer Reviewed Creative Practice Research', *TEXT*, **13** (1).

Nelson, R. (2009) 'Modes of Practice-as-Research Knowledge and their Place in the Academy', in L. Allegue, B. Kershaw, S. Jones and A. Piccini (eds) *Practice-as-Research in Performance and Screen*. Basingstoke: Palgrave Macmillan, pp. 112–30.

Nelson, Robin (2006) 'Practice as Research and the Problem of Knowledge', *Performance Research*, **11**, (4), 105–16.

Pakes, A. (2003) 'Original Embodied Knowledge: The Epistemology of the New in Dance Practice as Research', *Research in Dance Education*, **4** (2), 127–49.

PARIP (2006) 'Practice as Research in Performance'; http://www.bris.ac.uk/parip/ introduction.htm.

Riley, Shannon Rose and Hunter, Lynette (eds) (2009) *Mapping Landscapes for Performance as Research*. New York: Palgrave Macmillan.

Saxton, J. and Miller, C. (eds) (1998). *Drama and Theatre in Education: The Research of Practice, The Practice of Research*. London: IDEA Publications.

Schatzki, T.R., Knorr Cetina, K. and Savigny, E. von (eds) (2001) *The Practice Turn in Contemporary Theory*. London and New York. Routledge.

Schippers, H. (2007) 'The Marriage of Art and Academia: Challenges and Opportunities for Music Research in Practice-based Environments', *Dutch Journal of Music Theory*, **12**, 34–40.

Schön, D. (1983) *The Reflective Practitioner: How Professionals Think in Action*. Hampshire: Ashgate.

Scrivener, S. (2002) 'The Art Object Does Not Embody a Form of Knowledge', *Working Papers in Art and Design*, **2**; http://www.herts.ac.uk/artdes/research/ papers/wpades/vol2/scrivenerfull.html (accessed 23 August 2010).

Scrivener, S. (2004) 'The Practical Implications of Applying a Theory of Practice Based Research: A Case Study', *Working Papers in Art and Design*, **3**; http:// sitem.herts.ac.uk/artdes_research/papers/wpades/vol3/ssfull.html, accessed 16 December 2011.

Sinner, A. *et al.* (eds) (2006) Arts-Based Educational Research Dissertations: Reviewing the Practies of New Scholars', *Canadian Journal of Education*, **29**, (4), 1223–70).

Smith, H. and Dean, R. (eds) (2009) *Practice-led Research, Research-led Practice in the Creative Arts*. Edinburgh: Edinburgh University Press.

Sullivan, G. (2010 [2005]) *Art Practice as Research: Inquiry in the Visual Arts*. London: Sage.

Thomas, E. (ed.) (2001) *Research Training in the Creative and Performing Arts and Design*. Lichfield: UK Council for Graduate Education.

Thompson, P. (ed.) (2003) 'Practice as Research (Notes and Queries)', *Studies in Theatre and Performance*, **22** (3), 159–80.

Trimingham, M. (2002) 'A Methodology for Practice as Research', *Studies in Theatre and Performance*, **22** (1), 54–60.

Zarrilli, P. (2001) 'Negotiating Performance Epistemologies: Knowledges "about", "in" and "for"', *Studies in Theatre and Performance*, **21** (131–46).

Index